# GEORGE CALEB
# BINGHAM

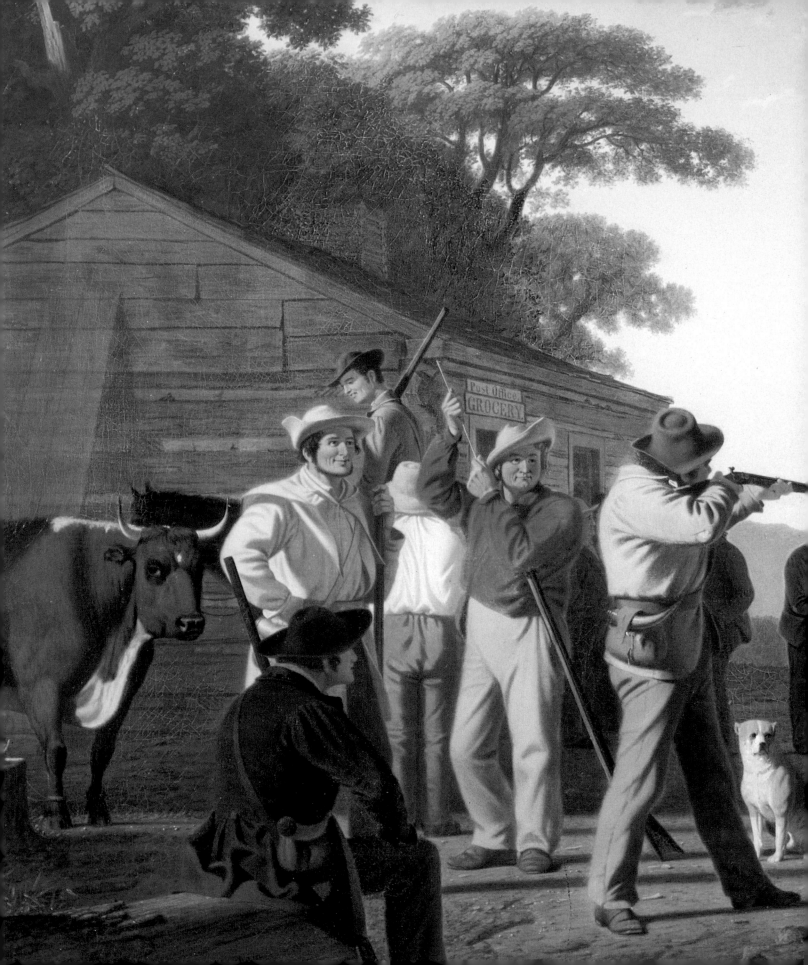

# GEORGE CALEB
# BINGHAM

Michael Edward Shapiro

Barbara Groseclose

Elizabeth Johns

Paul C. Nagel

John Wilmerding

The Saint Louis Art Museum in association with
Harry N. Abrams, Inc., Publishers, New York

PROJECT DIRECTOR: Margaret L. Kaplan
DESIGNER: Lisa Govan, The Sarabande Press

Published on the occasion of the exhibition *George Caleb Bingham*, organized by The Saint Louis
Art Museum, in association with the National Gallery of Art, Washington, D.C.

This exhibition and catalogue have been made possible by generous funding from Boatmen's
Bancshares, Inc., and the Henry Luce Foundation, Inc. Additional funds were provided by the
National Endowment for the Arts, a Federal agency, and the Missouri Arts Council, a state agency.

Library of Congress Cataloging-in-Publication Data

George Caleb Bingham/Michael Edward Shapiro . . . [et al.].
p.   cm.
Catalog of an exhibition held at the Saint Louis Art Museum, Feb.
22–May 13, 1990, and at the National Gallery of Art, June 15–Sept. 30, 1990.
ISBN 0-8109-3102-8. —ISBN 0-89178-033-5 (pbk.)
1. Bingham, George Caleb, 1811–1879—Exhibitions.   Shapiro,
Michael Edward.   II. St. Louis Art Museum.   III. National Gallery of Art (U.S.)
ND237.B587A4      1990
759.13—dc20                                              89–35750
                                                         CIP

Published in 1990 by Harry N. Abrams, Incorporated, New York, a Times Mirror Company, in
association with The Saint Louis Art Museum. All rights reserved. No part of the contents of this
book may be reproduced without the written permission of the publishers

Printed and bound in Japan

Front Cover: *Jolly Flatboatmen in Port* (detail). 1857.
The Saint Louis Art Museum, St. Louis, Missouri
Back Cover: *Fur Traders Descending the Missouri*. 1845.
The Metropolitan Museum of Art, New York
Pages 2–3: Detail of *Shooting for the Beef*, 1850 (Plate 29)
Pages 4–5: Detail of *The Concealed Enemy*, 1845 (Plate 9)

# CONTENTS

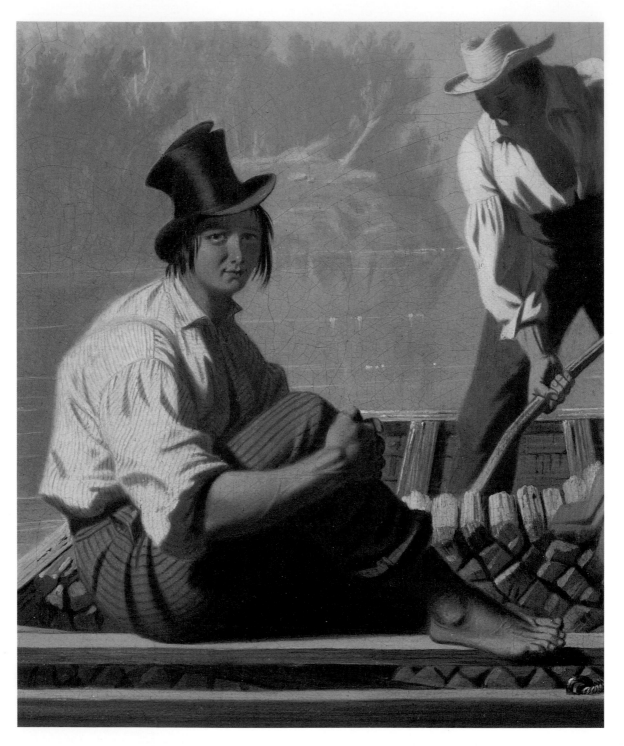

*Plate 1 detail of* Boatmen on the Missouri, *1846. (See Plate 38.)*

# ACKNOWLEDGMENTS

T his book results from many contributions. It grows out of more than four decades of dedicated scholarship by E. Maurice Bloch, who more than any other individual has codified George Caleb Bingham's work, and produced publications which made our work immeasurably easier. The Henry Luce Foundation, Inc., through Henry Luce III, president; Robert E. Armstrong, vice president and executive director; and Mary Jane Crook, program officer, provided early and vital financial support for this book and the exhibition it accompanies. We warmly appreciate their continuing assistance to our program of reconsidering the achievements of important American artists.

The contributing authors gave substance and form to the initial idea of this book. Paul Nagel, Elizabeth Johns, Barbara Groseclose, and John Wilmerding each energetically delved into different aspects of the artist's life and work. We hope these efforts will open new doors to understanding and appreciating Bingham and his paintings.

For The Saint Louis Art Museum, this book represents the efforts of many of its staff members. James D. Burke, director, was enthusiastic and supportive of the project from its inception. Rick Simoncelli, assistant director, helped with the coordination of both the book and the exhibition. The publications department under the leadership of Mary Ann Steiner saw the book through all stages of production. Warm thanks are extended to Kathleen Schodrowski, Pat Woods, Suzanne Tyler, and Leslie Weinstein of the publications department. Anne Benedict, director of development, and Margaret Elliott, development officer, secured much of the funding for the exhibition. In the curatorial department, the strong research assistance of Kathleen Heins helped curator and guest authors alike. Traci Sanders was a model of assistance and organization throughout, and Maureen Megerian, curatorial assistant; Debbie Boyer, curatorial coordinator; and Kristen

Gladsky, secretary of the Museum's curatorial group, also provided needed additional support. Registrar Nick Ohlman and his assistant, Marie Nordmann, arranged the transport of all works of art. Additional support was provided by Kay Porter in Public Relations, Elizabeth Vallance in Education, Dan Esarey in Building Operations, and Rita Wells in the Museum Shop.

At the National Gallery of Art, Franklin Kelly, Jr., and upon his departure, Nicolai Cikovsky, Jr., curator of American Art, were the primary contacts. Ann Bigley, Dodge Thompson, and Liz Weil were also unfailingly helpful. John Wilmerding, first as deputy director of the National Gallery, then as the Sarofim Professor of American Art at Princeton University, helped nurture and keep the exhibition in focus.

At The Bingham Trust, we are especially appreciative of Charles E. Valier's continuing interest in the artist and of the support of trustee members James A. Singer and Herman Sutherland. Senator Christopher Bond, who as governor of Missouri led the successful effort to retain the Bingham drawings in the state, lent his support to the exhibition, as did Senator John Danforth.

Boatmen's Bancshares, Inc. traces its roots back to the time of Bingham and possesses three of the artist's most important paintings. Chairman of the Board Donald N. Brandin has always been a sincere and consistent Bingham supporter. We are especially pleased that such a generous lender agreed to sponsor the St. Louis installation of the exhibition.

In addition, financial assistance for this project was provided by the National Endowment for the Arts, a federal agency.

Neither the exhibition nor the book would have been possible without the support of the individual and institutional owners who agreed to lend their works of art to the exhibition. We list them as follows: at the Anschutz Corporation, Philip S. Anschutz and Elizabeth Cunningham, curator; at Boatmen's Bancshares, Donald N. Brandin; at The Brooklyn Museum, Robert T. Buck, director, and Linda S. Ferber, chief curator, and Barbara Gallati, associate curator; at The Corcoran Gallery, Christina Ohr-Cahall, director, and Franklin Kelly, Jr., curator; at the Detroit Institute of Arts, Samuel Sachs II, director, and Nancy Rivard Shaw; Jamee and Marshall Field; at The Fine Arts Museums of San Francisco, Harry S. Parker III, director, Steven A. Nash, associate director and chief curator, and Marc Simpson, curator; Richard Manoogian; at The Metropolitan Museum of Art, Philippe de Montebello, director, John K. Howat, department chairman, and Doreen Bolger, associate curator; at the Museum of Fine Arts, Boston, Alan Shestack, director, and Theodore E. Stebbins, Jr., curator; at The Nelson-Atkins Museum of Art, Marc F. Wilson,

director, and Henry Adams, curator; at the State Historical Society of Missouri, James W. Goodrich, director, and Sidney Larson, curator; at the Wadsworth Atheneum, Patrick McCaughey, director, and Elizabeth Kornhauser, curator; at Washington University, Joseph D. Kettner II, director; at The White House, Rex W. Scouten, curator, and Betty C. Monkman, registrar; and two anonymous private collectors.

A number of institutions and individuals were generous lenders of Bingham portraits to the portrait section of the St. Louis installation. They include Mrs. W. Coleman Branton; Miss Adelaide Cherbonnier; Mr. and Mrs. John C. Cooper III; Don Bradbury, director at the Kansas City Public Library; Mr. B. H. Rucker, chief of Historic Sites at the Missouri Department of Natural Resources; Mr. Robert Archibald, director at the Missouri Historical Society; Mr. George E. Stier; Mr. J. Gordon Kingsley, president of William Jewell College; and four anonymous lenders.

Additional assistance was provided by the staffs of the libraries of the State Historical Society in Columbia and the Mercantile Library in St. Louis. We also thank Gerald Bolas, director of the Portland Art Museum; Russell Burke; Alex and Caroline Castro; Catherine Kennedy; Bob Kolbrener; Leah Lipton, Framingham State University; Coradean and Cecil Naylor; The New-York Historical Society; Ed Nygren, director of the Smith College Museum of Art; Charles van Ravenswaay; Lewis Sharp, director of the Denver Art Museum; at the Virginia Museum of Art, Paul Perrot and William Rasmussen; and at the Missouri Historical Society, Kenneth Winn.

We are particularly grateful to members of the Rollins family for their continuing efforts to maintain the memory of the extraordinary friendship that existed between Bingham and his closest friend and mentor, James Sidney Rollins.

At Harry N. Abrams, Inc., Executive Editor Margaret L. Kaplan has been an enthusiastic pillar of advice and assistance throughout the project, as have been Adele Westbrook, Senior Editor, and the book's designer, Lisa Govan.

Finally, I would like to thank my wife, Lisa, for her support as she willingly shared many a winter evening as I expressed my hope to rekindle the memory of George Caleb Bingham.

*Michael Edward Shapiro*
*Chief Curator*
*The Saint Louis Art Museum*

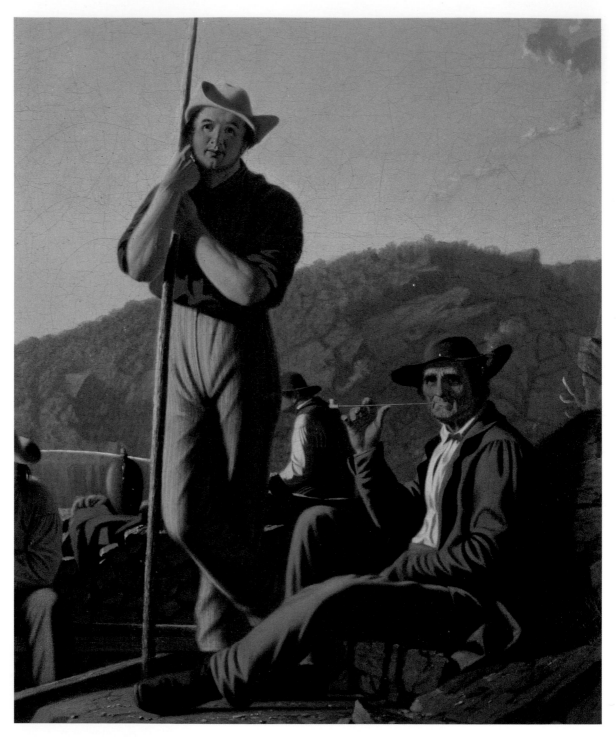

*Plate 2 detail of* The Wood-Boat, *1850. (See Plate 42.)*

# FOREWORD

George Caleb Bingham was one of Missouri's and one of America's greatest artists. Raised in central Missouri, he lived as an itinerant painter in St. Louis and, as a mature artist, in Independence and Kansas City. Working before America's vastness was made manageable by a web of roads and railways, Bingham found his subjects in the trappers and boatmen who populated his state's great rivers, the Missouri and the Mississippi. He also depicted social and political life of what was then still the frontier, preserving with timeless, classic dignity the features and spirit of the American democracy. The Saint Louis Art Museum and the National Gallery of Art are proud to join in bringing Bingham's work back to the region that provided his greatest inspiration, and via its capital, to the nation whose energy, ambition, and institutions he celebrated.

We are grateful to the many persons and institutions who made this exhibition and book possible. The Henry Luce Foundation, Inc., through Henry Luce III, president; Robert E. Armstrong, vice president; and Mary Jane Crook, program officer, provided early financial support. Additional financial assistance for the project was provided by the National Endowment for the Arts, a federal agency.

We appreciate the support of The Bingham Trust, most especially Charles E. Valier, whose interest in the artist has been constant, and trustee members James A. Singer and Herman Sutherland. Governor (now Senator) Christopher S. Bond led the successful effort to retain the Bingham drawings in the state, as did Senator John Danforth.

Boatmen's Bancshares, Inc., an organization that traces its roots to the time of Bingham, agreed to lend three of the artist's most important paintings from its collection, and further to sponsor the

installation of the exhibition in St. Louis. We thank Boatmen's chairman, Donald N. Brandin, whose support of this exhibition is a further statement of his commitment to Bingham the artist.

Michael E. Shapiro, chief curator at The Saint Louis Art Museum, originated and organized the exhibition. We heartily commend him for his inspiration and energy. We also acknowledge Nicolai Cikovsky, Jr., curator of American art at the National Gallery, who coordinated the exhibition in Washington, and his former colleague, Franklin Kelly, who contributed to the exhibition in its formative stages. We thank the contributors to the catalogue whose scholarship has given us a fresh look at the artist.

No exhibition is possible without its lenders. We warmly thank the individual lenders and institutions for their splendid generosity. Their willingness to share these works of frontier life from the middle of the last century enriches our enjoyment of paintings that have become indelible images of our national experience.

*James D. Burke*
*Director*
*The Saint Louis Art Museum*

*J. Carter Brown*
*Director*
*National Gallery of Art*

# GEORGE CALEB
# BINGHAM

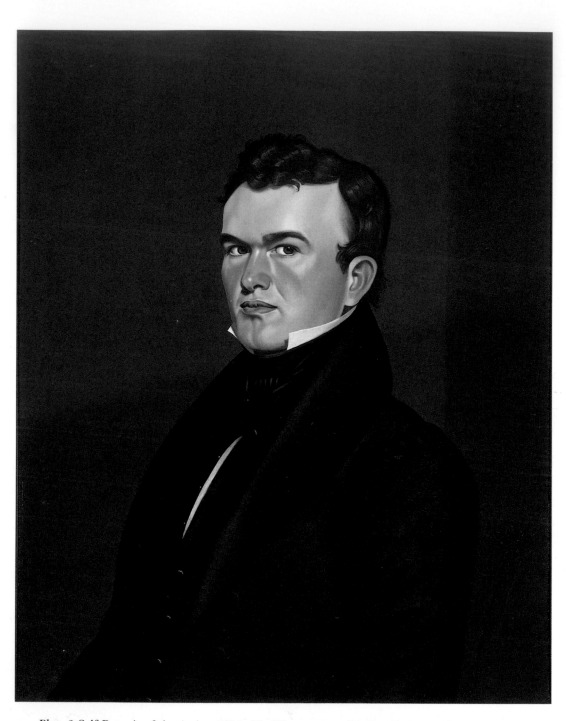

*Plate 3* Self-Portrait of the Artist. *1834–35. Oil on canvas, 71.12 × 57.15 cm. (28 × 22½ in.).*
*The Saint Louis Art Museum, St. Louis, Missouri Purchase: Eliza McMillan Fund*

# THE MAN AND HIS TIMES

## By Paul C. Nagel

In 1878, George Caleb Bingham's life was nearly over. Fame as one of America's great painters, something Bingham coveted, would not be firmly his until well into the twentieth century. Indeed, even Bingham's renown as "the Missouri artist" ebbed in 1878, for he was then riding on repute earned earlier. Consequently, the aging artist was flattered in November 1878 by an invitation from Virginia to advise in choosing a monument honoring General Robert E. Lee. Though he was proudly a Missourian, Bingham cherished his birth in the Old Dominion, and he hoped that appearing in Richmond "may be of some advantage to me professionally."

George probably undertook the journey with encouragement from his recent bride and third wife, Martha Lykins Bingham, whom nearly everyone called Mattie. A second cousin to General Stonewall Jackson, Mattie revered memories of the Confederacy. Consequently, each of the Binghams had reason to be disappointed upon arriving in Richmond to learn that funds for the homage to General Lee had not materialized. The Lee monument competition was not settled for another ten years, during which interval Bingham's name went into eclipse.

After the excursion to Richmond, Mattie Bingham brought her ailing husband back to Kansas City, where he died in July 1879 at age 68. The widow tried to keep his work alive by exhibiting his paintings and sketches in Kansas City's Brunswick Hotel. However, this collection was scattered after Mattie's death in 1890. Her will decreed that everything be sold at auction and the proceeds used to support the Confederate Soldiers Home in Higginsville, Missouri. For forty years thereafter, Bingham was nearly forgotten. Then The Metropolitan Museum of Art in New York had the

inspiration in 1933 to purchase *Fur Traders Descending the Missouri* (1845), acknowledged today as Bingham's masterpiece and one of the finest creations by an American painter.

In 1934, Meyric R. Rogers, director of the City Art Museum of Saint Louis, assembled an exhibition of twenty-eight Bingham works. The show was a success, and when it moved to The Museum of Modern Art in 1935, Bingham's exile was over. Thirty years later, the distinguished critic Hilton Kramer would call Bingham "an immensely gifted artist," part of whose achievement was to make "something original—and at times, something exalted—out of the very deprivations of his situation."

While this assessment has been reiterated and enlarged since 1963, it leaves us to wonder about Bingham's "situation." Were his life and personality as simple and hearty as the rivers and political scenes he depicted in *The Jolly Flatboatmen* and *The County Election*? The answer does not come easily, for relatively few Bingham letters have survived. However, enough have now been gathered to make possible a biography that is more than the traditional tale of how a self-trained artist captured frontier life. Hidden in the Bingham correspondence is a story of contradictions about a painter who was himself a paradox.

Examples of such contrasts are numerous. For instance, while Bingham's likeable and open nature won many friends, he could be harshly opinionated and rude. Professing to loathe most politicians and their calling, Bingham several times sought election to public office and was often embroiled in controversy. While claiming to prefer a Spartan existence, he was actually extravagant, self-indulgent, and disorganized in his personal habits, and he made outrageous demands upon his friends. His nature blended the shrewd and the naive. He himself claimed the women in his life kept him going, yet females are all but invisible in his greatest paintings. He said he feared to show them realistically.

Other important paradoxes: while Bingham owned slaves during much of his life in Missouri, he became an ardent Unionist and detested what he described as the Southern mentality; while he used his brush to depict the workings of primitive democracy, the artist himself was an elitist whose partisan allegiance usually took him to the Whig or Republican parties; as a youth he rejected an attorney's career, but he remained always eager to comment upon law and political science; while his canvases breathe a love for the uncluttered American West, he came to relish life in Europe, and to the end of his days he futilely sought diplomatic assignments in Rome, Paris, or Berlin.

Finally, there is the paradox central to Bingham's career. On the one hand were those

occasions when he spoke yearningly of wishing only to be the finest painter in America. Indeed, at times Bingham seemed contented by assuring himself that his work was the best. Mostly, however, this lofty but infrequent mood retreated before George's insistence that art alone was incomplete, and that a painting was a means to an end—that of financial success. Increasingly, Bingham allowed his talent and time to be drained by business, especially in overseeing the work of engravers as he stood by, impatient to hawk the results.

Ironically, this paradox involving Bingham's consuming materialistic bent, his subject matter, and the events of his life combine to make him our quintessential American painter. Do not his most popular canvases glory in pioneer life and simple democracy? Was not he himself part of the early migration westward, going to live on the very edge of the frontier? Yet with this behind him, the restless Bingham became an ambitious capitalist and politician. The result is that his biography has a strikingly American flavor, and reminds us of the lively tension between America's values and her artists.

George Caleb Bingham was born on March 20, 1811 in Virginia's Shenandoah Valley. His family lived in the region to which, in 1809, Thomas Jefferson had retired, eager to trade the frustrations of politics for the beauty of his home, Monticello, set within the Blue Ridge mountains. In nearby Augusta County, Bingham spent his first eight years. Matthias Amend, George's maternal grandfather and veteran of the Revolution, had settled along Augusta's South River—as "a millwright and most excellent workman," his grandson later affirmed.

An early widower, Matthias cherished his only daughter, Mary, who had been born in Pennsylvania in 1787. It was said Mary inherited her mother's love of books and learning, an inclination that daily led her six miles to attend the only nearby school. A teacher at heart, Mary soon taught her father to read and write, just as she would eventually instruct her own family. So devoted was Matthias Amend to this remarkable young woman that he gave up everything to keep her with him after she fell in love during 1807.

In that year, farmers to the east of Augusta County suffered from a drought which dried up the streams, causing harvests of grain to be sent west for grinding at mills such as Amend's. One such shipment was from a Methodist clergyman, the Reverend George Bingham. Originally from New England, Parson Bingham and his wife, Louisa Vest, operated a tobacco and grain plantation with slave labor. The yield from their fields was carried to Amend's mill by the planter-preacher's son, Henry Vest Bingham. When he returned, Henry had left his heart with the miller's daughter.

The next year, 1808, Mary Amend and Henry Bingham were married. Old Matthias gave them ownership of the mill along with 1,180 acres and several slaves. The young couple agreed to keep Matthias with them for the rest of his life. However, the miller did not bargain for the upheaval caused by his son-in-law's trusting outlook. As a courteous Virginian, it was natural that Henry Bingham should consent to pledge the Amend land and mill as surety for a friend's debt. All was lost in 1818 when the friend died. Under the circumstances, there seemed nothing better for the Binghams than to join others from the Old Dominion in moving west, where the land was said to be bountiful, fertile, and cheap.

After making an inspection trip across Kentucky, Indiana, and Illinois, Henry found his preference for a new home in Missouri Territory, just beyond the Mississippi River. During 1819, the Bingham family removed to the wilderness town of Franklin, in the process losing their collection of fine Virginia horses which succumbed to an equine "immigrant" disease. The Bingham slaves, probably seven of them, survived the journey. Some remained with the family until the Civil War. Grandfather Amend, who also had come along, proved less fortunate. He was drowned in the Missouri River, which dominated the village.

Mary and Henry Bingham brought six children on the westward trek. A seventh, Amanda, was born in Missouri. The eldest son, Matthias Amend Bingham, eventually fought in the Texas Revolution and was quartermaster general during the Texas Republic's brief life. He remained near Houston, acquired much land, and died a bachelor in 1861. Another son, Isaac Newton Bingham, was, like his grandfather, victim to the treacherous waters of the Missouri River. A third brother, Henry V. Bingham, Jr., became a carpenter, living until 1876. Two sisters died early, while the youngest child, Amanda, survived into the twentieth century.

Amanda remained particularly close to her parents' second son, George Caleb, named after Parson Bingham. According to family lore, George was a precocious and observant child, always drawing or painting on anything at hand, even the walls of his grandfather's mill. Both parents encouraged the child to copy subjects faithfully. Journeying west, young George stored in his memory sights from the most primitive stages of the frontier, colorfully represented by the Kentucky magistrate who invited George's father to dine amid the hogs and dogs that shared the kitchen. The host graciously ordered the animals kept out, but a watchful hound at the door leaped beneath the magistrate's chair to grab a crust on the floor. In dragging the dog away, a dutiful son brought the parent crashing down in an uproarious scene which Henry Bingham delighted to recount.

When the family entered Missouri Territory, which became a state two years later, Spanish, French, and English influence remained. Sioux Indians stalked the countryside where prairie grasses grew waist-high to a tall person. The town of Franklin was only two years old when the Binghams arrived, but already it bustled because of its convenient location beside the Missouri River. Like the town, Henry and Mary Bingham prospered at first. Henry opened an inn, *The Square and Compass,* where visitors to Franklin congregated. Soon the Binghams purchased public land across the river in Saline County, hoping to produce tobacco for a cigar factory they began in Franklin. Neighbors elected Henry Bingham a justice of the peace, and made him chairman of a committee to improve community health. In 1822, he was chosen a judge of the Howard County Court.

This was the pinnacle of Henry's career. Within a few months, the tobacco business faltered and Bingham's health, never robust, gave way to malaria. He died on the day after Christmas 1823, age thirty-eight. He left Mary Bingham a large family, a failed business, and sizeable debts. Nevertheless, with her talents and the hard work of children and slaves, Mary kept the family together. She opened a school for girls, said to be the first female seminary west of the Mississippi, and hired a woman named Mattie Wood to teach art. Bingham tradition has it that George served both as school janitor and Miss Wood's prize pupil.

The school was welcomed by the town, for Franklin liked to boast of its progress. However, all of Franklin's pride availed nothing amid disaster after 1825, when the village learned the truth of an observation George's father had made—that Franklin was situated upon "the strongest and most turbulent current in the world." The Missouri River overflowed, causing its banks at Franklin to crumble, and the town to tumble in. By 1829, a New Franklin was founded on higher ground, but too late to catch the progress of those other river communities nearby, Arrow Rock and Boonville.

Before this calamity, however, Franklin had been the scene of young George Bingham's first remembered inspiration to be a painter. In 1820, he had the luck to meet an artist capable of firing his talent. One of the lodgers at his father's inn was Chester Harding, who, though not yet thirty, was soon to be one of America's leading portraitists. Harding had been in Warren County, near St. Louis, sketching the legendary pathfinder, Daniel Boone. The artist had then come upriver, hoping to find business in Franklin while he completed Boone's portrait.

Fifty years afterward, George Bingham still emphasized what it had meant for him as a nine-year-old to watch Harding at work. Probably by the arranging of his father, George won the task of

19

assisting the visiting artist. "The wonder and delight with which his works filled my mind impressed them indelibly upon my then unburthened memory," George recalled. Unfortunately, he left no further recollection about his early artistic development.

After Franklin had been washed away, Mary Bingham took George and the family across the river to the 120–acre farm in Saline County which she and her husband had bought from the United States land office. President John Quincy Adams had signed the final papers on November 10, 1825. At some point, the Binghams also acquired additional acreage nearby. Mary liked the area, for its hills and valleys reminded her of happier times in Virginia. Also, the farm was near a log church where she began another school.

Not far from Mary's property was the farm of her brother-in-law, John Bingham, recently arrived from Virginia. Both families were located near a new town situated where Indians once sharpened their weapons. First called New Philadelphia, the hamlet was soon renamed Arrow Rock. It grew rapidly, twenty-five of its acres being donated by George's uncle, John Bingham, who proved more prosperous than his brother Henry had been. Arrow Rock was a more appealing place for George than his mother's farm. Even today, one can see why. On a picturesque hillside, the town has an admirable view of the Missouri River.

In George's youth, this location made the village a lively place, especially from the presence of trappers and traders. The immigration of many other Virginia-bred citizens besides the Binghams gave Arrow Rock a very Southern outlook. The town produced three of Missouri's early governors, all of whom began their careers in the style of stump speaking and personal canvassing for votes, the methods by which democracy flourished in Saline County. Such colorful politics, along with the traders, trappers, and boatmen who frequented Arrow Rock, caught the imagination of George Bingham, becoming the subjects of his most successful paintings.

Aware of the inspiration Chester Harding had brought her son, Mary Bingham concluded that George was wasted on the farm, just as she herself would linger there no longer than necessary. George was sent into Arrow Rock in 1828, for enough slaves and children remained to run the farm without him. He was apprenticed to the Reverend Jesse Green, a cabinetmaker and Methodist minister. According to family lore, the move was encouraged by Uncle John Bingham, who considered the family disgraced when it had a member idly sketching when there was work to do in the fields.

Not that George was certain of making a career of art. At times, he considered being an

attorney; then a surge of religious zeal drew him briefly to try preaching. However, by age twenty he seemed to settle upon painting portraits as a livelihood. His preparation apparently was advanced mostly by George himself. The example of Chester Harding taught him that portraits were a marketable commodity, even at an outpost of civilization. George's appreciation for culture which prized the work of an artist came from his mother and her library, the only sources for his education. All his life, George expressed obligation to Mary Bingham and he signed his letters to her as "your dutiful son."

By 1835, George was busily painting the likenesses of citizens in Saline, Howard, and Cooper counties, and had taken his brush as far as St. Louis where he advertised himself as a "portrait painter." He now had the satisfaction of helping support his mother and her younger children. It was also in 1835 that George wrote his first surviving letters. They were to Sarah Elizabeth Hutchison, a sixteen-year-old schoolgirl. George was nearly twenty-four. His letters show an open, eager nature as he spoke excitedly of his professional hopes, of his religious views, and of his growing affection for the young woman (Plate 3, Fig. 1).

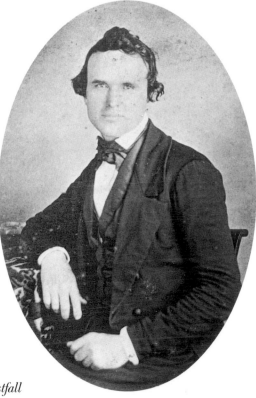

*Fig. 1 George Caleb Bingham, photo as a young man. c. 1860. Photographer: Frank Thomas. The State Historical Society of Missouri, St. Louis, Missouri Gift of Mrs. W. D. Westfall*

"You have a right to be acquainted with all that relates to myself," he told Elizabeth. Consequently, she learned that George feared he was faltering in his spiritual life, for he was not, he said, enjoying "that constant peace which ever follows a faithful believer of [religious] precepts." He spoke of the visits by "melancholy" which assailed him. Yet the young man showed he could endure hardship cheerfully, as when, shortly before his marriage, George caught smallpox. The illness left him permanently bald and obliged to wear a wig.

As a suitor, Bingham saw that Elizabeth was well informed about what would become the ruling impulse in his life—"the determination to do my utmost to rise in my profession." What grieved George was his slow progress. While contending that the subjects of his portraits were gratified by his work, Bingham complained: "It is seldom I can please myself." He tried to help Elizabeth, daughter of a village pharmacist, to sense "the mortifications and anxieties which attend the work of a painter; and of the toil and study which it requires to give him success and raise him to distinction." In time, George came to believe that genius and frustration were inevitably companions.

Success and eminence were goals that young Bingham often mentioned, when he was not complaining how he had "scarcely learned to paint the human face." Nevertheless, he assured Elizabeth he would persevere, even if he had to use "the cats and dogs" for subjects. Having watched her fiancé hustle up and down the Missouri River in pursuit of work for his paints and brush, Elizabeth could hardly have been surprised when George confessed as their wedding neared: "I can't endure the horrors of inaction." He wrote this from St. Louis—where in rapid succession he turned out ten portraits and copied two scenes of buffalo hunts. The latter were to be displayed in Louisville, "where they will serve to make me somewhat known as a painter."

In the spring of 1836, George Caleb Bingham and Elizabeth Hutchison were married, the groom assuring his seventeen-year-old bride that his happiness would come entirely from promoting hers. George also pledged "close application" to his calling. Soon, a pregnant Elizabeth discovered how that promise would often mean separation from her husband while he went off in search of business. When their first child, Newton Bingham, was born on March 26, 1837, George was far down the Mississippi River at Natchez, where he painted for five months. He had the grace to write Elizabeth of how he disliked "living alone."

A few months later, George bought a lot in Arrow Rock where he built a two-room brick residence near a stirring view of the Missouri River. The vista was not, however, enough to keep the

new owner at home for long. Installing his mother as permanent occupant and leaving Elizabeth and their son with her parents in Boonville, George soon resumed his chase of financial and artistic success. This time he roamed afar, to Philadelphia and New York. It was early in 1838.

While he was absent only six months, they constituted the most important interval of Bingham's life. In Philadelphia he haunted the Academy of Fine Arts, where he encountered the paintings of Emanuel Leutze and William Sidney Mount. Most important was his discovery of the genre painting style, by which an artist sought realistically to describe scenes from everyday life. The approach thrilled George, who saw it as an outlet for his fascination with the sights which surrounded him back in Missouri. These were scenes which featured subjects fast becoming national favorites, such as trappers, farmers, raftsmen, and politicians.

But he hesitated, for how could he win a living from genre painting in Missouri? While in Philadelphia, he made at least one attempt, a now-vanished work he called *Western Boatmen Ashore* (1838), which he left with the Apollo Gallery in New York. Then, midway in 1838, he took his inspiration back to Arrow Rock, where it lasted long enough for him to produce six pictures which he sent to the National Academy of Design exhibition in New York. The shipment—all now lost—was a mixture of landscapes, portrait studies, action scenes, and more early genre work. Then the money ran out and he was obliged to concentrate on "doing heads," where the income was steady. Bingham's great work would have to wait.

He took to the road again in 1840; this time he was absent from Arrow Rock for four years. At first traveling alone—Elizabeth was once more dropped off in Boonville—George went to St. Louis to paint community leaders. However, he was pursued by letters from his unhappy wife. "I am getting almost out of patience," Elizabeth warned him. She did not wish to be left behind. Wouldn't "my dear Husband" come back "to your little family. We will be so delighted to see you." Could he not find a means whereby "we can live together and enjoy more of each others society than we have hitherto enjoyed [?]"

Elizabeth had other reasons to be "unsettled." She grieved over a second son who died soon after birth, and now, with George away, she was six months pregnant. Being a good-hearted, if often distracted mate, Bingham was touched by his wife's plea. He returned to Arrow Rock with a startling plan—the entire family should remove to the nation's capital. A Whig, William Henry Harrison, had been elected president in the 1840 election, bringing George to hope that a stay in

Washington would lead to useful political connections as he painted portraits of the great and near great—mostly the latter, it turned out.

George's decision to try painting amid Washington politics arose from a friendship he had recently formed with James S. Rollins, who was to be in the Missouri legislature several times, twice an unsuccessful candidate for governor, and had two terms as a congressman. Not the least of his attainments was Rollins's role as George's confessor, financial angel, errandsman, and mentor. It was Rollins, remembered for having a powerful, paternal character, to whom the fatherless Bingham turned throughout life for comfort, direction, help, and money. Only because many of George's letters to James were preserved is a biography of the artist possible. The pity is that Rollins's letters are lost.

Scion of a family whose roots were in Virginia and Kentucky, James Rollins was a successful attorney, landholder, and civic leader in Columbia, a town some thirty miles east of Arrow Rock. It was there that Rollins succeeded in having the University of Missouri established. Busy though he was, Rollins somehow found the time to encourage Bingham through a long and intimate association. It began when James enlisted Columbia citizens to pay twenty-five dollars each to George for painting their portraits. The artist admired his subjects, who were mostly well-to-do folks, and he soon was sympathizing with their usually cautious and aristocratic viewpoint.

However, there was another reason why George came to claim some classes of humanity were better suited than others for governance. His stay in Philadelphia apparently had afforded alarming views of what he called the "mob-cratic influence." Returning to Missouri, he brought with him a cynicism about "the patriot mob." When his Whig favorites rarely won elections, George heaped blame upon unprincipled demagogues, as he usually styled those with whom he disagreed.

When they were not talking about the delicate health of Missouri's Whig party, George told James Rollins of his hopes to be more than a frontier portraitist. "I cannot foresee where my destiny will lead me," he said, as he spoke of returning East "for improvement in my profession." Although he claimed to dread leaving Missouri, George explained why it was necessary: "There is no honorable sacrifice which I would not make to attain eminence in the art to which I have devoted myself." After all, George assured James, his difficulties were no greater than "those which impeded the course of Harding and Sully and many others." He promised his friend: "I shall be successful."

According to George, it was logical that he should form political alliances. As he saw it, a

partisan artist could win lucrative legislative commissions for paintings to adorn public buildings. Thus, George's enlistment as a Whig was due only in part to his increasingly fierce views on issues of the day. What neither Bingham nor Rollins could foresee, of course, was how often being a political warrior would hinder George's artistic work. But late in 1840, as George and Elizabeth set out for the East, partisanship carried the scent of professional success.

The Binghams, with little Newton, were soon comfortable in Washington. George moved into a studio in the basement of the Capitol where he shared space with another artist, John Cranch, a cousin of former president John Quincy Adams. The family took up residence in a boardinghouse on Pennsylvania Avenue, the only paved street in Washington. Twenty-two-year-old Elizabeth reported to Mary Bingham, back in Arrow Rock, that it cost the alarming figure of fifteen dollars a week for board, a sum which, however, entitled the family to "cakes, ice creams, mince pies, and a great variety of meat and fowl." She also complained that Washington "is not as pretty a place as St. Louis." Meanwhile, George hastened to inspect the Executive Mansion, coming away convinced "there is no furniture in the house too good" for a Whig chief executive.

The Binghams were cheerful for three months, although George had fewer patrons than anticipated and no commission arrived from the Missouri legislature, for whom he was eager to paint portraits of George Washington and Thomas Jefferson. With not enough professional work to restrain him, George admitted he was easily tempted into political talk. He told James Rollins that he had to keep reminding himself: "I am a painter and desire to do nothing else." At least that was his determination, he said, unless the fight against rascality should enlist him to run for office. George pledged he would answer such a call, although he insisted he preferred "contending only for the smiles of the graces."

Unfortunately, smiles were scarce among the Binghams when spring arrived in 1841. George adored his son Newton, and was devastated when the boy died of croup on March 13. The pain was only partly eased when, two days later, Elizabeth gave birth to Horace Bingham (Fig. 2). Then came the death of George's hero, President Harrison, and suddenly Washington was intolerable. As soon as Elizabeth could travel, the family sought consolation—and more income—in Petersburg, Virginia.

By autumn, George's spirits still languished and subjects for portraits became scarce in Petersburg. Sending Elizabeth and Horace back to live on Pennsylvania Avenue, George traveled to the Shenandoah Valley to visit scenes of his childhood. Relatives and friends welcomed him, and

showed him the sketches he once made on the walls of Grandfather Amend's mill. George, however, was more impressed by the call he paid upon Old Tom, an aged slave he remembered.

After receiving the fervent blessing of his black friend, George wrote to his mother: "I felt that if the prayers of any man would avail for me, his would." However, the experience did little to relieve George's melancholy and he returned to Washington, unable to think of his dead son without bursting into tears. He tried to take comfort in asserting that the child had been spared living in "this world, so full of woes." "We only are the sufferers," George reminded his mother. Saying he envied the lad who now "slept," George announced he would "willingly resign all things else, and lie down with him."

*Fig. 2* The Sleeping Child: Horace Bingham. *1843–44. Oil on canvas, 88.90 × 73.66 cm. (35 × 29 in.). Mrs. Williston J. O'Connell*

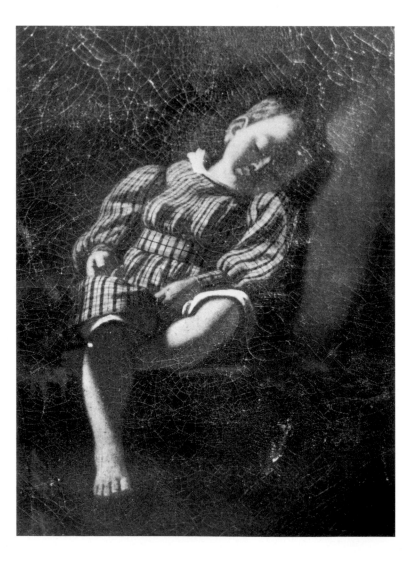

During 1842, George's mood scarcely lifted. He painted desultorily and spent money waste-fully. A worried Elizabeth found that she often attended church without her husband. In November, she took the baby back to Missouri, a step which evidently nudged George toward reality. Acknowledging that he had behaved badly to those around him, George pledged to Elizabeth: "I shall endeavor for the future to avoid everything calculated to produce the least rupture between us."

From friends at the boardinghouse, Elizabeth received accounts of George's loneliness, his glum face, and his daily trips to the post office looking for a letter from her. His messages to her were increasingly contrite, as he conceded "how often I have suffered to yield to fretfulness and given you pain." Not until a year after Newton's death did George's depressed state seem to ease, and Elizabeth had word that her husband was painting industriously. George began sounding like his former self, assuring Elizabeth of his revived belief that "I can be nothing else but a painter." But if he was to do so, he confessed: "I cannot live at Arrow Rock, how much-soever I might desire it."

When George suggested they settle permanently in Washington and rent a house of their own, Elizabeth hastened back in the spring of 1843. However, the plan to remain in the East lasted barely a year. During that time, George painted mostly portraits, including one of John Quincy Adams. But it was not the disappointing income from these efforts which changed George's mind about Missouri residence. Instead, it resulted from a trip he and Elizabeth made to Philadelphia in the summer of 1843.

This second visit to the Pennsylvania Academy of Fine Arts had a more lasting impact upon Bingham, and thus upon the history of American painting. He could not shake off the effect of seeing the latest work of the nation's finest genre artists. Once again, George began visualizing what superior contributions to that field he could make with scenes of Missouri life. Then, after a severe illness which reminded him that time for earthly accomplishment was brief, the Binghams gave up living in Washington and returned to Missouri in 1844.

There, George's artistic accomplishment was at first hardly auspicious. The old partisan impulse made him devote precious time to painting parade banners honoring Henry Clay, the Whig candidate for president in 1844. Then came a happy distraction when a daughter was born. Elizabeth and he named the baby Clara. George had to sell the house in Arrow Rock, for it was much too small. During the next decade, he and his family either rented quarters or lived with relatives and friends in Arrow Rock, Boonville, and Columbia.

As these political and family needs were met, George moved to accept the challenge he had

confronted in Philadelphia. He set out to see if, in fact, he could outdistance all other genre painters. This lofty-sounding resolve, however, contained more than noble aspiration. George now believed it was likely such work could bring a steady financial income. While in the East, he had discovered an organization willing to purchase genre paintings, engrave them, and then distribute the prints among its membership. This was the American Art-Union of New York, whose aim was to patronize painters, which meant even an artist in far-off Missouri could participate in a national market. It was such assurance which finally brought the practical-minded Bingham to be more than a local portraitist.

George's affiliation with the Art-Union in 1845 began what would be a dozen years of magnificent achievement. In late spring of that year, he completed the first of his genre paintings to survive, *Fur Traders Descending the Missouri* (Plates 4, 33), today considered his masterpiece. The rivals for that distinction were all painted before 1857 and constitute an array of river and political scenes of astonishing beauty and historical usefulness. It was as if George recognized he was barely in time to catch the olden days before they vanished. Making amends for his dallying, he produced superb genre canvases in rapid succession. By 1852, when his association with the Art-Union ended, George had sent twenty paintings to New York.

Bingham never received more than $350 for any of these canvases, but that amount was considered good pay. There was further reward in knowing that engravings of his work, distributed to the organization's members, were broadcasting the name of George Caleb Bingham far beyond the banks of the Missouri River. Notable among his early consignments to the Art-Union were *The Jolly Flatboatmen* (Plates 5, 37), *Raftsmen Playing Cards* (1847), *Watching the Cargo* (1849), *The Stump Orator* (1847), *Shooting for the Beef* (1850), *The Wood-Boat* (1850), and *Country Politician* (1849)—an outpouring of work which continued even when distress re-entered George's personal life.

In 1846, he made room in his zeal for genre painting to become Arrow Rock's Whig candidate for the Missouri legislature, winning a contested victory. Even though a committee investigation recommended George, a vote in the Democratically dominated House of Representatives gave the seat to his opponent, leaving the artist outraged. "An Angel could scarcely pass through what I have experienced without being contaminated," Bingham told Rollins, adding, *"God help poor human nature."* What he had seen made him want "to strip off my clothes and bury them, scour my body all over with sand and water, put on a clean suit, and keep out of the mire of politics *forever*."

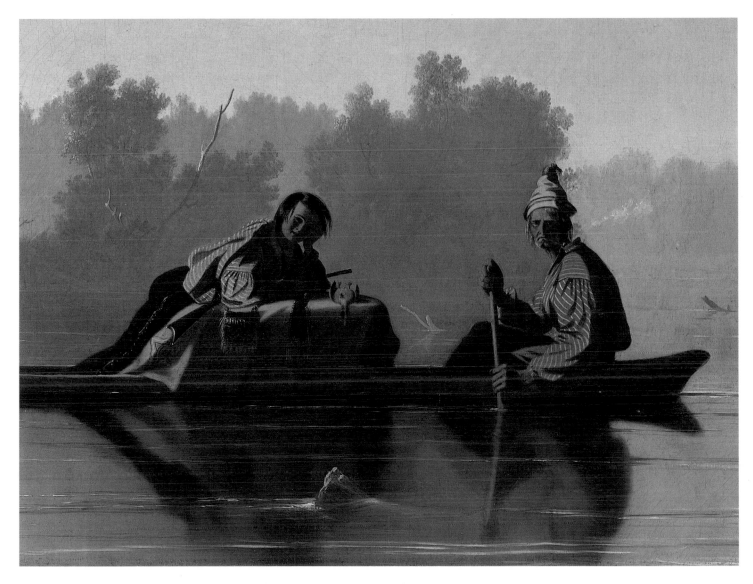

*Plate 4 detail of* Fur Traders Descending the Missouri, *1845. (See Plate 33.)*

Two years later, his pledge forgotten, George made another run for the legislature. This time he won clearly. Shortly before he took his seat, however, Elizabeth Bingham died on November 24, 1848. She was twenty-nine years old and had been prostrated by childbirth in what Mary Bingham, who nursed her, called "large and more severe sufferings than is commonly allotted to mortals." As Elizabeth departed, her last words attempted to console George, who was sobbing at her bedside. Mary, too, mourned her daughter-in-law's "cheerful voice that is no more."

Choosing to flee Arrow Rock, George left Elizabeth's "dear motherless children" with his own mother. The bereaved artist went first to the capital, Jefferson City, for his legislative term. That done, he traveled to New York, where he painted in the reassuring presence of the Art-Union. "Poor George is destined to be a lone wanderer," his mother predicted—with remarkable inaccuracy, as it turned out. Mary Bingham had not counted upon the restorative powers of what her son had recently acknowledged as his "rather unchristian fondness for women."

With the help of James Rollins, George promptly found a second wife. She was Eliza Thomas, age twenty, the daughter of a professor at the University of Missouri in Columbia. They were married a year after Elizabeth's death, a step which evidently soothed George and renewed his artistic vigor. Forthcoming were such achievements as *Canvassing for a Vote* (1851–52), *The County Election* (Plates 6, 8), *The Emigration of Daniel Boone* (1851), *Stump Speaking* (1853–54), and *The Verdict of the People* (1854–55). Some of these were painted in Missouri, others in New York and Philadelphia, as George often let his career prod him into going East.

Continuing personal sadness also may have kept Bingham roaming. The baby born to Elizabeth had died. George's beloved brother Henry, who had taken his family to Texas in search of health, returned to Arrow Rock in 1849 only to lose his wife and three children to cholera. Sister Amanda married James Barnes, a hapless fellow who was rescued by being assigned to work the Bingham farm, while George rented a house in town for Amanda and his mother. Then, in May 1851, came the most severe stroke. The family's anchor, Mary Bingham, died at age sixty-four. Absent at the time were George and Eliza, gone to New York, where George was painting and exhibiting his work.

Hurrying back to Missouri, George stood beside his mother's grave on a pleasant knoll in the Arrow Rock cemetery. Today, her stone's inscription is all but obliterated, but visitors can read a plaque placed later by the Daughters of the American Revolution as a fitting tribute to this hardy pioneer woman from Virginia, who had, amid great adversity, managed to educate her children and

grandchildren, along with many other youngsters on the Missouri frontier. What no tablet in the rural graveyard describes is Mary's support for her artist son. George could not forget how her hand and voice had trembled as she said farewell to him for the last time.

Mary Bingham's death altered George's life in other ways, for it meant he had to assume the care of his two surviving children. Son Horace was sent to be educated by Eliza's father, Professor Robert S. Thomas. Eliza herself, who thus far was barren, undertook the rearing of little Clara. The two females became vagabonds of a sort, accompanying George as he roamed in America and then in Europe. His latest restlessness was caused by a development almost as unsettling as losing his mother.

In 1852, George became enraged at the Art-Union. It was more than a trifling issue which infuriated him. An unsigned article in the Art-Union's publication for December 1851 had relegated Bingham's work to a place behind that of William Sidney Mount. An ungenerous critic called George's paintings undisciplined, mannered, and even lazy. Though the Art-Union's manager sought to soothe the offended painter by reminding him that those artists who were mauled by the press usually saw their work outlive their detractors, Bingham spoke of "wanton injury," and called the attack "unprovoked and unsustained by the slightest evidence." There must be, George warned, "a prosecution for damages."

Soon afterwards, the Art-Union went out of existence and left no source for reparations. George consoled himself with assurances that it was he who could best help the public appreciate the quality of his art. At once, he undertook the circulation and sale of his paintings and engravings. It meant the end of Bingham's finest work. Without the Art-Union's promulgation of his art, George turned into more entrepreneur than painter. Filled with wrath, he failed to appreciate how much his creative efforts had been emancipated when the Art-Union supervised the engraving and distribution of his genre paintings.

For the next eight years, George devoted much of his time to overseeing the work of engravers, and then to peddling the results. He had high hopes particularly for a profitable circulation of *The County Election* (1851–52). This canvas, along with *The Verdict of the People, Jolly Flatboatmen in Port* (1857), and *Stump Speaking* constituted the last of Bingham's great achievements. Finished by 1857, they marked the close of the dozen years of George's artistic triumph, at least in part because he gave himself so ardently to turning them into financial bonanzas.

Backed with encouragement and financing from James Rollins, George was often in Philadel-

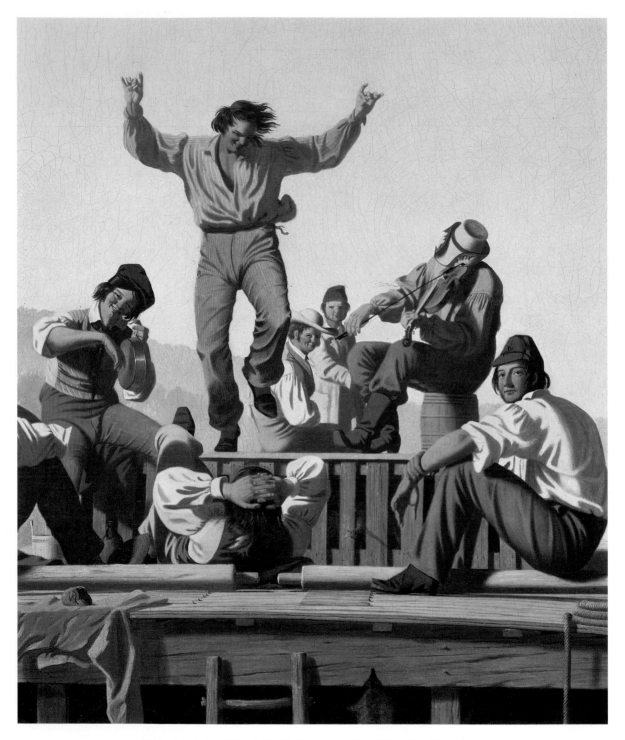

*Plate 5 detail of* The Jolly Flatboatmen *(1), 1846. (See Plate 37.)*

phia after 1852. Choosing John Sartain as his engraver, Bingham stayed around to exhort Sartain to work well and speedily. When the engraver took longer than expected to prepare *The County Election,* George painted a second version (Plate 16), and with it toured the South in search of subscriptions for the forthcoming print. He was pleased with how the engraving proceeded, particularly after Sartain agreed to charge only $1,250 for copying *The County Election.* Bingham informed Rollins that normally $4,000 would be the fee for such tedious toil. But Sartain so admired George's achievement that, according to the flattered artist, he was willing to labor for love.

After spending many days talking up his work at county fairs and other occasions around the country, all the time gauging the crowds to detect when "the bait is taken," George became even more enthusiastic about his ability. Vanished were his youthful doubts. He assured Rollins in 1853 that *The County Election* would be "the best print that has yet been published on this side of the Atlantic." Having said this, George could easily put himself on the pinnacle: "In the familiar line which I have chosen, I am the greatest among the disciples of the brush, which my native land has yet produced."

At age forty-two, Bingham saw himself "laying the foundation of a fortune sufficient to meet my humble expectations." Actually, George and Eliza had costly tastes, keeping him on the prowl for every gainful opportunity. He renewed his determination to persuade the Missouri legislature to commission portraits of Washington and Jefferson. Awaiting word, he completed *The Verdict of the People* in 1855, while he, Eliza, and Clara enjoyed living in "the best" neighborhoods of Philadelphia. Mrs. Bingham took advantage of the location to receive training in her own artistry, piano performance. Warm weather often took the family to the expensive haunts of Cape May at the mouth of Delaware Bay.

Gratifying as he found Philadelphia, George became discouraged by John Sartain's languid style and eventually decided to take his engraving needs to the Paris firm of Goupil. Though the latter promised speedy results, Bingham decided he must personally supervise the work. His goal was to have *The Verdict of the People* quickly available to what George assured James Rollins, his patient backer, would be an appreciative and generous public. To keep himself otherwise occupied while in Europe, Bingham carried out the long-sought assignment from the Missouri lawmakers to paint the likenesses of Jefferson and Washington.

On August 24, 1856, he, Eliza, and Clara set sail. Had Bingham remained in the United States, the history of American art might have been quite different. George probably would have

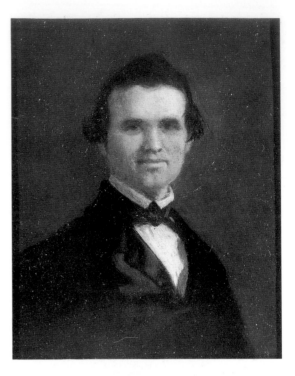

Fig. 3 Eliza Thomas Bingham. Tintype.
The State Historical Society of Missouri,
Columbia, Missouri

Fig. 4 Self-Portrait of the Artist. 1849–50.
Oil on copper, 7.62 × 6.35 cm. (3 × 2½ in.).
National Portrait Gallery, Smithsonian Institution,
Washington, D.C.

Fig. 5 George Caleb Bingham, mid-life.
Photograph of daguerreotype in brooch,
miniature portrait medallion, 1⁹⁄₁₆ in. l. × 1⅛ in. w.
The State Historical Society of Missouri,
Columbia, Missouri Gift of
Mrs. Wallace Walters and Mrs. Charles Horton

begun a new genre series, for he had been planning something "illustrative of squatter Sovereignty," by which he meant scenes showing sectional rivalry over public land. This unfulfilled project would doubtless have shown Bingham's indignation at the tactics Southern states were using to plant slaveholders in locales like Kansas territory, next door to Missouri. As he left America, George told Rollins: "I myself have gone clean over to the black Republicans."

Bingham foresaw that feuding between North and South "will sweep onward with a fury which no human force can withstand." Not even the distractions of European scenes kept George's thoughts from the spectacle at home. His letters to Rollins consisted mostly of comments about America's domestic crisis, particularly after President James Buchanan proved as weak as Bingham anticipated. "He will be blown out of political existence by a Northern tornado." Surely, George fumed, everyone could see that slavery's advocates "may justly be regarded as abandoned by God to their peculiar madness."

The Bingham family was not long in Paris before George was disenchanted with the city. He found it noisy, expensive, and his talkative nature was stifled since he could not speak French. After deciding he could still supervise Goupil's engravers by living in Germany, George took Eliza and Clara to Düsseldorf in November 1856. There, after finishing *Jolly Flatboatmen in Port*, he concentrated upon the Washington and Jefferson commission, comforted that Parisian engravers seemed more efficient than those in Philadelphia, in spite of his absence.

There was also solace in the comparatively small size of Düsseldorf, about 40,000, and in its location on the Rhine River, reminiscent of Missouri scenes. The town also contained five hundred artists, some of whom spoke English. George was especially gratified to have the help of Emanuel Leutze, whose work in genre painting Bingham continued to admire, if grudgingly. The Binghams soon found themselves in love with the Old World. In his many letters to James Rollins, George never spoke of homesickness or sighed to be back along the Missouri River where he might paint what he knew best. Instead, he sought to enlist his friend in a campaign to secure a diplomatic assignment which would keep the Binghams abroad.

As time passed, George was pleased to discover that Leutze and other Düsseldorf painters avoided emulating the old masters, going instead "to nature for the Truths which it employs." Bingham claimed that his new colleagues worked on a basis "so simple and so rational" that the results had "a freshness, vigor and truth" which any viewer could grasp. All of this reassured the Missourian, who feared he might alienate his market in America if he took up a new style,

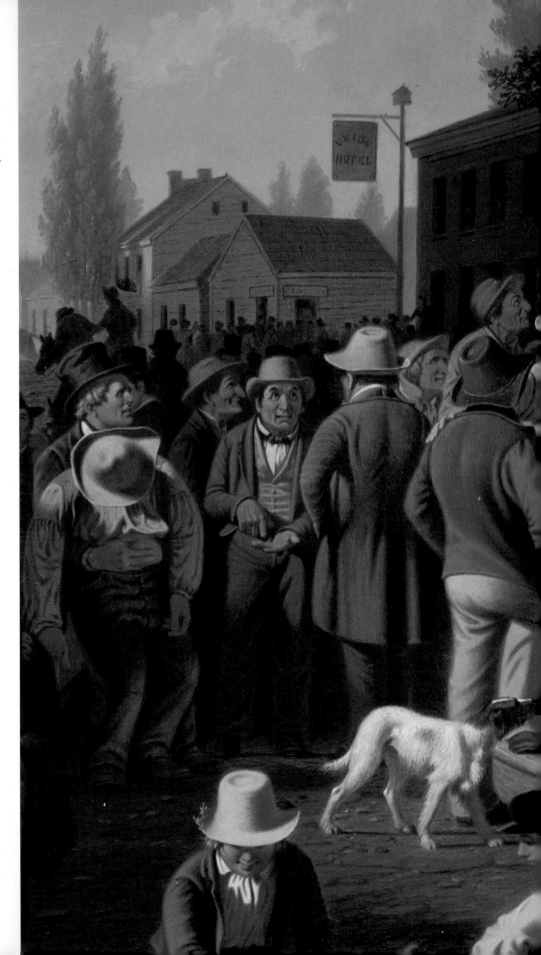

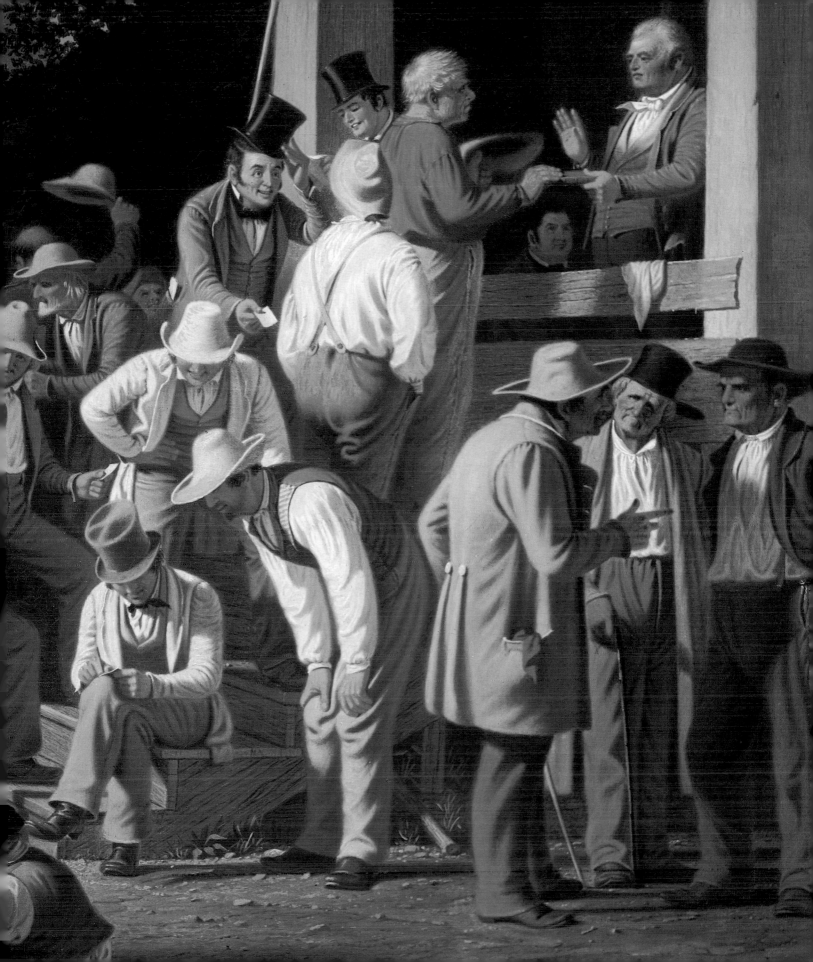

particularly any of those adopted by Parisian painters. George had rushed away from the Louvre appalled by the "conflicting statements" offered there by artists, all of whom variously claimed to portray nature. It left one "staggering in doubt," he said, and scarcely knowing what was "truth or falsehood."

Preferring to think of practical matters, George began planning his own publishing house, intending through it to distribute an engraving of his *George Washington* (1856–57). Meanwhile, he eagerly awaited appointment in the U.S. foreign services, never appreciating how in such a role he would be handicapped by his sharp, impulsive tongue and his general impatience with humanity. The United States offered George no post in Europe, nor did the artist succeed in a second scheme to find money for a longer stay in Germany. This alternative would have entailed a commission from Congress to paint a giant portrait of Daniel Boone for the Capitol. "It seems to me," Bingham remarked to Rollins, "that a western artist with a western subject should receive special considera-tion." Congress evidently disagreed.

Other maneuvers appealed to George. He sought to place his son Horace in West Point. When this proved unsuccessful, the young man was summoned to join Eliza and Clara in gaining a "more thorough education" which Bingham was convinced could be had in Europe "with far less cost, including even the voyage." Once Horace had reached Düsseldorf, George announced that, having completed *George Washington* and *Thomas Jefferson* (1857–58), he must briefly return to America with the framed canvases. In his view, only he was competent to assure these portraits a safe voyage and proper hanging in Missouri's capitol. Early in 1859, he was back in Jefferson City.

Missouri's legislators were so pleased by Bingham's work that he was awarded a new commission, this for likenesses of Andrew Jackson and Henry Clay. Such a reception "cheered" George, who spoke of signs "that my devotion to Art for so many years may at length receive its reward." Much encouraged, he left a partial payment toward his sizeable financial indebtedness to the generous James Rollins. Bingham also gave Rollins a request for yet another good turn. This one had a comical delicacy.

While he was painting the portrait of George Washington, Bingham's fourteen-year-old daughter Clara evidently had been working beside him, creating in needlepoint her version of the first president. Someone, most likely her father, decided that Clara's handiwork should be carried back to Missouri for presentation to the legislature at the same time George delivered his portraits.

And so members of the House of Representatives found themselves with a gift that they could scarcely refuse. As Clara's proud father watched, George Washington in needlepoint was solemnly hung behind the Speaker's chair in the House chamber.

Of course the gentlemen of the legislature had to demonstrate their gratitude. It was agreed funds must be appropriated toward a suitable gift for Miss Bingham. But what sort of present and how much should the taxpayers spend? As House members considered the weighty matter, Clara's father was at their elbow, offering advice. "I suggested . . . a *ladies work box* to be made to order in Paris," George reported to Rollins. The box must contain "apartments for writing, drawing, and sewing implements." Ever creative, Bingham urged that his child's memento "have elegantly engraved upon it the Arms of our State, the name of the Governor, the President of the Senate, the Speaker of the House of Representatives."

Then came a point which gave pause even to the usually irrepressible Bingham. He recognized that a person other than himself must advise the legislature on how much to pay for the work box. So James Rollins was begged to handle this detail. In a letter to his friend, George announced that, as "it was improper for me to suggest any sum to be appropriated," he had recommended that legislators "confer with you upon the subject." To prepare Rollins, George whispered the desirable amount—five hundred dollars would do nicely—and urged his friend to realize how the result would "favor Clara very much." Furthermore, Rollins must notify the House that Bingham would himself be pleased to take a bank draft for the appropriated amount and see that the magnificent work box was created in Paris (Fig. 6).

These delicate negotiations were interrupted when George was summoned back to Düsseldorf with word that Eliza was ill again. Her uneasy health was mostly the result of a series of miscarriages which kept her under a physician's care. There were also worries about Eliza's emotions, for George described her as crushed by calamity. Barely had he reached Germany, however, when there were more unhappy tidings. Eliza's father had died, making it unthinkable for the Binghams to remain abroad. As soon as Eliza was well enough to travel, the family reluctantly said farewell to Europe. Two years later, in September 1861, Eliza gave birth to a son. The elated George named the child James Rollins Bingham as tribute to a great friendship.

The uproar over slavery had, of course, not quieted while the Binghams lived in Germany. Back in the United States, Bingham was immediately optimistic about the approaching election of 1860, announcing that Abraham Lincoln was the candidate who somehow would "allay the present

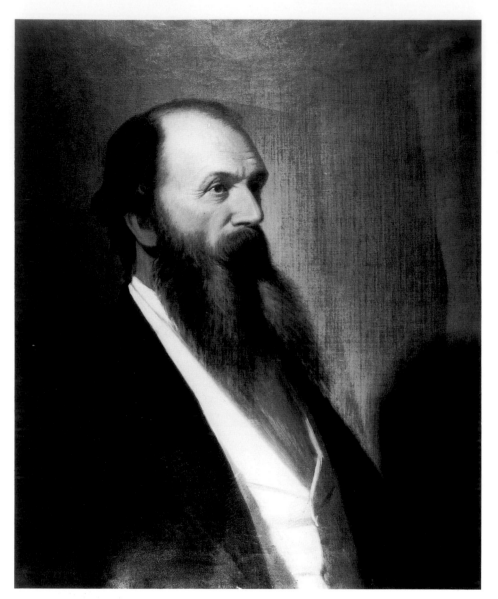

*Fig. 6* Maj. James Sidney Rollins. *1871. Oil on canvas, 76.2 × 64.1 cm. (30⅓ × 25¼ in.). The State Historical Society of Missouri, Columbia, Missouri*

sectional strife." The crisis had George's full attention, as he pledged to fight any threat to the federal Union. He disliked and distrusted militant Southerners, not because they owned slaves, but because their campaign to protect and expand bondage led them, in his opinion, to trifle with the federal system, and thus to threaten law and order. Chattel bondage itself had no enemy in Bingham.

In 1850, George had owned a male and female slave. Three years later, he took four more slaves from his sister Amanda when he bought her share of Mary Bingham's estate. These four included

the beloved "Aunt Lucy," who, as a young woman, had come west with the family in 1819. George must have disposed of these persons soon thereafter, for when he listed his property in 1856 before sailing for France, no slaves were enumerated. In 1860, George's brother Henry and other relatives in Arrow Rock still held slaves. The much-admired James Rollins claimed to have twenty-four, while friends in Jackson County, including George's next wife, Mattie Lykins, and her first husband, owned lesser numbers.

For Bingham, there was no harm in possessing this form of property, so long as advocates of bondage did not permit their preference to cause them to disrupt national peace. As late as November 1860, George believed a war between the states was avoidable, unless politicians should "shrink from the performance of their duty." For him, it was as simple as that. He informed Rollins that to put down secession the federal government had only "to persevere firmly in the discharge of its specific duties, and to protect its officers employed therein by such force as may be necessary."

Expecting a show of discipline from Washington to bring the South to its senses, Bingham's characterization of Southerners, especially those in South Carolina, was colored by the artist's usual flamboyant language. Most Southerners, he assured Rollins, were "as averse to intellectual as to physical labor." They believed that it required only one of their own to be "an overmatch for twenty Yankees." South Carolinians considered themselves "the greatest people in the world . . . and that the Federal Government is all that prevents a full manifestation of these facts."

Never lacking in courage—even Bingham's detractors conceded that—George sought more than a spectator's role in the crisis. During the winter of 1860–61, he spoke publicly for preserving the Union. Then, as Missouri split tragically into secession and national factions, George prepared to exhibit his new portrait of Andrew Jackson around the state. He hoped thereby to shame those Democrats favoring disunion by reminding them of how their party's great founder had condemned nullification and secession thirty years earlier. Bingham even considered taking his road show to Illinois, where he visualized calling upon President-elect Lincoln.

Meanwhile, no matter how grave the crisis, George's appetite for patronage persisted. Hoping his campaign for the Union would endear him to the new Republican administration, he spoke guilelessly of expecting from Lincoln "an honorable and lucrative appointment abroad, either in France or Italy." Rollins, who was now in Congress, was implored to explain to everyone in Washington that, "Southerner as I am," the Missouri artist deserved a public post. If not that, then

George pleaded that he be assigned to paint something for the federal Capitol. He promised "a better picture than that by Leutze."

There was no appointment, no commission, not even a Washington clerkship for Bingham, and he was left to complain at how the War caused economic depression for painters. He found himself "all out of employment and Art far below every thing else in such times as these." Becoming one of the first men in Kansas City to enlist in a federal reserve regiment, George served as captain until January 1862, when he was appointed treasurer of Missouri by Governor Hamilton R. Gamble, one of Rollins's closest allies.

Bingham lived in Jefferson City until his term expired in 1865. Evidently a diligent and honest official, he was too busy and bored to be happy in the role, even though he appointed his son Horace, then twenty-one, as chief clerk in the treasurer's office at an annual salary of $800. Few Bingham letters survive from this period. We know that in 1861 George's brother Matthias died in Texas, leaving his tangled holdings to his two brothers and sister in Missouri. As executor for Matthias' estate, George hastened to Texas, where his pleasure in playing lawyer proved useful for the heirs. Soon after George returned from this trip, his daughter Clara Bingham married a Methodist minister, Thomas B. King, son of a former governor of Missouri. George's feelings about this event and about the death soon thereafter of Horace Bingham are unknown.

In 1864, as the Civil War drew to a close, the Binghams purchased nineteen acres and a house on the south side of Independence, a town in Jackson County. They lived there until 1870, when the family moved into Kansas City. It was during 1865, in the pleasant surroundings of Independence, that Bingham decided his next contribution to politics need not entail speeches and maneuvering. He began work on a large, historical canvas, aiming to show the horror brought by war to Missouri. Although the state remained in the Union, the bloodshed and internal hatred had been enormous, stemming mostly from widespread brutality by guerrillas and bushwhackers who killed perhaps 27,000 citizens. These thugs had displayed a special zeal in the border counties near Kansas.

What roused Bingham's powerful temper was the method chosen by Major General Thomas Ewing to end this lawlessness. As the officer in charge of the federal military district surrounding Kansas City, Ewing issued on August 25, 1863, his Order No. 11. It decreed that all farm residents in the border counties must abandon their homes and property within a fortnight. Save for those few persons whom the suspicious Ewing considered loyal, the population was compelled to leave the

district. Ewing heaped insult upon injury by calling in the hated Kansas cavalry to help enforce the edict.

When Bingham learned of Order No. 11, he rushed to Jackson County to dissuade Ewing. He probably also wanted to spare harm to the property of Eliza's late father, an estate in which George himself had a stake. Facing each other, the general and the artist disagreed completely. Ewing claimed his action was a military necessity, while Bingham pointed to the misery it caused. When Ewing refused to rescind the order, Bingham warned: "I will make you infamous with pen and brush as far as I am able." Though most of those displaced by Ewing were permitted to return home late in 1863, George's wrath only intensified.

As a sympathetic friend recalled, "Bingham was a man of strong convictions; in fact, his opinions were convictions." Thus, between 1865 and 1868, George worked his viewpoint into a painting which, while inferior to his earlier work, leaves his judgment of General Ewing in no doubt. The canvas depicts the officer relishing an evil triumph as Missouri females plead with him. The women were courageously defending brutalized young men and graybeards, helpless before Ewing's persecution.

Bingham insisted his painting, entitled *Order No. 11*, sought no more than to teach that "the tendencies of military power are anti-republican and despotic, and that to preserve liberty and secure its blessings, the supremacy of civil authority must be carefully maintained." Nevertheless, in this controversy, as in most, Bingham could not resist mingling personalities and principles. Convinced of Ewing's warped character and motive, George hounded him into the 1870s by distributing prints of *Order No. 11* (Plate 7), and making speeches. The unforgiving Missourian even visited Ohio, where he worked to defeat Ewing's campaign for governor.

When he was not pursuing Ewing, Bingham spent his final years mostly painting portraits and selling prints. His friendship with James Rollins, strong as ever, produced what George considered the finest of his character studies, a majestic likeness of Rollins, completed in March 1873. Unfortunately, the canvas was destroyed by fire in January 1901 at the University of Missouri. In February 1911, flames also brought down the capitol at Jefferson City; with it went the portraits Bingham had painted at the behest of the legislature.

Financing from the faithful Rollins in 1871 brought the creation of a business firm entitled George Bingham and Company. Its purpose was to produce and sell engravings of the artist's genre triumphs. This included *Order No. 11*, which George carried to Louisville's Industrial Exposition

in 1873, hoping to drum up buyers for engravings of it. Despite earnings from his commercial ventures, however, George usually needed money. Twice, help came from public sources.

In 1875, he was designated adjutant general of Missouri. The job involved supporting petitions presented to the federal government on behalf of property damaged during the Civil War. Included among these was one from his father-in-law's estate. Then came a more appropriate post, a professorship in art at the University of Missouri, where James Rollins presided over the Board of Curators. However, while this appointment made few demands, it carried little income, so that despite his failing strength, George kept looking for more lucrative occupations.

He regularly toyed with running for governor or for Congress, boasting that "the times require a man who *has* enemies, a man who is cordially hated by all the scoundrels who infest our public offices and fatten upon public spoils." But George's heart was not in such ventures, and usually he withdrew his name before a candidacy became serious. Occasionally, he spoke of taking up residence in New York, and he never lost his ambition for a diplomatic appointment which would enable him to return to Europe. Toward the last, George began banking on his son Rollins's future. In 1873, when the lad was only twelve, the father circulated word that his only surviving male offspring was brilliant.

Increasingly troubled by lung disease, Bingham was now more inclined to seek religious solace. He assured James Rollins that life's sorrows "are in harmony with the All wise, the All good, and the Boundless love. The compensating future will show us in our final triumph over mortality that the good Ruler orders all things for our ultimate good." These spiritual inclinations were encouraged by Eliza, whose "goodness" George could not praise enough. They had been married a quarter century. "I shrink from thinking," Bingham confided to Rollins, "what would have been my fate and that of my motherless children, if this rare and excellent woman, so precisely adapted to my wants, and always adapting herself to my eccentricities, had not been given to me."

But George was not the only one who was ailing. Eliza suffered a neurosis which plagued her with delusions, a condition that seemed to be worsening in 1876. Hoping a change of scene might help, George sent Eliza and their son, Rollins, to enjoy the national centennial exposition in Philadelphia. He also wanted them to tour Virginia. Evidently, these remedies brought no relief, for Eliza Bingham, age forty-seven, returned home to be hospitalized in the Missouri asylum for the insane at Fulton.

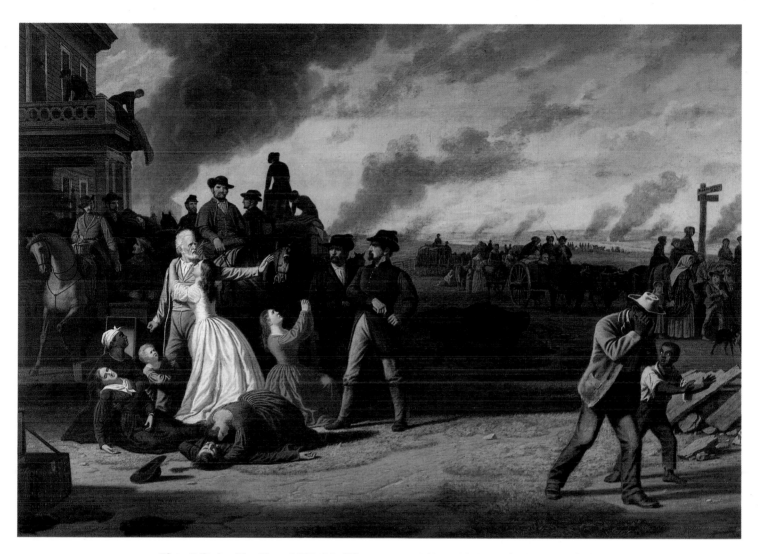

*Plate 7* Order No. 11. *c. 1865–70. Oil on canvas, 141 × 199.4 cm. (55½ × 78½ in.).*
*Cincinnati Art Museum, Cincinnati, Ohio The Edwin and Virginia Irwin Memorial*

Within a few weeks she was dead, having beheld, George reported, "brilliant visions of Heaven, and her departed relatives and friends who are inhabitants thereof." Claiming Christ sat beside her, Eliza called upon George to perform "impossible things." When he resisted, she announced that he did not love her. The physicians were obliged to keep George away from his wife, which added to his anguish. He told Rollins: "I would willingly die for her, if by so doing I could restore her to health." After her death on November 3, 1876, George described his own visions in which Eliza returned, talked with him, and kissed him.

The visitations ceased, leaving George to assert: "I have a sad and lonely life now." His mother had said much the same when Elizabeth, his first wife, died. Once again, the widower overcame his plight and found another spouse. In Kansas City, a close friend of the Binghams, Mattie Lykins, was widowed a few weeks before George lost Eliza. Within a year, George had taken up residence with Mattie at the Lykins Institution, an orphanage she operated on the outskirts of Kansas City. The dynamic and outgoing Mrs. Lykins must have been a singular contrast to the quiet, musical Eliza Bingham. George quickly adapted to these differences, including Mattie's Unitarianism. After all, Eliza had made a Baptist out of George, in spite of his staunch Methodism.

Born in Kentucky in 1824 and descended from a signer of the Declaration, Mattie Livingston became in 1851 the second wife of Dr. Johnston Lykins, an early mayor of Kansas City. When the Civil War began, Mattie's ardent Southern sympathy led military authorities, who feared her spirited behavior would enlarge the border conflict, to order her exiled in the safer precincts of eastern Missouri. After the war, Mattie took orphaned children as her special concern, particularly those left by Confederate soldiers. She was aggressive, a relentless manager, and was said to have legal understanding superior to that of most Kansas City attorneys.

Mattie's strong personality alienated some who knew her, including Eliza Bingham's sister, Mary, and her husband, James Piper. Although Piper had prospered through investments in the Pony Express, George did not like "my miserable brother-in-law." Apparently James Piper had once drawn the ire of Mattie Lykins. Her scolding of him in a public scene left deep scars, which made the Pipers all the more indignant when they learned that the supposedly grieving George had sought the companionship of Widow Lykins. Evidently in retaliation, James and Mary Piper undertook to lure Rollins Bingham away from his father by warning him that his parent's antics threatened the son's legacy.

For a time, the Pipers succeeded so well that George was overcome by anxiety and anger. He

had good reason to be upset. His son loudly repudiated him as a father, and began making slanderous remarks about Mrs. Lykins. Wondering if young Rollins was "deranged," the father admitted: "I scarcely know what to do or where to turn for relief." What particularly hurt was that George had tried to be generous and patient with a son he admitted he "almost idolized." "What a boy, thus at sixteen, to put himself over his father!" When George heard that his son referred to him as "a foolish old man in his dotage," the besieged parent had little to comfort him but Mattie's letters, which addressed him as "my darling" and "my dear abused one."

Rollins Bingham, who apparently had been troublesome and headstrong even before his mother died, was soon restored to his father, an outcome due mostly to intervention by Mattie Lykins and James Rollins (Fig. 7). After discovering how severing ties with his father had set himself adrift from his indulgent parent's purse, Rollins decided to admit he had heeded his Aunt and Uncle Pipers' gossip about Mrs. Lykins.

After the Pipers insisted they had been misunderstood, George stopped threatening to sue them and prepared for his third marriage. On June 18, 1878, George and Mattie were wed in an early-morning ceremony at the orphanage. A newspaper reporter ungenerously noted that the bridal couple were the oldest persons among those assembled. After a gigantic breakfast, Mattie took her husband to Colorado for a honeymoon, hoping he might throw off the cough which so often troubled him.

For a time George's health and outlook revived. The grateful husband asserted of his new wife: "I can safely say, in the highest sense of the term, that she is no ordinary woman." He felt better about his painting, perhaps not realizing that with *Order No. 11,* his work seemed to lose the marvelous quality of the political and river depictions. Instead, Bingham had begun giving his portraits, landscapes, and other subjects more than a touch of the contrived and dramatic style he had observed in Europe. The presence of such new elements in his work did not, however, seem to trouble George, who claimed "that my skill rather increases than diminishes with increasing years."

Mattie encouraged her husband and urged particularly that he be in earnest about his faculty tasks at the University. The pair briefly lived in Columbia, where George ran out of excuses to avoid theorizing about art. The president of the University insisted that Professor Bingham owed the scholarly community a formal public lecture. George reluctantly complied. "I have never been able to write anything about Art in a manner satisfactory to myself, and I believe the same is the case, to a great extent, with nearly all Artists."

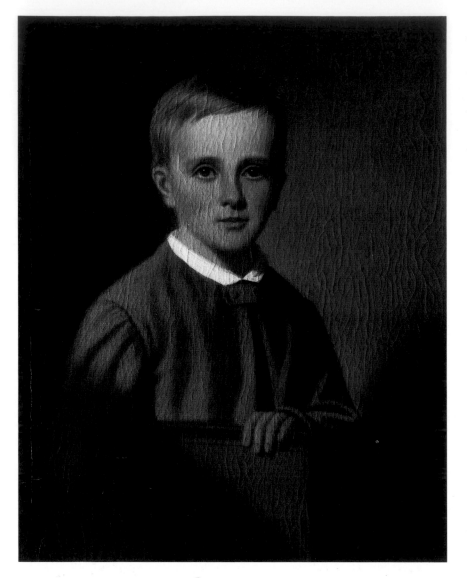

*Fig.* 7 James Rollins
Bingham. *c. 1870. Oil
on canvas, 71.12 ×
60.96 cm. (28 × 24 in.).*
Mrs. W. Coleman Branton

Late in 1878, George prepared remarks he called "Art, the Ideal of Art, and the Utility of Art."
Living up to its ponderous title, the lecture included lines such as: "Art is the outward expression of
the esthetics sentiment produced in the mind by the contemplation of the grand and beautiful in
nature, and it is the imitation in Art of that which creates this sentiment that constitutes its
expression." Weakened lungs and severe illness kept Bingham from delivering the oration. With the
author back in Kansas City and bedfast, it was of course James Rollins who had to read the lecture to
a campus audience on March 1, 1879 (Figs. 8, 9, 10).

Soon afterwards, George improved enough to visit the Rollins family for two months.

Seemingly strong, he returned to Kansas City on July 5. Two days later, he died from what was termed cholera morbus. Mattie arranged his burial in Union Cemetery, beautifully located in rural environs near her orphanage. Today the graveyard is difficult to find, surrounded as it is by buildings and commerce. George was interred in the same plot with his good friend, Dr. Johnston Lykins. Mattie left enough space between the two husbands for herself.

Mayor Lykins was given an ordinary tombstone which proclaimed: "There shall be no more death." However, the widow had something special in mind for George. She commissioned a tall monument bearing a medallion bust of "General Bingham," as the public had come to call George for his service in the state adjutant's office. The inscription now can scarcely be read: "Eminently gifted, almost unaided he won such distinction in his profession that he is known as the Missouri

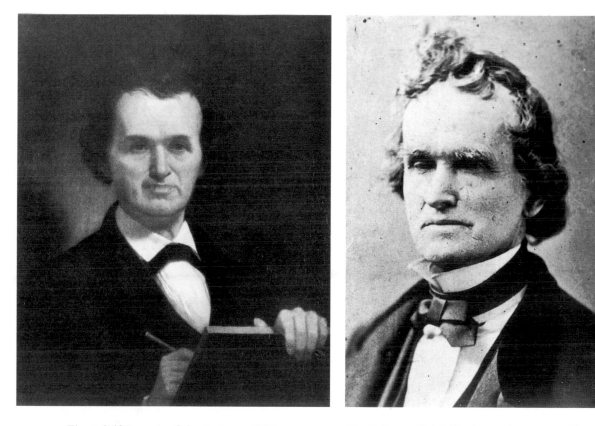

Fig. 8 Self-Portrait of the Artist. c. 1877.
Oil on canvas, 67.31 × 54.61 cm. (27 × 22 in.).
The Kansas City Public Library, Kansas City, Missouri

Fig. 9 George Caleb Bingham, photo as an old man.
The State Historical Society of Missouri,
Columbia, Missouri

*Fig. 10 Interior photo of James Rollins home. c. 1873–1914. Columbia, Missouri Private collection*

artist." After losing a battle with cancer, Mattie took her place between her mates in September 1890. Her stepson, Rollins Bingham, was with her when she died.

The story of George Caleb Bingham closed with one more good turn by James Rollins. The latter delivered so stirring a eulogy at the artist's funeral that a newspaper reported the remarks made one "think better of human nature, and teaches us that, after all, men are better than we think them." Bingham might prefer as an epitaph his own comment once made to Rollins: *"The Jolly Flatboatmen* and *County Election* assure us that [American] social and political characteristics as daily and annually exhibited will not be lost in the lapse of time for want of an art record rendering them full justice."

Indeed so.

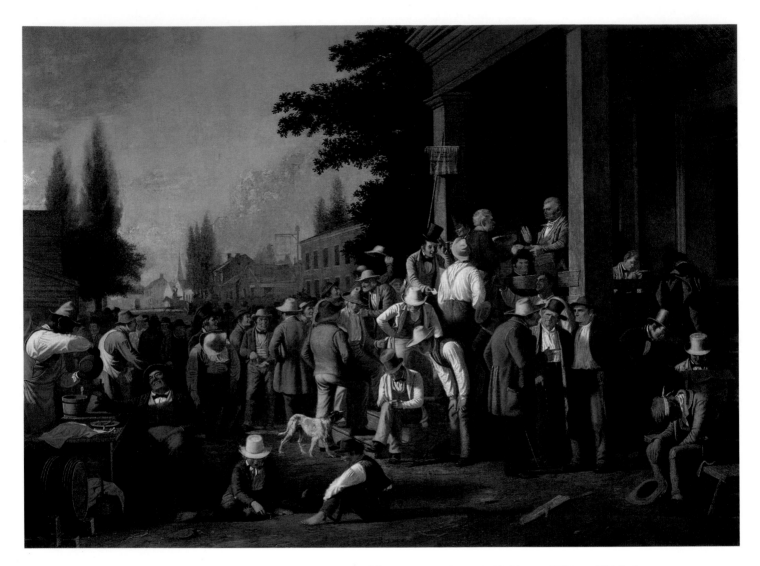

*Plate 8* The County Election *(1). 1851–52. Oil on canvas, 90.01 × 123.82 cm. (35⁷/₁₆ × 48³/₄ in.).*
*The Saint Louis Art Museum, St. Louis, Missouri Museum Purchase*

# THE "MISSOURI ARTIST" AS HISTORIAN

## By Barbara Groseclose

The French may have originated the adage which claims that the more things change, the more they stay the same, but events in American politics constantly seem to prove it. The behavior of a candidate in our most recent national election who withdrew from the race because he found the campaign "too dirty" and almost immediately afterwards decided to run for office again is not an isolated occurrence in American history. George Caleb Bingham also declared he would "strip off my clothes and bury them, scour my body all over with sand and water, put on a clean suit and keep out of the mire of politics *forever*," when his election to the state legislature of Missouri was contested in 1846; scarcely a year and a half later he was stumping for office again and in 1848 won the seat he had earlier lost.[1]

After serving as a representative of Saline County in the state legislature for two years, Bingham later unsuccessfully ran for Congress as a delegate from Missouri's sixth district, was appointed president of the Kansas City Board of Police Commissioners in 1874 (the same year he again attempted to run for Congress), and was made adjutant-general of Missouri in 1875. In between he faithfully attended national political conventions, pressed claims for appointment as a consul-general overseas, and maintained a steady personal involvement in local elections. Although Bingham's political career never reached beyond a regional level, he was throughout his life profoundly concerned with national issues as they affected Missouri. It seems reasonable to assume that the imagery in the political paintings of this artist-politician would be to a large degree focused and shaped by experiences and beliefs related to his activities in public life. But how or through what means did Bingham's painting and politics intersect?

Another engrossing interest of Bingham's—history—suggests a possible connection. Believing art to be history's "most efficient hand-maid," Bingham consciously set out to be the painter-chronicler of his time and place. He said as much when he told his lifelong friend and political mentor James S. Rollins that his paintings would guarantee "our social and political characteristics as daily and annually exhibited will not be lost in the lapse of time for want of an Art record rendering them full justice."[2] In many ways, Bingham succeeded. He is admired today as an artist whose paintings and drawings combine aesthetic merit with informative documentation of American social history, an assessment which crops up especially regarding works depicting the election process.[3]

Because the artist was an ardent Whig, some familiarity with the Whig party and its political and governmental role in Missouri will be useful in attempting to link Bingham's two careers. Knowledge of the policies of Missouri Whigs bears strongly on our specific comprehension of the partisan, regional, and national elements of the election series: *Country Politician* (1849), *Canvassing for a Vote* (1852), *The County Election* (1851–52), *Stump Speaking* (1853), and *The Verdict of the People* (1854–55). Although the topics of the political paintings concern events and activities that take place throughout the United States, Bingham was in his "Art record," as in his public life, locally minded. When he embarked on the election series, the historian in Bingham, proud of Missouri's newly-won place as a "civilized" participant in the national enterprise, clashed with Bingham the Whig politician, whose disgruntlement over the strength of Jacksonian Democrats throughout the country, and especially in his home state, could not be suppressed. The resulting friction created in Bingham's political genre painting an unresolved ambivalence which becomes more pronounced the deeper one explores his paintings. Rather than weakening his efforts, however, the buried conflicts within Bingham's political works invigorate and energize, making them stand out as among the best of his oeuvre and lifting them far above his attempts to represent purely historical topics. The artist wanted the latter to be commemorative masterpieces of national stature. But the visual excitement generated by the tensions in his political series may have resulted in many of Bingham's more lasting contributions to American history and art.

The Whig party began as splinter groups and special-interest factions such as the anti-Masonic party, states-rights advocates, and Democrats disaffected by Andrew Jackson's stand on currency, all coalescing to form a political organization to field candidates opposing Democrats on all levels of government in 1834. The distinguishing and unifying feature of the Whig party can be

summed up as anti-Jacksonian. Organized in Missouri in 1839, Whigs met with little success on the state and county levels, and they did not even win the state in the campaigns of 1840 and 1848, when Whigs were elected President.[4] Perhaps because they encompassed a wide diversity of opinion, Missouri Whigs did not always formulate platforms, since denunciations of "executive usurpation" were the gist of their battle cries in the post-Jacksonian years. Only reluctantly did they adopt the electioneering techniques of their rivals, which made use of populist imagery and mass rallies.[5] Often reluctant, in fact, to campaign at all, Whigs in Missouri seldom ran a full slate for any election; Bingham and his friend Rollins numbered among the few party members who made themselves regularly available as candidates. Less than two decades after its founding, the Whig party in Missouri was undone in part, as the country would soon be, by the contest over slavery.

In retrospect, it may have been easier for Bingham to pursue his desire to be a historian in paint than to maintain his own or others' devotion to the persistently flagging Whigs. Unlike Whigs, historians and would-be historians in mid-nineteenth-century America rarely wavered in enthusiasm or fluctuated in dedication. Moreover, they usually met with the willing acceptance, even participation, of a citizenry eager to collaborate in the task of formulating a national past. In Bingham's part of the country, ideas of what constituted "history" were predicated for the most part on the newness of the region. The business of settling the frontier had left these communities little time for the accumulation of records and documents in comprehensive archives upon which historians might draw. The urgency of collecting a past before too much of it was lost to neglect or ignorance, as well as the nationalistic desire for an "American" history, prompted the founding of local history societies—of which there were only four in 1820 but sixty-two more by 1860— throughout the United States.[6] These "bastions of localism" gathered treaties, school and church rolls, maps, records of transactions relating to territory, colony, city, or state, genealogical and autobiographical manuscripts, and other, similar documents touching on the growth and present condition of their communities.[7] But it was not simply to assure accurate record-keeping alone that most of these historical societies functioned. Rather, regional boosterism and a narrowly focused patriotism instigated their efforts and provided their most far-reaching contributions: the promotion of their community, in order to attract settlers or commercial investment, and the legitimization of their citizens, whose devotion to national objectives established their "civilized" credentials.

Similarly, writers of national history looked at minutiae, seeking to find in the particle elements of the whole. Two main tenets of historical belief gave rise to this methodology. Foremost

was the attempt by historians to inculcate among their readers the idea of an advanced, enlightened, and refined American culture grown out of the wilderness, one whose political and economic systems furnished a mandate for other nations of the world and, somewhat more to the point, one whose past could supply the groundwork for the actions of future Americans. To this didactic end, they used language and sought themes emphasizing what they saw as the civilized state of the country and the progress made in transforming the wilderness. Second, many historians believed in the existence of patterns that, once discovered, exposed the true order of a nation's past and revealed its national character; for these historians, not only the actions of individual heroes needed to be recorded but the traits of ordinary people required documentation in order to accumulate evidence of such a character.[8]

Although it is debatable whether progress consistently or genuinely leads to something better, it continues to be regarded as unceasing and necessary change. "Civilization," on the other hand, takes on different meanings depending on time and place. In the United States of Bingham's day, an ordered and peaceful civic life, industrious and diligent citizens, and a monogamous domestic structure generally were supposed to be features of a civilized society; especially valued were the concepts of private property and cultivation of land.[9] It will be readily observed that in Bingham's times "civilization" was synonymous with the mode of existence favored by societies of European origin.

As if to declare Eurocentricity more firmly, early American writers and artists would contrast civilization's constituent features with the behaviors of native Indians, whose way of life was perceived as lacking *all* such civilizing elements. Eventually, the urges impelling Americans across the continent toward the fulfillment of their "manifest destiny" made it imperative to dislodge the Indians. Advancing the European notion of civilization by exposing the manner in which Indian culture differed then proved doubly convenient, since to consider them as the opposite of civilized, that is, as savages, meant their removal as obstacles to progress carried some "moral" justification.

Bingham's art as social history fully displays the impact of the desire, so widespread and compelling it might be called a national ethos, to boast of the progressively civilized development of life in the new country. For Bingham, this meant especially American life as it was lived in Missouri. As a whole, his art formed a pictorialized collective history of his region and, in turn, the activities of the people he delineated added to the framing of a national biography. He rarely drew upon negative iconography to advance the notion of civilization in the West, painting only two Indian scenes, *The*

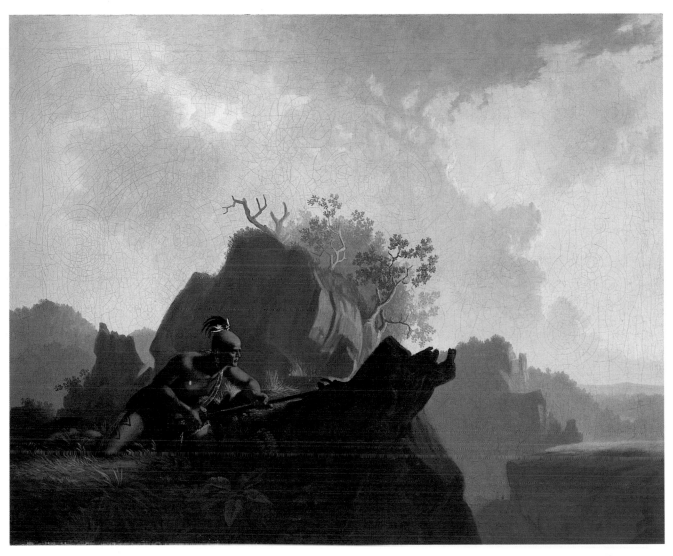

*Plate 9* The Concealed Enemy. *1845. Oil on canvas, 74.29 × 92.71 cm. (29¼ × 36½ in.).*
*Stark Museum of Art, Orange, Texas*

---

*Concealed Enemy* (1845) and *Captured by the Indians* (1848). But in both of these, the imagery sets "savagery" against civilization, an opposition the viewer makes by implication in looking at each individual canvas, and by comparison when each canvas is seen in terms of its pendant.

In *The Concealed Enemy* (Plate 9), an Osage warrior crouches behind a boulder, menace in his scowling face and tightly grasped weapon. His intended victim, doubtless imagined to be a white settler by most of Bingham's contemporaries, is more vividly imperiled because unseen. Long

shadows of sunset heighten the sense of dramatic anticipation, as do the nervous outlines of the rocks and scrubby vegetation. Deceitfulness in his concealment, violence in his intentions, and wildness in his lair sum up the Indian's savage traits and, by way of association, the dangers of the uncleared forest. Henry Adams has ably demonstrated that *The Concealed Enemy* forms a pendant to *Fur Traders Descending the Missouri* (see Plate 33), not merely because the two paintings were executed the same year, are the same size, and depict the West, but because to the Indian's savagery is juxtaposed a visualization of "emerging civilization."[10] First titled by Bingham "French Fur Trader and His Half-Breed Son," the painting offers on every point positive contrast to its mate: a means of support rather than danger may be found in the forest; the light breaks in an optimistic sunrise, not a sunset of decline; the dominant lines have the calm strengths of a horizontal rather than the agitation evoked by jagged forms.[11]

Both Adams and E. Maurice Bloch, Bingham's biographer, name two other paintings as pendants to each other (or as Bloch terms it, "companion designs"): *Captured by the Indians* (Plate 10) and *Belated Wayfarers* (Plate 11).[12] They do not, however, further elaborate on the paintings' relationship. In composition, the works are alike, not dissimilar, as was the case with the earlier pair. In both scenes, the figures and setting lay partly exposed by a light-filled diagonal, the illumination of a campfire in an otherwise impenetrably dark forest at night. Both share a central figure across which strong lights and shadows play, a large tree trunk with low branches, a sleeping man sitting with bald head bowed and his arms on his thighs, a boulder or rocky outcropping to the right, and a barren forest floor. In the case of *Captured by the Indians* and *Belated Wayfarers*, the pendant relationship again derives from a subtext which posits a contrast between civilization and savagery.

The earlier painting is based on a captivity narrative, a type of literature that proliferated in the eighteenth century and remained of strong interest to nineteenth-century readers. These accounts usually had some basis in actual circumstance, but most often facts were the point of departure for propaganda against native Americans.[13] The style of discourse varied, from religiously-oriented prose to sensationalistic journalism, though none permitted an interpretation of Indian behavior as anything other than violent, disruptive, vengeful, and irrational. Many captivity accounts tell the same story Bingham presents in his painting. Women, the overwhelming majority of captivity protagonists, are kidnapped along with one or more of their children, and are led off into the wilderness. A pause in their flight allows the prisoner time to reflect on everything that has

happened, or to pray, which the woman does here. Her prayer and the innocence of the child who sleeps in her lap intensify the wary and haunted look of the Indians.[14] Almost exactly the same forest setting, on the other hand, offers no threat in *Belated Wayfarers.* Indeed, the wilderness—normally the Indian's habitat—is apparently a place of known safety, a sanctuary, for the sleep of the reclining man looks neither uneasy nor fitful, but rather deep and tranquil. Like Endymion, whose pose he evokes, he is watched only by the moon. Thus to see *Belated Wayfarers* alongside *Captured by the Indians* underlines the former's serenity and leads to the inference that an absence of Indians might be equated with security, and therefore civilization, in the forests of the West.

A similar implication occurs in pairing the menace-filled *The Concealed Enemy* with a peaceful *Fur Traders Descending the Missouri* (see Plate 33). Early in the history of the West, when the white population was sparse, Europeans had traded—often in furs—and intermixed with Indians; as larger numbers of settlers and the resulting agrarian economy took over in the nineteenth century, Europeans felt that the Indian must make way. Bingham's pointed reference to the half-breed son of the trapper calls attention to assimilation, one of the two destinies the inexorable flow of white immigrants assigned to the Indians. The second fate, of which *Belated Wayfarers* can remind us, was removal, either by death or forced displacement. Indians were forced to abandon lands claimed by whites and take up their lives in locations chosen for them by the government. In one of these transfers involving Missouri tribes, the United States moved 90,000 Indians into the territory west and south of the Platte River, an undertaking essentially completed by 1840.[15] If Bingham's pendants from 1845 delineate aspects of the first stage of contact between Indian and white, hindsight allows the suggestion that his second pair adumbrates the denouement of their transactions. More important in terms of Bingham's concepts of history as they appear in his art, the two sets of pendants may reflect Bingham's most forceful attempts to locate *his* West within civilized boundaries and to demonstrate the changes that progress was bringing or had brought to the region.

Among Bingham's cast of Western characters, fur traders and squatters fall near the mid-point on a continuum between savagery and civilization, being neither settled and agrarian, nor wholly nomadic. Fur traders, like scouts and hunters such as Daniel Boone, served in literature and the visual arts as convenient symbols of the *coming* of civilization, its advance guard breaching the wilderness. (The flowing river bearing the canoe in Bingham's painting characterizes the trappers' easy passage between the two conditions.) Squatters, on the other hand, were sometimes seen to represent a less positive element. They drifted about on the edges of society, too white to be classed

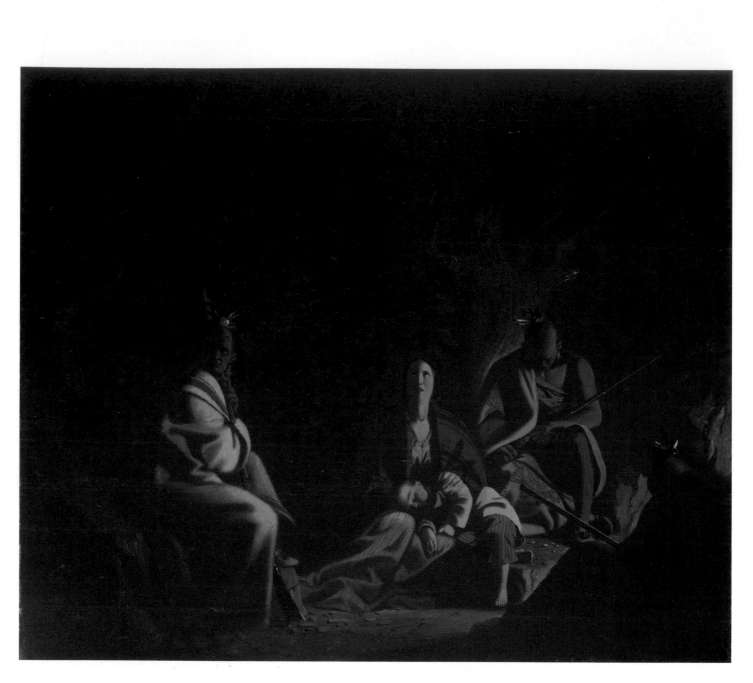

*Plate 10* Captured by the Indians. *1848. Oil on canvas, 63.5 × 76.3 cm. (25 × 30 in.).*
*The Saint Louis Art Museum, St. Louis, Missouri Bequest of Arthur C. Hoskins*

*Plate 11* Belated Wayfarers. *1852. Oil on canvas, 62.6×75.2 cm. (24⅝×29⅝ in.).*
*The Saint Louis Art Museum, St. Louis, Missouri Gift of Arthur C. Hoskins*

with savages and too itinerant to be called civilized. "The Squatters as a class," wrote Bingham, "are not fond of the toil of agriculture, but erect their rude cabins upon those remote portions of the National domain, where abundant game supplies their phisical [*sic*] wants. When this source of subsistence becomes diminished, in consequence of increasing settlement around, they . . . again follow the receding footsteps of [the] Savage."[16] Oddly, *The Squatters* (Plate 12) is one of the few canvases Bingham painted in which a woman is present, but given the customary duties of women, especially of this class, it is not difficult to see why labor might lead the artist to include a female. More interestingly, in view of the interpretation of harshness usually given his statement, Bingham portrayed the male figures in the painting quite sympathetically. Though meanly clothed, the two men in the foreground do not look shifty-eyed, hostile, or, in the case of the younger one, "un-yeomanly." A placid, healthy-looking dog—Bingham's visual equivalent of a Greek chorus throughout his *oeuvre* is canine—reinforces the alert yet mild demeanor of the men. Perhaps Bingham's picture is not as strong as his words, because to denigrate squatters would be to compromise the worthiness of the migration West. However unattractive people found them, squatters did constitute a part of that endeavor, and nowhere does Bingham present a negative view of the ongoing expansion or of Missouri's place therein.[17] Instead, Bingham's genre paintings portray the transformation of the state caused by the westward movement. He often chose subject matter that showed the people of Missouri poised between pioneer days, when the frontier of the migration was Missouri, and the settled and cultivated present, when the harbingers of civilization had moved or were moving onward. Transient squatters were but one sign of that passage.

In Bingham's paintings, customs shown in *Shooting for the Beef* (1850), and occupations, such as fur trading or working on man-powered boats, not only bear witness to the dying of an era but also underline the artist's role as local historian. Even as he painted, steam and rail were beginning to replace flatboats as freight transport, most of the fur traders had retreated to more isolated areas, and the marksmen's skills were increasingly unnecessary to subsistence. But rather than give a strictly "historical" documentation, the artist combined the idea of transcription, a record, with a mood of nostalgia, a memory. The sheer tranquility imposed on many of his river paintings by this combination—*Boatmen on the Missouri* (see Plates 1, 38), for instance—fills their detailed and busy scenes with a sense of lassitude. As a steamboat puffs gently toward them, two figures in the foreground candidly meet our eyes, the locking gazes defining the present moment. In contrast, the pale and diffused light encases them and instills poetry, denying time. As though cognizant of their

own near extinction as a breed, a knowledge intimated by their passive and slouching postures, the boatmen wait to surrender their portion of the West. The viewer realizes the rivers of pioneer Missouri will in time belong to the new age of the steamboat.

Most paintings by Bingham assert the contemporaneity of Missouri, by implication if not always by such graphic example, while simultaneously documenting the passing of the frontier. His work might be the pictorial equivalent of what local historical societies wanted to do as promotional and archival organizations. And just as Bingham did not limit himself to recording token events or unusual ones, historical societies did not confine their purview to a few items or a narrow scope. Founded in 1844 and incorporated the following year, the Missouri Historical and Philosophical Society (MHPS) was made up of "respectable gentlemen" from all over the state, including Bingham's great friend James Rollins. The list of subjects for which the Jefferson City institution wished to acquire memorabilia, books, specimens, manuscripts, records, letters, and maps approaches total comprehensiveness, touching on everything in or under the state from coal to needlework, birth certificates to bank accounts. Minerals and fossils would "[present] a striking proof of the varied soil and mineral wealth of Missouri," and the anticipated archive of newspapers (which in the Secretary's colorful prose were lauded as "the mighty arteries through which gushes the pulse of public opinion") were identified as invaluable "memorials of our social and political history . . . [indicating] at a glance our onward march in intelligence and civilization."[18] Early on, the members also resolved to publish "a small, neat pamphlet" about the Society and its collections for distribution to other states, a self-advertising gesture repeated by almost all other historical societies that bespoke the twin themes of pride and progress found throughout their annual reports.[19]

To this point the discussion of Bingham's art has been in terms of those paintings that established his aims, built regional memories, and launched his reputation. Their motives and techniques offer a loose analogy to the purposes and methodologies of local history societies like the one in Jefferson City. Both Bingham and the MHPS wanted to instill the notion of Missouri's distinctiveness (in Bingham's case because it was an image Eastern audiences wanted to buy as well as one to which he personally subscribed), while claiming at the same time the state's attainment of that stage of development identified with older parts of the country. The events recorded by the election series, in contrast, depict national rites, subject matter that seems to differentiate them. But regionalism plays an important role in the conceptualization and execution of these paintings too.

*Plate 12* The Squatters. *1850. Oil on canvas, 59.37 × 71.76 cm. (23⅜ × 28¼ in.). Museum of Fine Arts, Boston, Massachusetts Bequest of Henry L. Shattuck in memory of the late Ralph W. Gray*

What does set them apart is the nervous energy and iconographic voltage produced by the yoking of historian and politician.

Not that the political paintings were always dynamically organized, multi-figured affairs full of complicated or abstruse references. *Country Politician* (Plate 13), for example, is a relatively modest, low-key work. The perception of its content by a local viewer, however, reveals the sectionalism Bingham's fellow Missourians discerned in all of his political subjects, for what appears as a traditional genre interior with four neatly arranged figures was described by the *Daily Missouri Republican*, April 17, 1849, as a group discussing the Wilmot Proviso.[20] The eager speaker and his mildly interested listeners, including one next to a stove who warms the seat of his pants while reading a poster advertising a circus, looked so familiar and authentic that the reporter took it for granted the conversation must be about matters of interest to people he knew. The inception of Bingham's own political career at this time and the issues he faced may have furnished the painting's special immediacy. In any case, it is not easy to understand why a local writer might think the topic of slavery legislation would ignite in Missouri the kind of zealousness Bingham's speaker exudes.

Whether the United States should—or *could*—legislate on the question of slavery in recently acquired territories was debated not only in Missouri but throughout the country, from the time of Wilmot's anti-slavery amendment regarding lands purchased from Mexico in 1846 until the Civil War. The Missouri state legislature, with people and parties of divided opinions about both slavery and the extent of federal power, passed the "Jackson Resolutions" in 1849 instructing their United States Congressmen and Senators to break the Proviso. The Democrat who proposed the measure, Claiborne Fox Jackson, was a pro-slavery, states' rights militant whose other claim to historical notice was that he married in succession the three daughters of Missouri's Democratic kingpin, John Sappington, whose son defeated Bingham in his first campaign. The most vociferous opponent of the Jackson Resolutions likewise was a Democrat: U.S. Senator Thomas Hart Benton came back from Washington D.C. to roar his objections to the Jackson Resolutions in fiery speeches throughout the state. The subsequent defeat of Benton, who was turned out of office in 1850 primarily on this issue after thirty years of service, was but one indication of the strength of pro-slavery factions in Missouri.

Bingham entered the state legislature in 1848, the same year that the Jackson Resolutions were proposed, having won at last the seat for Saline County held by the Democratic incumbent, Darwin Sappington. In an effort to introduce a more workable plan, Bingham made a name for himself on

66

behalf of the state's Whigs by offering the "Bingham Resolutions," which declared that, although the United States Congress *could* legislate on matters relating to slavery, it *should not*. Incorporated into the Whig state platform of that year, the Bingham Resolutions were meant to placate hotheads on both sides. Yet Bingham was not by nature a propitiator. As he told Rollins in 1850: "I have never been in favor of making the slightest sacrifice to conciliate either the test Whigs [Whigs who insisted party orthodoxy be judged on the question of one's belief in Congress's right to pass legislation on the slavery issue] or the Anties [Democrats who opposed Benton's stand on slavery]. With a frank avowal of our principals and a straight [*sic*] forward policy we can consistently act with all who act with us, and to Benton and his friends I would extend the right hand of fellowship as far as they place themselves upon our ground."[21]

Three years later Bingham, sensing the nature of his affinity to his old Democratic antagonist Benton as positions hardened on slavery, told Rollins, "I have quite a serious notion to make '*Old Bullion*' [Benton's nickname since 1832 when he debated the question of "hard" versus "soft" currency] *appealing to the people of Missouri* the subject of a future picture."[22] There is no evidence that he ever put his "notion" on canvas. There does exist a drawing (Fig. 11) that has been associated usually with the now-lost painting of *The Stump Orator* (1847), because it illustrates a single figure before a makeshift lectern with his right hand in an orator's rhetorical gesture. If the large nose, long and thin lips, wispy and unkempt hair, and prominent bushy eyebrows of the face in the drawing are compared to Benton's features as pictured in an anonymous engraving of c. 1850–55 (Fig. 12), one finds a close match.[23] In addition, the drawing emphasizes the speaker's "portly figure," a feature of Benton's physique that Bingham mentioned specifically in his letter to Rollins about the Senator. The resemblances suggest Bingham may have begun here to work out ideas for the projected painting.

Bingham even planned at what moment he would paint *"Old Bullion" Appealing*: "That passage in the commencement of his speech at Fayette, in which he designates the friends he came to address as those only who had heads *to perceive and hearts to feel the truth* would afford . . . the best point of time for pictorial representation . . ."[24] He refers to the speech Benton delivered in 1849 at Fayette, the home of Claiborne Fox Jackson, in which he loosed his formidable rhetoric upon a crowd "braying, whistling, yelling and groaning" as he mounted the podium. "My friends, and in that term I comprehend those who come here to learn the truth, and to believe it, and none others," he began sternly, and when he finished three hours later, his audience had been respectfully silent

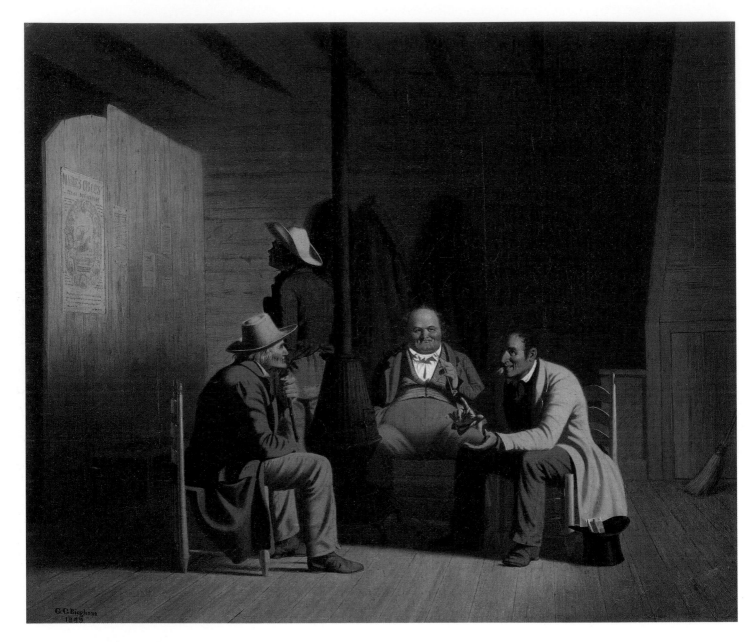

*Plate 13* Country Politician. *1849. Oil on canvas, 50.8 × 60.96 cm. (20 × 24 in.). The Fine Arts Museums of San Francisco, San Francisco, California Gift of Mr. and Mrs. John D. Rockefeller III*

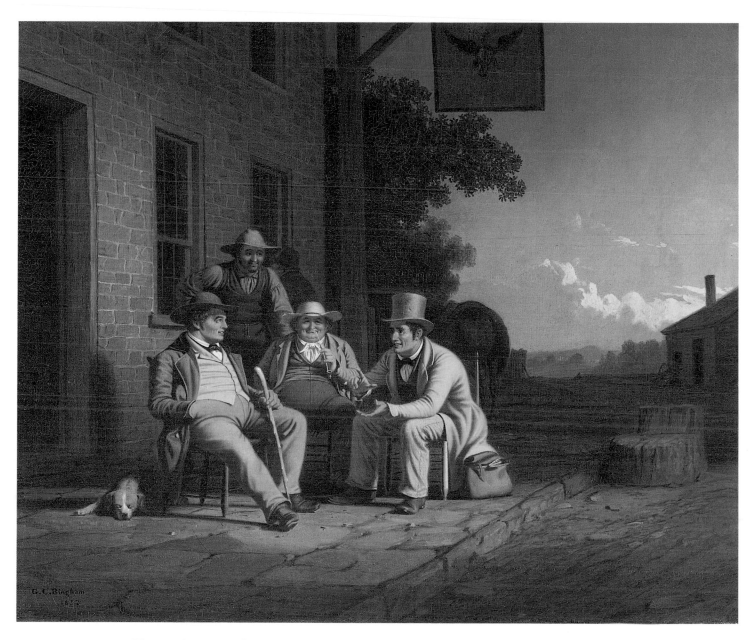

*Plate 14* Canvassing for a Vote. *1851–52. Oil on canvas, 63.81 × 76.67 cm. (25¹/₈ × 30³/₁₆ in.).*
*The Nelson-Atkins Museum of Art, Kansas City, Missouri Nelson Fund*

74

*Fig. 11* Stump Speaker.
*1853–54. Brush, black ink,
and wash over pencil on
paper. 25.71 × 17.30 cm.
(10⅛ × 6¹³⁄₁₆ in.). The
People of Missouri Acquired
through the generosity of the
Friends of the Albrecht Art
Museum, St. Joseph, Missouri*

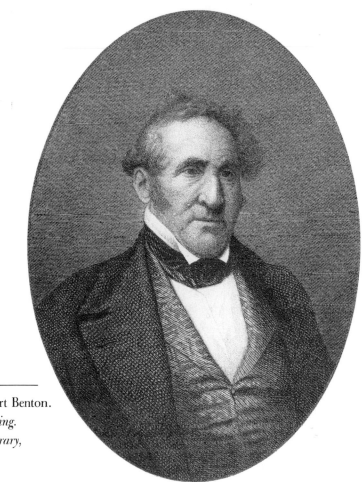

*Fig. 12* Thomas Hart Benton.
*c. 1850–55. Engraving.*
*New York Public Library,*
*New York, New York*

throughout.[25] Most campaigners probably could not summon a fraction of Benton's renowned eloquence, though they were frequently obliged, like all politicians, to speak before disruptively noisy or blankly apathetic listeners with as much enthusiasm as they could plausibly send forth.

Bingham knew this and the other difficulties mass campaigns entailed: "Upon the stump I had to contend with the abilities of others besides my competitors. Against me was arrayed, not only a large portion of the concentrated wealth of the county in which I reside, but I found, meeting me regularly at my own appointments, the *great* champion of our opponents from the other end of the Senatorial district. Opposed by such a combination; assailed both in front and flank, with an *ex-governor* whenever the occasion offered bearing down on my rear, I still found myself sustained by the consciousness of a good cause."[26] The candidate leaning dramatically toward his audience in *Stump Speaking* (Plates 15, 17) seems to be sharing the campaign stand with

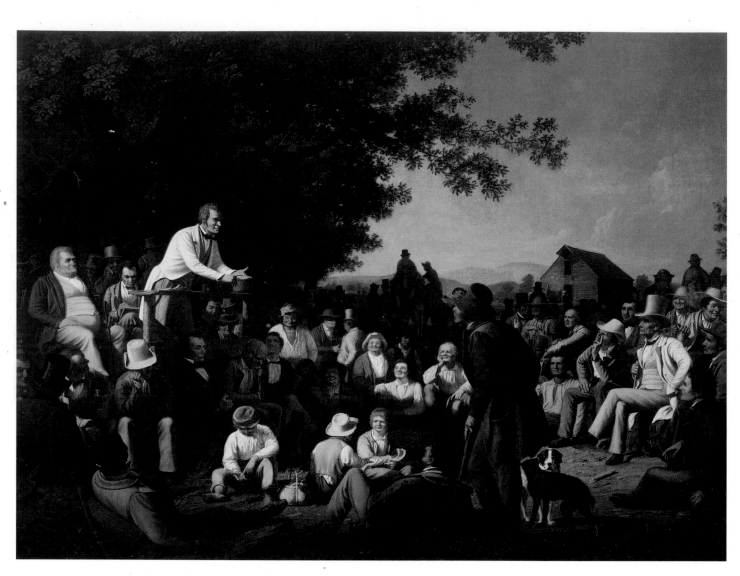

*Plate 15* Stump Speaking. *1853–54. Oil on canvas, 107.95 × 147.32 cm. (42½ × 58 in.).*
*Boatmen's Bancshares, Inc., St. Louis, Missouri*

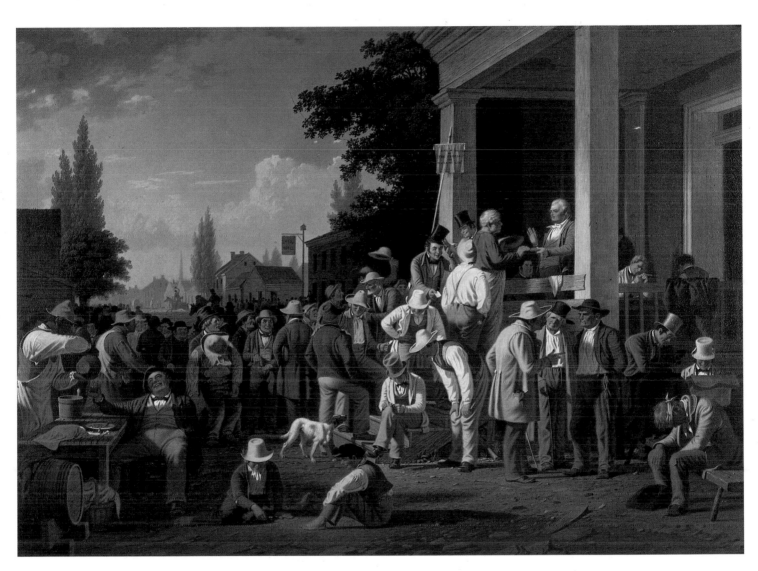

*Plate 16* The County Election *(2). 1852. Oil on canvas, 96.52 × 132.08 cm. (38 × 52 in.).*
*Boatmen's Bancshares, Inc., St. Louis, Missouri*

opponents, as Bingham described himself doing. The fat man behind the speaker in the painting has been identified as Meredith Miles Marmaduke of Saline County, who in fact *was* the Democratic ex-governor when Bingham was campaigning and whose portrait Bingham painted in 1834.[27] Marmaduke was also, incidentally, the brother-in-law of Darwin Sappington, Bingham's erstwhile opponent. The "candidate" Bingham depicts gains for his efforts a mostly interested and quiet audience, rather than being "assailed both in front and flank" by a noisy, unruly crowd and partisan foes. The odd character here and there dozes and a foolish-looking man slyly assesses his companions, but the faces of the majority reveal concern, amusement, serious thought, contemplation—an array of more or less intelligent responses to that part of the election process in which positions are argued.

Although he showed none of the Whig's usual antipathy towards the boisterous campaign style of the Jacksonian era, Bingham painted in *Country Politician* and *Stump Speaking* the rational discourse and enlightened electorate that Whigs liked to believe were associated primarily with their own party. In this regard, it is useful to recall how closely tied to Whig propagandizing Bingham's genre initially was. Commissioned by local supporters, he designed campaign banners for the 1840 and 1844 presidential contests (all but a single fragment appear to be lost), illustrating Whig party leaders in several popular stereotypes—in front of log cabins, with cider barrels, and so forth. His painting of campaign banners occurred close to the time Bingham accelerated his interest in politics and seems to have exerted a direct influence on his art. For example, a derivation of *Country Politician,* a small painting called *Canvassing for a Vote* (Plate 14), moves the former's figure group outdoors and bears a similarity to a Whig campaign print of 1841 entitled *Log Cabin Politicians.*[28] So while a refined exchange of political views might be both a Whig ideal and the artist's own romanticized picture of the civilized behavior of Missouri's people when they debated, Bingham's acquaintance with popular campaign imagery and his impassioned description of his own campaign experiences make it possible *Stump Speaking* was meant to give a Whiggish prod at a Democratic foe, in this case, Marmaduke. What is more, a wry remark the artist made to Rollins as he was painting the work betrays an absence of illusions about politicking in general and prompts another look at his speaker and audience.

"Instead of the select company my plan at first embraced," he told his friend about *Stump Speaking,* "I have an audience that would be no discredit to the most populous precinct of Buncombe."[29] The North Carolina county which had given the nation a U.S. Representative

notorious for his endless palavering about slavery (and whose presence in Congress cast none too kindly a light on his constituents), also endowed the English language with a valuable noun, today spelled "bunkum." Bingham's understanding of bunkum and the realities of campaigning may have also led him to erode an otherwise complimentary picture of politician and electorate by visual nuance. What looks to be an innocent picture of the candidate earnestly beseeching intelligent listeners holds a few muted ironic notes upon closer observation: an almost magnetic force pulls together what should be the antithesis of a scruffy, apparently dumbfounded voter and a dapper, sedulously arguing candidate; a child positioned directly below the candidate apes his elder's rhetorical gesture; two dogs sniff each other suspiciously, arousing irresistible comparison with political opponents squaring off. Humor borders on the sardonic and imparts a spirited edge to the entire scene.

The election series was not painted in narrative sequence, and *The County Election* (see Plate 8) preceded *Stump Speaking* by a year.[30] In the former, two boys throwing a knife remind the viewer of the heightened challenges in a political contest as the game nears its finish. The game they play, mumble-the-peg, grows more dangerous and requires more skill at the end. But *The County Election* furnishes more clues—less subtle and less comic than *Stump Speaking*—about the equation of politics with a trivial but rough game. One does not find, for example, wholly reasonable folk casting their vote in *The County Election.* Instead, a rowdy festival seems to be going on. A conspicuous cider barrel at the left, with the western counterpart of a jolly toper beside it, compositionally mediates between the observer and Bingham's talkative figures, whose fervor diminishes only when they are drunk or injured. *Viva-voce* balloting, voters collared by gabbling candidates or their agents at the penultimate moment of decision, laughter, arguments both angry and perfunctory, genial calls of welcome to neighbors, even the querulous grunts of an impatient fellow dragging an inebriated man toward the polling place make up the cacophony we might hear if sounds could erupt from Bingham's crowd.

As a work of art, *The County Election* usually is not so much analyzed as feted, which would be appropriate for a painting that functions almost like a monument commemorating freedom of choice. Factors that might temper (although not preclude) such an exalted assessment lie in a bundle of small details. In particular, the figures, all types frequently drawn by Bingham, sometimes behave with considerably less probity than is desirable during an election. A man placed directly below the balloting appears to flip a coin, giving rise to the possibility that a vote has been

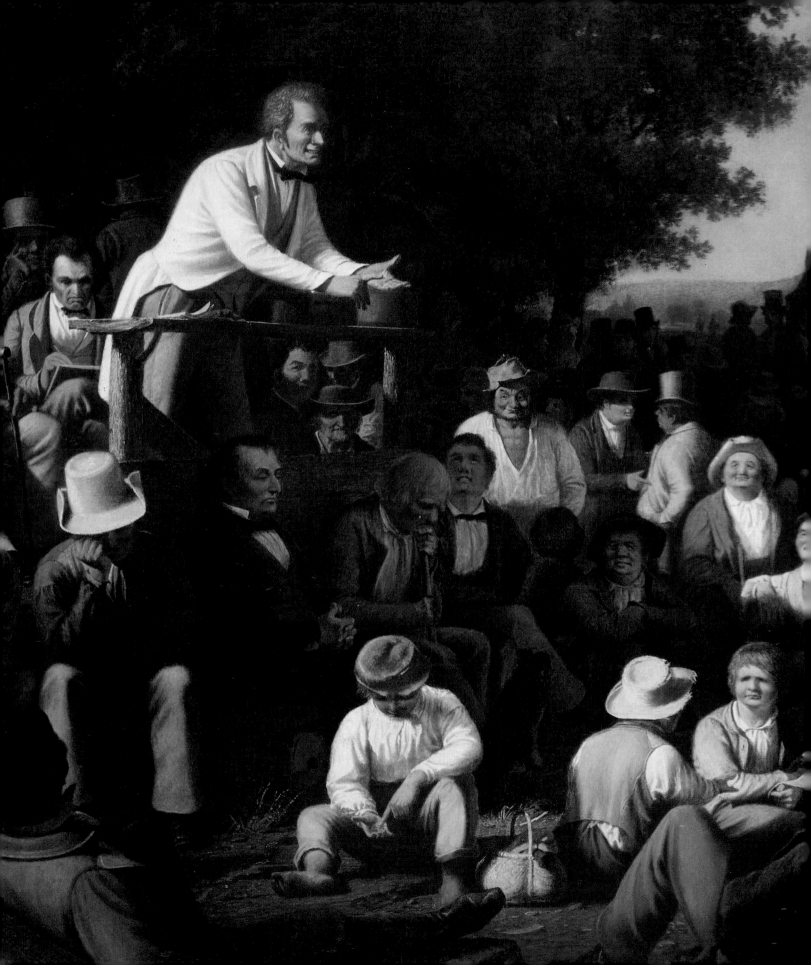

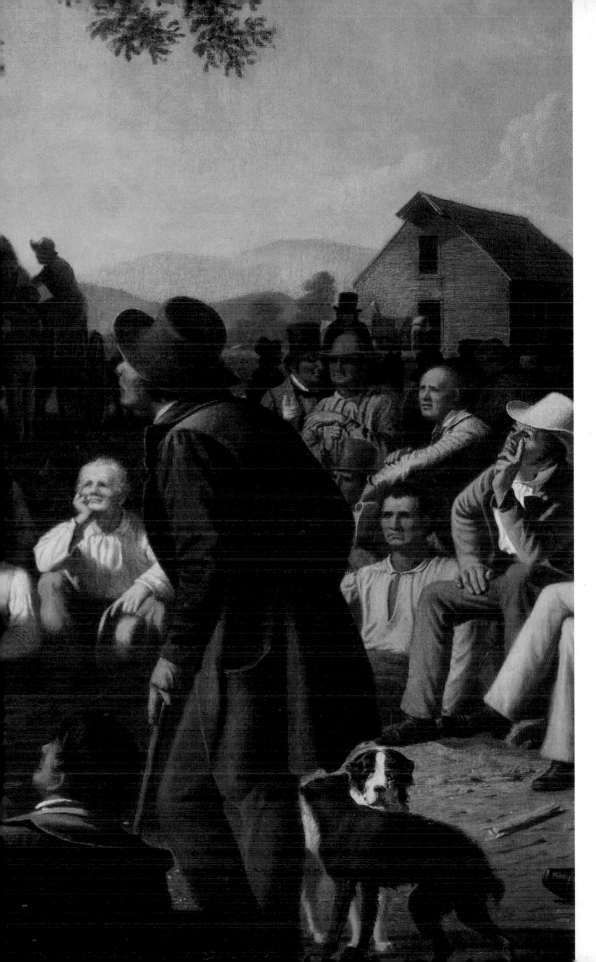

purchased or that someone thinks a voting decision may be equated with the chance toss of a coin.[31] Neither the battered man to the right nor the unconscious drunk being lugged to the polling place provide admirable models of democracy in action. Echoing a voter's indecisiveness, a mangy dog peers uncertainly at the crowd on the steps. Throughout, Bingham's expansive but quite unobtrusively plotted design gives the figures ample space to enact their vignetted dramas and provides the viewer with excellent opportunities for reading them. The banner propped on the porch steps, bearing a Jacksonian-flavored motto, adds one more unsettling touch. "The Will of the People the Supreme Law," it clearly reads, setting up a discontinuity between stated ideal and the opportunistic, sometimes crude bunch Bingham equally carefully portrays. Is voting a genuine assessment of people's will? Are we to suppose the term "people" implies rabble to some degree? Is the solemn purpose of voting jeopardized by these bumptious festivities?

No single feature of Bingham's painting was unknown to American elections actual or pictorialized. Far from it. As many artists illustrated documentable chicanery or even violence at the polls as those who represented an equally true and serious ideal of democracy. What proves intriguing about *The County Election* is that it does not seem to convey one or the other point of view very securely. The subject gave Bingham a chance to show Missourians advantageously, exercising their sovereignty and displaying their good citizenship, yet one does not come away from the painting assured that Bingham totally grasped the opportunity. An irreconcilability between Bingham as Whig and Bingham as historian, at which *Stump Speaking* only hints and the multiple sources of *Country Politician* foreshadow, is signalled by the equivocal aspect of *The County Election*. The artist, like any partisan frequently dejected by his party's losses, perhaps felt ambivalent about celebrating the electoral process when his own candidates so often did not win. Ironically the painting's unresolved ambiguities, even though not always consciously noticed by viewers, are responsible for much of the high-pitched and tense animation that, in turn, makes the work enthralling.

Bingham's ambivalence of tone can also be related to a disabling stereotype within which Whigs were unjustifiably trapped, contributing to their perennial status as a minority in Missouri. While there are a number of possible explanations for their failures at the election box, one that is frequently offered has to do with the perception of Whigs as elitist. Because proportionately more professional and business men belonged to the Whig party than the Democratic and because Whigs tended to be apathetic (or worse) about soliciting the votes of the masses, the adjective "aristocratic"

stuck to Whigs, nationally as well as in Missouri.[32] As a matter of policy, the Whig party never opposed universal white male suffrage—and contrary to Jacksonian myth, most states, including Missouri, enfranchised all propertied white men. Yet Whigs often reinforced rather than dispelled a supercilious class image by rhetoric that sounded anti-democratic when they meant to be anti-Democratic. When, for example, the response of Missouri Whigs to a Democratic victory went so far as to call the results "the despotism not of a single tyrant but of a thousand," Whig historian J. V. Mering observes, it becomes easy to understand why "Missouri Whigs were simply not convincing in their professions of devotion to the common man."[33] It did not help matters that Missouri Whigs held their first "log-cabin raising," a campaign technique designed to ingratiate them with non-urban or poorer classes, on the lawn of a mansion and attended the ceremony in formal attire.[34] Bingham's drawings exhibit a capacious and absorbing interest in the ordinary man which we may presume reflects his own sensibility, but he was as a Whig *and* an historian caught, like his party, between recognizing the virtues of popular sovereignty and, in the main, feeling alienated from the mass electorate because of the choices they made.

*The Verdict of the People* (Plates 18, 19), Bingham's next political subject and one which he told Rollins would "cap the Clymax [*sic*]" of his series, reverses with subtle changes the general design that helped vivify *The County Election.*[35] Many of the same characters appear in both works, and the location of *Verdict,* amid buildings and trees similar but not identical to the earlier painting, might be intended to suggest another neighborhood in the same town. *The Verdict of the People* also shares *The County Election*'s diversity of expression, as the results of voting call forth a mixture of jubilation, disgruntlement, and debate from the throng. There resemblances cease. The mood of *Verdict* is more hectic, its style is bolder, and certain episodes and references are more problematic.

A sharper and more abrupt contrast in light and shadow than one usually finds in Bingham's genre increases the slightly manic air of the painting's widely grinning revelers. Indeed, in comparison to Bingham's usual style, exaggeration and profuseness abound, from the nearly caricaturish facial features of some of the participants (especially those in the group clustered around the steps) to the grotesque shadow cast by the head of a man leaning toward a small boy on the porch ledge, a shadow which mimics the trailing shape of the flag in the distance. Hats of every variety catch the light on brim or crown or upturned interior. The angle of their placement helps move the viewer's eye around the composition, as do other repetitions: the small circular wheel of the wheelbarrow on the left and the larger hoop held by the boy on the right; the white cloth spilling over

the wheelbarrow edge and the red scarf flung aloft; the raised arm of the dancer (a former and future Jolly Flatboatman) and that of the fellow cheering. A stack of hats on a man riding a white horse—perhaps the spoils of the old wager, "I'll bet my hat"—lead the viewer to a group of women who look down on the multitude from a safely secluded balcony. Like the little boys, dogs, and black man, they act as counterpoints to the broadly emotional displays of white males.[36]

Slightly to the left of the canvas's middle sits a man with grimly furrowed visage, adding numbers. Their sum obviously does not please him. Enclosed by a semi-circle of absorbed figures whose hats all tilt toward his calculations, he is located directly in front of and under a tally slip being handed from one man to another on which two columns of figures are totaled: 1406 and 1410. While a four-vote margin may have been the result of an election Bingham particularly cared about and that today is historically obscure, the detail may also manifest—given the provocative way he draws our attention to the legible numbers—the artist's equivocal feeling about "the people" and their "verdicts." What *is* the people's judgment when a vote is so close? (Bingham's own narrow loss in 1846 comes to mind.) Across the street a banner fluttering from the women's perch reads "Freedom for Virtue. Remember the Ladies." Who are "the people" when fully one-half of the nation is excluded from the franchise?[37] Although Bingham made gleeful allusion to one particular election when he first began to plan the canvas, it was a time when his letters to Rollins were also full of anxiety over the vote on the Kansas-Nebraska Act and what its passage would mean to Missouri and to the nation, as well as to the Whigs. The provision of the Act perhaps most consequential to Missouri that Bingham found worrisome was introduced by Senator Stephen Douglas in December 1853 and made into law in May of 1854. Just as Bingham was beginning this painting, the act put the question of slavery in each territory to "popular sovereignty."

Why Bingham worried about Missouri in regard to the Kansas-Nebraska Act is not difficult to understand. Over and over, beginning with the Missouri Compromise of 1820, Congress had attempted to quiet the furor over slavery (to quell it seemed out of the question) by "equalizing" the number of slave and free states, and slave and free territories. A second compromise in 1850 permitted California to enter the Union as a free state. At the same time Utah and New Mexico were to be organized as territories without a decision as to their status. Then the Kansas-Nebraska Act put the question of slavery in those two territories to popular vote. And to Kansas, Missouri's neighbor, flocked abolitionists from New England and slavery proponents from the South, all determined to sway the forthcoming election. In addition, slaveholding Missourians tried to form

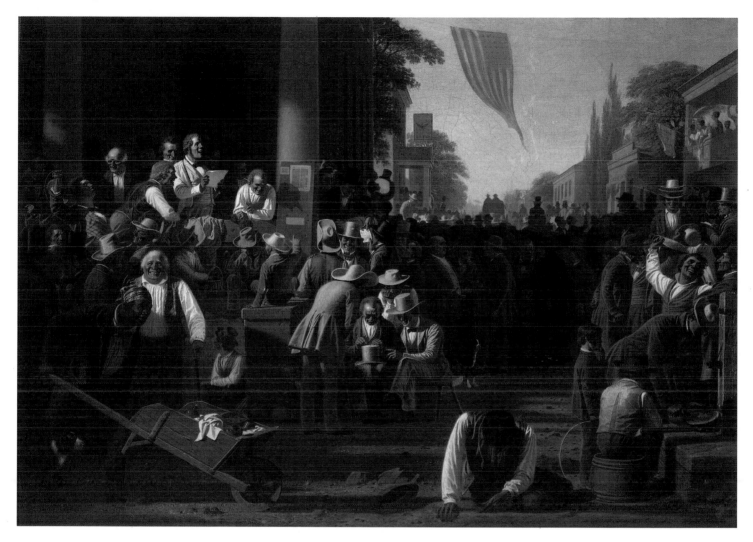

*Plate 18* The Verdict of the People. *1854–55. Oil on canvas, 116.84 × 165.10 cm. (46 × 65 in.).*
*Boatmen's Bancshares, Inc., St. Louis, Missouri*

settlements in Kansas. Sporadic violence between the factions eventually led to a raid on Lawrence, Kansas, by "Border Ruffians" [Missourians], John Brown's response at Pottawatomie in 1856, and the attack in Osawatomie by Missourians bent on revenge; the two massacres at Lawrence and Osawatomie were not the end, but the start, of bloodshed in Kansas and Missouri that continued throughout the Civil War and afterwards. About the "verdict" of balloting in Kansas, fears were justified. In the voting of November 1854, 3,300 Missourians crossed the border to vote with 3,000 Kansans, the former succeeding in sending a pro-slavery candidate to Congress.[38]

The slavery question and the issue pertaining to it raised by the Act would drive Thomas Hart Benton from the Democrats and help break up the Whigs. Like Benton, Bingham was opposed to the Kansas-Nebraska Act: "I fear," he wrote Rollins, "you are all at least half committed in favor of [the] Nebraska bill. Old Bullion turns out to be the only man of *full stature* in our entire Congressional delegation, and if I resided in his district I would take great pleasure in voting for him in opposition to any Whig who sacrifices right to expediency." In addition to pondering national affairs while he worked on *The Verdict of the People,* Bingham commented on a private, local orientation to the painting that had to do with his sympathy for Benton. "I have already [April 16, 1854] commenced *thinking* for another composition, which I will entitle *The Verdict of the People. I* intend it to be a representation of the scene that takes place at the close of an exciting political contest . . . I might very properly introduce into it some of those comically long faces which were seen about Fayette when our friend Claib was so genteelly whipped last summer," he wrote.[39] "Our friend Claib" is Bingham's sarcastic reference to Claiborne Fox Jackson, his earlier and constant Democratic foe in the central Missouri region, whose Resolutions Benton had attempted to neutralize. The special election in the summer of 1853 to which Bingham cheerfully referred saw the defeat of the pro-slavery Jackson by James J. Lindley, a Whig who won with the support of anti-slavery, pro-Benton Democrats.

A shrewd historian and a skilled painter, Bingham made sure that all of his election canvases could be regarded, at least initially, as exemplars of the American system—persuasive monuments to democracy intended to boast the ideals of the nation. He could also be preoccupied with an issue of overwhelming local as well as national concern, like the question of slavery in Kansas, in *The Verdict of the People,* and simultaneously connect the painting privately to an election involving a personal foe in Missouri who was "whipped" on matters bearing directly on that issue. Or he could derogate with subtlety what to his eyes were the Jacksonian party's assumptions and usurpations, as

he did in *The County Election*. Bingham operated successfully on more than one level because his personal political convictions imbued the "historical" election paintings with the tensions and strengths of his keenest partisan interests. The political series is enriched because Bingham the politician and Bingham the historian were mutually engaged; their episodes of ambivalence and irony bring ritual to life, at the same time disclosing the manner in which his co-careers mutually, if antagonistically, informed the content.

We may test the unique results of Bingham's paintings when politician and historian met by comparing them to his paintings of historical subjects that were unconcerned with political activities. Here nineteenth-century concepts of historiography on a national level again come into play and remind us of Bingham's vow. Early American heroes and their deeds, from which scholars like Bancroft and Prescott were crafting the outline of a past specific to this country, appealed to Bingham as material for a more formal "art-record."[40] Legend has it that he painted "Old Danl Boone in a buckskin dress" for a tavern sign when he was a young boy. In 1844, among images Bingham planned to include on political banners as "emblimatical [*sic*] . . . of the early state of the west," he mentioned "Daniel Boone . . . in one of his death struggles with an Indian . . ."[41] When he did paint Boone in a formal composition — *The Emigration of Daniel Boone* (see Plate 32) — it was among the first of his attempts to commemorate early American history. Through a rugged gap framed by artfully blasted trees in the Appalachian mountains, a band of settlers marches toward the viewer. The stalwart and dignified Boone, rifle over his shoulder, leads the white horse upon which his wife, Rebecca, rides sidesaddle, a dull brown shawl wrapped, Madonna-like, about her head and upper body. She is the apex of a triangle which slopes down toward a hunter on the right, his rifle cradled in his arms, and a man on the left who has rather peculiarly stopped at the climactic moment to adjust his shoe. A dog, his nose and tail extended, looks off into what must be the unexplored woods. Behind the rifle carriers, who stand for hunters and trappers, come the ax-wielders, representing settlers, and cattle, to stock the farms that are planned. Men and animals are linked one to another by Rebecca Boone and her daughter, symbols of domesticity. The roster of civilization is thus complete. Even the flawed characters of the country's diverse citizenry (the squatters, perhaps?) are present, indicated by the man rather fiercely beating an animal with his

Overleaf: *Plate 19 detail of* The Verdict of the People, *1854–55. (See Plate 18.)*

---

83

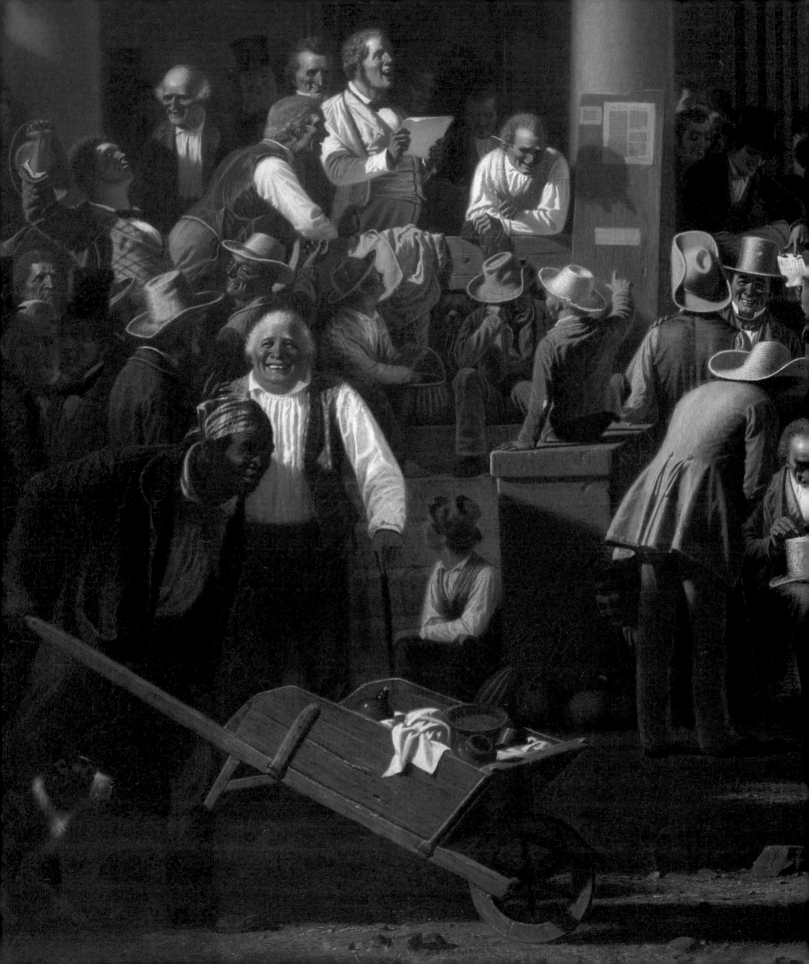

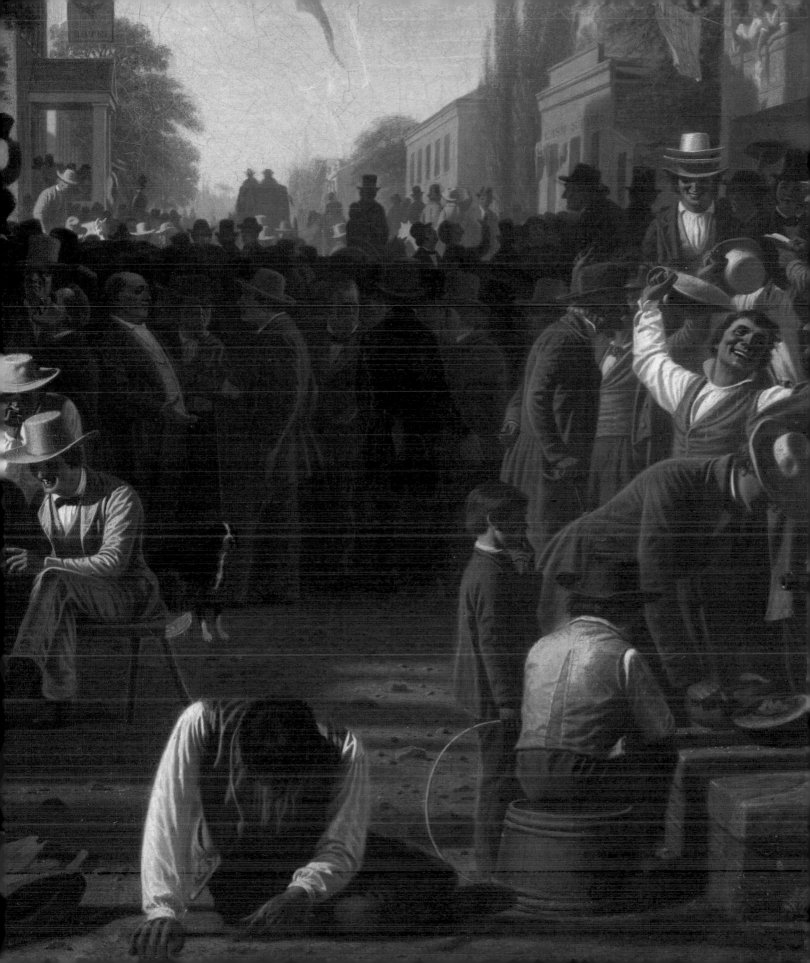

whip. As Dawn Glanz pointed out in her thorough and insightful analysis of this painting, "When the artist placed the observer in the unsettled Kentucky forests to watch the advancement of civilization from the East, he implied that national history was to be viewed from the vantage point of Western territories. Perhaps no other visual device could have more emphatically identified the American national destiny with the West."[42] The dualism of the political series has little if any bearing upon this painting, but the opposition posed between savagery and civilization in pendants like *Captured by the Indians* and *Belated Wayfarers* is germane. What the viewpoint chosen by Bingham also suggests is the essentially ineluctable quality of the white man's advance. Coupled with the splayed pyramidal design that presents a wall of figures and fills the gap, our point of view (which is the same as that of the inhabitants of the woods) fosters a sense of inescapability.

Bingham's thrilling and loyally regional conception is not enhanced by the figures themselves, whose solemn awareness of the momentousness of the occasion overburdens their already portentous roles. Certainly historical subjects no less than genre require credible, if momentarily transcendent, characters whom the viewer can identify as human beings, however extraordinary the deed being represented. Bingham uncharacteristically did not provide Boone and his entourage with a comfortable space in which to exist or with a convincing ability to engage in motion; it is as if the figures' symbolic qualities precluded their having physical or intellectual dimension. And if one compares the gleaming eyes and incipiently lively mouths, for instance, among the silent crowd in *Stump Speaking* with the clenched jaws and piercing stares of the quiet pioneer band, the latter's wooden and mechanical expression is obvious.

Rigidity of figures and action likewise affect the credibility of *Washington Crossing the Delaware* (Fig. 13). In this painting, the participants' wholly unbelievable expressions stifle the dramatic moment, just as the design, lacking both inspiration and a successful depiction of movement, brings the flatboat to a halt. A deadly resemblance to his paintings of Missouri boatmen lurks in Bingham's visualization of this pivotal episode from the Revolutionary War. The painting's deficiencies are all the more unfortunate because *Washington Crossing the Delaware* was Bingham's most deliberate bid for national fame as a history painter.[43]

The unusually long time between Bingham's first efforts on *Washington Crossing the Delaware* and its completion cannot entirely be explained. Initially, Bingham may have been delayed by his departure in 1856 for Düsseldorf, a center of art well known for painters with an interest in

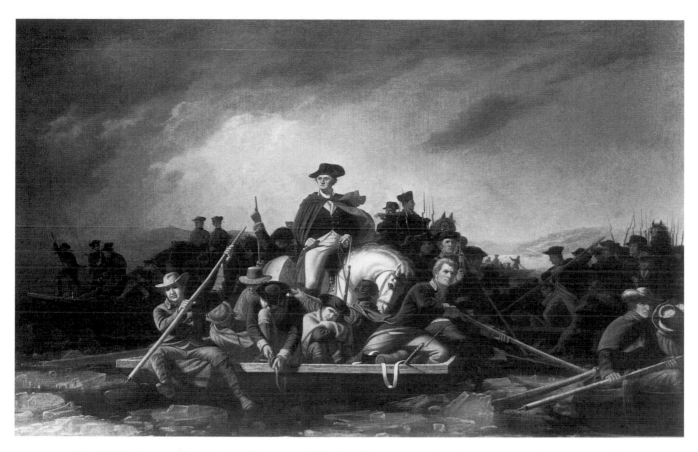

*Fig. 13* Washington Crossing the Delaware. *1856–71. Oil on canvas, 92.07 × 145.41 cm. (36¼ × 57¼ in.).*
*The Chrysler Museum, Norfolk, Virginia Gift of Walter P. Chrysler, Jr.,*
*in honor of Walter P. Chrysler, Sr.*

tendentious art (and also for genre of sometimes numbing banality). The Civil War broke out a few years after his return in 1858, apparently forcing Bingham to curtail his painting somewhat, and the hiatus may have contributed to the crippling of his technique. Coincidentally, in the years directly before the War he had ceased to be a Whig or, to be more precise, the Whigs ceased to exist, leaving Bingham without a party.[44] He became more or less non-partisan, supporting candidates with moderate anti-slavery platforms, while his political energies focused on the devastations in Missouri prior to and during the War. Thus, the remainder of his extant canvases with historical topics focus upon recondite incidents taking place in his home state during the Civil War. Principle, not party, engaged him in *Order No. 11* (1865–68 and 1869–70) and *Major Dean in Jail* (Fig. 14), two

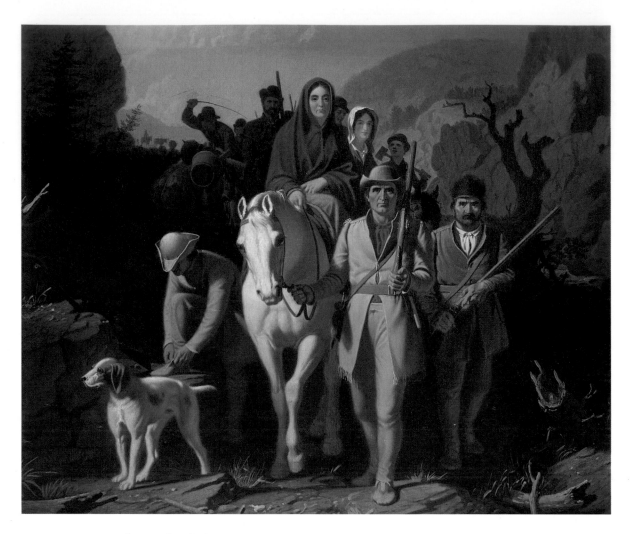

*Plate 20 detail of* The Emigration of Daniel Boone, *1851–52. (See Plate 32.)*

incidents from Missouri's tragic years under martial law; both were painted by Bingham after a lengthy pause in his social and political "record-keeping."

*Major Dean in Jail,* as Bloch has noted, may be called historical genre due to the simplicity and near informality of the seated figure in his cell.[45] The work is inscribed on the reverse in pencil: "Rev. Mr. Dean—Baptist Minister imprisoned at Independence, Missouri, during the war for not taking the oath [of loyalty to the Union] before preaching the gospel. Painted by G. C. Bingham." The *Missouri Statesman* of July 6, 1866, identified the protagonist as "one of the first men in Missouri to take up arms in defense of the old flag," and this illustration of "an ignoble period of our

State's history," the reporter declared, would be a memento of the "reign of Radicalism," i.e., Missouri's government during the Civil War. Atypically, Bingham used a small (14½″ × 14¼″) format and painted in oil over a photograph on paper. Technically there is nothing else like it among Bingham's works. However, the incident provoking Dean's incarceration arose from a galling consequence of the Civil War in Missouri that had already kindled Bingham's anger.

Fanatics on both sides of the border war instigated by the crisis in Kansas in 1854 never slackened in violence, causing Missouri to be internally torn by the time the Civil War started. Martial law was imposed on the state, and loyalty oaths were required of its citizens, measures designed purportedly to curb pro-Southern zealots and guarantee the safety of Union soldiers. Bingham found the federal government's doubts about Missouri's fidelity abhorrent and martial law repugnant. He grew enraged when civilian outriders of the Union soldiers were permitted to engage in what he called "licensed robbery."[46] Adding insult to injury, Major General Thomas Ewing issued General Order No. 11 in 1863, forcing the evacuation of almost the entire population of four Missouri counties and the burning of the area's crops. Sadly, the scene depicted by Bingham testifies less to the havoc wreaked on Missouri citizens and more to the continued absence of the artist's wonted skill. One feels especially sharply the loss of his talent for engaging homely characters in deeds of national import without losing the humanity of one or the significance of the other.

I have argued elsewhere that *Order No. 11* (see Plate 7) actually culminates Bingham's political topics; his keen response to the issues of the day and his own experiences as a Whig increasingly led a tendency for specificity in his documentation which this painting epitomizes.[47] The Civil War and its effects in Missouri and on Bingham altered the tolerant, mocking tone one could find in *Stump Speaking,* and sheer anger seems to have spurred this attempt at the profundities of history painting. History painting usually benefits from interior tensions in style or content and possesses some kind of emotional charge, but Bingham's furious denunciation lessens both. The depth of his feelings paradoxically makes the dispossession of the civilians and the pillaging and burning of their goods mere melodrama. Extravagantly pitiful victims confront mercilessly evil soldiers. Static rather than dynamic, contrived rather than composed, the painting sinks under the weight of Bingham's own intensity of feeling.

Divided zeal, not an absence of fervor, brought Bingham's political series to life. His election series is thus at once capable of advertising the virtues of the American system, referring to regional (Missouri) politics, and indicating a Whig as opposed to a Democratic position *vis à vis* those

*Fig. 14* Major Dean in Jail. *1866. Oil over photograph on paper, 113.03 × 112.9 cm.*
*(14¹/₂ × 14¹/₄ in.). William Jewell College, Liberty, Missouri*

politics. Withal, they stand as visually satisfying pictures. It cannot and should not be thought that Bingham's canvases were ever partisan at the expense of the pride he took and the faith he had in democracy; his political subjects have been seen as paragons of Americana because those elements are so readily apparent. But neither should one ignore the barbed asides and interjections of a devoted, professional Whig, for his modulated tone of partisanship added an undercurrent of tension to seemingly innocuous events. The nineteenth-century concept of the historian's task, to insure the future of the United States by assembling the records of its past and trumpeting the progress which had brought American civilization to its present state of refinement, produced an important representative in Bingham. Memorializing on canvas Missouri's recent frontier conditions, delineating a heritage in which singular individuals like Daniel and Rebecca Boone and ordinary people like trappers and boatmen quite literally emerged from the wilderness to prepare the way for civilization, Bingham pictured a Missouri in which the dangers of the "wild West" had disappeared and to which progress had brought the responsibilities of sovereignty, the comforts of prosperity, and, on occasion, the excesses of war. Few visions of Americans have become so completely the incarnation of our history as Bingham's. None approach the zestful vitality, originating in the confrontation of the politician's partisanship with the historian's putative neutrality, that Bingham achieved in his representations of the West claiming its place in a new civilization.

*Plate 21* Cottage Scenery. *1845. Oil on canvas, 73.66 × 91.44 cm. (29 × 36 in.). The Corcoran Gallery of Art, Washington, D.C. Museum Purchase, Gallery Fund and Gifts of Charles C. Glover, Jr., Orme Wilson and Mr. and Mrs. Lansdell K. Christie, 1961*

# THE "MISSOURI ARTIST" AS ARTIST

## By Elizabeth Johns

Hardly had George Caleb Bingham returned to Missouri in 1844 from his second trip to the East Coast than the Missouri press elevated him from "portrait painter" to "the Missouri artist." Newspapermen from St. Louis to Columbia to Boonville, aware that no earlier artist in their state had been more than an itinerant portraitist, were quick to take pride in Bingham's new accomplishments. With an enlarged vision of what the artist might hope to do in America, Bingham had begun to extend his subjects beyond portraits to figural scenes and landscapes. His trips east to broaden his artistic experience, and even more, his new work in a variety of subjects, delighted his Missouri audiences. They boasted of him as a "native son," praised his application of his talent to Missouri or "Western" scenes, and eagerly reprinted words of recognition he received in New York.

On their side, New Yorkers presided over their city's exhibitions self-consciously, even ostentatiously. In print and in patronage, they judged the quality of works artists sent from across the young nation as worthy (or not) of the nation's cultural ambitions. Taking for granted that their city was the cultural heart of the nation, they had only vague notions of what "the West," to say nothing of "Missouri," was like. They seemed to be at once slightly incredulous that such a talented painter as Bingham had come from the West, and charmed by the pictures of Western characters this "Missouri artist" sent them.[48]

Today we remember Bingham primarily for these pictures of Western types—boatmen, traders, politicians, and voters. The consequence, however, is that the portraits that early and late were Bingham's bread and butter, his scenes of characters in the wilderness, the history paintings of his later years, and his landscapes have had little place in recent measures of his work. In an attempt

to follow Bingham's career as he shaped it, this essay explores some of these other aspects of his artistic production. Although the essay excludes portraiture, the reader needs to remember that throughout his career Bingham, like the majority of American artists of the time, assured himself income by painting portraits. Bingham's pursuit of landscape, certain genre scenes, and history, however, sheds valuable light on his ambitions as an artist, his audiences' expectations of art, and several key cultural issues before the Civil War.

Most modern Bingham admirers learn with surprise that he created a large body of landscapes. Also intriguing is that many of these landscapes from the brush of a Westerner do not *look* "Western"—as Bierstadt's scenes, for example, look Western. Bingham painted these works for two distinct audiences, and therein lie their rich implications.

Bingham painted almost all his landscapes during the decade from about 1840 until 1850, when he was vigorously adding new fields to his province as an artist. By 1838 and 1839, during his first extended artistic study in Philadelphia and New York, East Coast painters and critics had begun to exalt landscape painting as one of the most important artistic forms an American could paint.[49] Thomas Cole's brilliant depictions of Catskill mountain scenery had caused a sensation in 1825. Almost overnight, Cole became *the* painter to emulate. Enthusiastic New York patrons gave him more orders than he could fill, and he attracted such followers as Asher B. Durand, who would assume leadership of the landscape movement only a few years later. Critics, too, were caught up in the frenzy. In the new nationalistic journals that gave special attention to art exhibitions, they surveyed, analyzed, and evaluated the latest landscapes, often giving short shrift to artists who painted anything else.

Although across the Atlantic painters were also turning to the landscape, European artists tended to see nature as a pleasant relief from the city, and they celebrated peasants as models of simplicity. In America, landscape painting had quite different meanings. Here, painters and audiences alike saw in the landscape all the implications of the United States as a nation: its distinctiveness as a "new" land that had never known the decline of civilization (audiences did not think of Indians as having had a civilization), the country's (and thus the landscape's) potential for economic and political development, and the continent's special beauty. Moreover, American theorists saw landscape painting as a vehicle for the moral and aesthetic instruction of busy citizens—merchants, bankers, and lawyers, for example—who were entirely too occupied with material concerns. These cultural prescribers believed landscape taught morality, because nature

reminded the viewer of God. The landscape taught an aesthetic point of view, because the capacity to enjoy a scene had to be learned. By straining simply to appreciate a landscape painting, the theory went, the raw citizen would be civilized.[50]

As far as many East Coast critics and audiences during these years were concerned, genre painting (scenes of everyday life and characters) had a different status. As early as 1830 William Sidney Mount had won applause for his genre scenes of rural characters—applause from city audiences who liked the feeling of superiority to their rustic cousins that these images encouraged. Then in the early 1840s, public attention shifted to the political power of newly opening points West (especially Texas) and to the social characteristics of citizens who lived there. Eastern audiences, already steeped in a wide range of stories about "violent" Westerners, developed an appetite for visual images of Western types which a few artists began to meet. However, critics were dubious that genre painting was sufficiently serious as "art," especially painting that focused on socially questionable types. On the one hand, they saw genre scenes as "democratic" in spirit, appealing to a large audience and potentially highly entertaining. (Presumably, the citizen-subjects of an entertaining genre painting would not realize others were laughing at them.) On the other hand, they did not believe popular appeal and amusement were the hallmarks of the highest in art. Although Americans at large boasted about the nation's political and social equality, when they urged a distinctively American art most of them wanted painting that was "ideal" or "elevated." As the artist and historian William Dunlap declared somewhat anxiously in 1836, American art should demonstrate the superiority of the "Democratic experiment."[51] Artists and critics, including Dunlap himself, seem to have agreed that landscape painting best fulfilled this mission.

What more persuasive presentation, then, could Bingham have made to New Yorkers of his talents as a *Western* artist than to present himself as both landscapist and genre painter? The landscapes would meet the "higher" requirements of art, the genre scenes satisfy the simpler.

In making his mark as a landscapist, however, Bingham faced something of a dilemma. If he worked in Missouri, he could not paint the spectacular scenery of New York State for which audiences looked to Cole, Durand, and other Hudson River School painters. He solved the problem by creating landscapes that fulfilled functions other than exalting New York scenery: first, they embodied aspects of the landscape tradition that had come to American artists through the English landscape school, and second, they caught up the special glories and ideals of Missourians, many of which were shared by New Yorkers.

As a New York critic instructed his readers in 1839, to paint a landscape well was not to "imitate" nature, but to follow the "great principles of the art."[52] For Americans in the 1830s and 1840s, and thus for Bingham, these were the principles of the English landscape school, derived in part from the Baroque landscapist Claude Lorrain and in part from the Italian "sublime" landscapist Salvator Rosa. These principles had been transmitted through English examples (especially in engravings), English theory, and, by the early 1820s, American engravings. There were two basic types of landscape compositions. The "pastoral" emphasized a carefully composed, even contrived scene that drew the viewer into an experience of a harmonious nature, often one that had been husbanded for centuries; it conveyed man at home in the land. The "sublime," in contrast, conveyed a nature that was wild. In a scene that might be marked by cliffs, windblown trees, and dark storm clouds, this mood showed that man was at the mercy of natural elements. Thus the "sublime" was dramatic, while the "pastoral" was peaceful. Thomas Cole and Asher B. Durand understood these principles and used them in their art; indeed, through them they interpreted regional "views" popular with their audiences. Thus, Cole saw a dangerous precipice overlooking the Hudson River as "sublime," as did those of his audience who had also hiked in the region; and Durand presented cattle resting along the edge of cultivated fields as "pastoral"—an interpretation that satisfied citizens who saw the nation as an agrarian republic.

These were the guidelines that Bingham would follow as well. A substantial part of his potential audience in Missouri knew English aesthetic principles, as St. Louis was an old center of culture with several painting collections; moreover, it had long been a major stop on print distribution routes. Perhaps even more important, Bingham's broader audience—citizens outside of St. Louis, in towns across the state—had deep attachments to the land itself. Descended primarily from English and Scotch-Irish settlers (as opposed to the French and Spanish slightly farther south), they had long since made Missouri overwhelmingly agricultural, with farms and pastures dotting the landscape in vistas that denoted careful husbandry. To Missourians, their state was not "Western" in the sense of wild, but "Western" in the sense of "independent." Images of cultivated land symbolized a citizenry of landowners, farmers, and cattle raisers who were economically and politically responsible.[53] Bingham himself had close associations with the land. He had moved with his family from farm plots in Virginia to Missouri; he, too, like many of his viewers in Missouri and in New York, had been a farm boy.

Although Bingham made his first venture into landscape soon after his first trip to the East

Coast,[54] it was in 1845, when he was back in Boonville and St. Louis after several frustrating years of portraiture in Washington, D. C., that he made a deliberate play for recognition in New York. That year he sent four canvases to the American Art-Union — two landscapes and two genre scenes, all the same size. A national and nationalistic patronage organization, the Art-Union was composed of members throughout the country who, for a small annual membership fee, received at least one engraving per year and a chance to win an original work of American art through a lottery. The Art-Union's Committee of Directors bought works all year long for this year-end event, thereby giving encouragement to artists across the nation. Bingham seems to have carefully calculated his submission. With his companion genre scenes *Fur Traders Descending the Missouri* and *The Concealed Enemy,* he interpreted Western river characters of the 1810s and 1820s. Perhaps these paintings would have corrected his Eastern audience's notions about the "wildness" many attributed to the contemporary West. In *Fur Traders Descending the Missouri,* the French trader and his "half-breed" son float quietly down a Western river. Having placed their cargo of furs neatly in the middle of the dugout, they enjoy the early-morning atmosphere of idyllic calm. The other painting, *The Concealed Enemy,* identifies the true source of Western savagery: an armed Indian waits on the riverbank, as had many concealed enemies in the first days of fur trapping early in the century. Thus the pair of paintings presents a subtle history lesson, keyed to Eastern excitement about Western expansion: the Indian, member of a dying race, takes his stance late in the day; the traders, first thrust of "civilization," head downstream in the morning light. Americans were so certain this evolution had been divinely ordained that in 1845, the year Bingham painted these works, a New York editor coined the term "Manifest Destiny" to interpret the Westward movement.

The genre scenes, Bingham's assessment of the relationship between earlier social types in the changing West, were only half of his contribution to the Art-Union exhibition. With his other two paintings, *Cottage Scenery* (Plate 21) and *Landscape: Rural Scenery* (Plate 22), he made a claim for his skills in the higher arena of landscape. The pairs of paintings could hardly have been more different. The genre scenes, although idealized and presented as a history lesson, were tied to the disreputable character types Easterners spun stories about. The landscapes, on the other hand, embodied Bingham's ambitions to exalt the viewer above the everyday into the dignified realm of the aesthetic.

That Bingham shaped his skills as a landscapist by a study of prints and drawing books is dramatically revealed in *Cottage Scenery.* The painting is straight out of England, modeled on

*Fig. 15 George Morland,* Sportsmen Refreshing. *c. 1790. Published in* Connoisseur *magazine, 1906.*

landscape prints such as those by George Morland (1763–1804) that were printed in large editions and made their way to the United States. Working along the lines of such engraved scenes as Morland's *Sportsmen Refreshing* (Fig. 15), Bingham created a homestead hallowed by time. A partially thatched cottage, more likely to have been found in England or colonial Virginia than in Missouri, sits in the shade of huge old trees. The branches of the trees are gnarled; some are leafless; the one in the right foreground nearly dead. The fence, too, suggests a long tenure; posts are uneven, broken off with age. As in the Morland print, a threesome carries on a conversation. A woman leans over a Dutch-style half door, while a man, presumably her husband, rests against the fence. Both listen attentively to an old man who has seated himself to visit. The comfort of the three is echoed by the peaceful grazing of the cattle in the warm light of the distance on the right.

*Plate 22* Landscape: Rural Scenery. *1845 Oil on canvas, 73.66×91.44 cm. (29×36 in.). Private collection*

The other painting, *Landscape: Rural Scenery,* is a pendant. The flora may be American or English—willows and oaks are found in abundance along rivers in both settings. But the young woman washing her clothes at the riverbank, with the humble accessories of the handmade bench and buckets, suggests beginnings, perhaps the beginnings of a settlement in Missouri. And while a Morland scene was clearly Bingham's teacher in *Cottage Scenery,* a painting by the American landscapist Durand was his guide for the second work. The magnificent oak tree that dominates the center of Bingham's image echoes the central motif in Durand's *The Solitary Oak* (Fig. 16), one of the most popular landscapes at the National Academy exhibition the previous year when Bingham was in New York himself. The delicately narrative aspect of Bingham's two landscapes, and their sources, provide two nuances of meaning: *Cottage Scenery* conveys the English antecedents of the Missouri settler, and *Landscape: Rural Scenery* shows the settler in the vast American countryside. The first painting points to English pictorial sources, while the second honors the achievements of the new school of American landscapists.

The next year, encouraged by the positive reception he had received in New York, Bingham painted a single pastoral subject that would strike resonance in both East and West. In *Landscape with Cattle* (Plate 23), he paid explicit tribute to Durand, and in addition evoked the agrarian life of Missouri. He made a separate version of the painting for each audience, sending one to the Art-Union in New York and keeping the other in Missouri to offer for sale in St. Louis.[55] The landscape depicts a large open space on the edge of some woods, obviously near the edge of a river, with meadows stretching out to the left. Across the picture several healthy cattle rest contentedly. Using blues, browns, and greens that radiate an atmosphere of warmth and peace, Bingham painted a virtual paean to healthy Missouri farms. The St. Louis *Weekly Reveille* was delighted with the picture. On reporting in September that it was coming up for sale (it was being raffled at "Wool's picture store" for chances of five dollars each), a friendly editor offered the following endorsement: "For Raffle—*Beautiful Landscape*—a scene on the Mississippi, a landscape of exquisite beauty, painted by *Bingham,* an artist of undoubted genius belonging to our State, is up for *raffle*. . . . The painting . . . is a scene of quiet beauty, representing the majestic old woods rising on the rich bottom; the herd reclining beneath their shade; the river winding its way in the distance, and in the background a bold bluff rearing its high summit, in wild grandeur, beside the father of waters. In shade and coloring we think it unsurpassed by any effort of the best landscape painters of the present day, and whoever obtains it will possess a picture of rare character and undoubted value."[56] The

*Fig. 16 Asher B. Durand,* The Solitary Oak. *1844 Oil on canvas*
*The New-York Historical Society, New York, New York*

reporter went on to urge audiences that in the "East," the painting would bring considerably more money than the $120 Bingham would earn in St. Louis from the twenty-four chances at five dollars.

An evocation of the pastoral potential of America, *Landscape with Cattle* is a counterpart to *The Jolly Flatboatmen* of the same year. In *The Jolly Flatboatmen,* the rivermen enjoy a natural Eden; *Landscape with Cattle* projects a domesticated, farmer's Eden. In genre as well as in landscape, Bingham's Western world was receptive and peaceful.

By 1847 the artist had received exciting acclaim in New York as *the* painter of the West. New Yorkers celebrated him not for his landscapes, however, but for his genre scenes. So popular was his

*Plate 23* Landscape with Cattle. *1846. Oil on canvas, 96.5 × 121 (38 × 48 in.).*
*The Saint Louis Art Museum, St. Louis, Missouri Gift of Mrs. Chester Harding Krum*

painting, *The Jolly Flatboatmen,* for example, which he exhibited in 1847, that the American Art-Union engraved it for distribution to thousands of members. Thereafter, Bingham seemed to recognize that as far as New Yorkers were concerned his artistic character was fixed. In championing his genre scenes, the Art-Union was the single largest influence on his career. From 1847 until 1852, when the Art-Union ceased its operations, Bingham sent the New York organization twelve genre scenes and only one landscape.

Thus after 1847, he sought an audience for pastoral landscapes in Missouri and other areas of the settled West. It was for these fellow Westerners that over the next several years he painted many "cattle-pieces." He exhibited some of the paintings in Missouri and sent others to the Western Art Union in Cincinnati, where Ohio critics, too, were enthusiastic about his agrarian vision.[57] In 1849, for instance, the *Western Art Union Record* wrote about Bingham's *Landscape with Cattle*: "This large picture has attracted much attention from visitors to the Gallery. It is an autumnal scene: a fine group of cattle in the foreground: — to the left, trees, among which cattle are ranging, are scattered over an extensive plain, which is bounded by a sheet of water; beyond this rise the distant hills."[58] His home audiences were uniformly warm and supportive. Characteristic was the comment of the *Missouri Republican* on October 11, 1850, that one of his pastoral landscapes was "A small gem, an agricultural scene, taken from nature."[59]

Although agricultural scenes predominate his landscape work, Bingham did not stay exclusively with this pastoral mode. In the early 1850s, perhaps in admiration of the achievements of Thomas Cole, whose death in 1848 was still being mourned as a national loss, Bingham painted two "sublime" scenes, *The Storm* (Plate 24) and *Deer in Stormy Landscape* (Plate 25). Cole himself had found the sublime mode especially congenial in the early years of his career, and it continued to be identified with him. To be able to paint sublime scenes as well as pastoral ones was no small feather in an ambitious artist's cap, and it may have been that Bingham undertook his own sublime landscapes to round out his achievement. In contrast to the welcoming, fruitful land of his cattle scenes, Bingham's "sublime" works show an ominous nature subject to decay and distress. In *The Storm,* the viewer looks across a torrent of water at a dark, violently agitated forest and sky illuminated by sharp touches of light. Bingham placed a blasted tree in the right foreground, its diagonal heightened by bright light, and a deer on the left, who runs in fright at the fierceness of the storm. Cole had employed these picture-making devices regularly, as early as in his *Lake with Dead Trees* (Fig. 17). Almost as though such elements represented the very definition of a sublime

*Fig. 17 Thomas Cole,* Lake with Dead Trees. *1825. Oil on canvas, 68.6 × 86.4 cm. (27 × 34 in.).*
*Allen Memorial Art Museum, Oberlin College, Oberlin, Ohio Gift of Charles F. Olney*

painting, Bingham employed them again in his *Deer in Stormy Landscape,* a companion to *The Storm* that shows the clearing of the atmosphere just after a storm. This, too—the depiction of a passing storm—was a favorite technique with Cole. Bingham organized the space in both these landscapes quite differently from the open, flat sweep of his cattle scenes. The storms take place in a vista that is centered by a virtual funnel, through which the viewer glimpses a distant, heroic mountain.

We do not know if Bingham painted this pair only for his own satisfaction or if he exhibited and perhaps even sold them. In mode, they recall the landscape from his early genre scene *The*

*Concealed Enemy*; in tone, they stand separate from almost the totality of his work. Soon after finishing them, he abandoned landscape painting almost completely.

When he turned to Cole again for inspiration, with *Landscape with Waterwheel and Boy Fishing* (Plate 26), he resumed the pastoral mode. This work radiates the gentle peacefulness of Cole's *The Old Mill at Sunset* (Fig. 18), which had been exhibited at the Academy during Bingham's long tenure on the East Coast. Bingham flooded his painting with warm light. In the freshness of a summer morning, near a well-built mill and mill house that suggest the sturdy principles of country life, he depicted a young boy hanging his fishing line over the dam. He may well have conceived the picture as continuing the sequence he had painted in the mid-1840s, of country scenes in which settlers gradually make the land their own. Or perhaps he undertook the painting in an auto-biographical and memorial mood. When Bingham began the painting, the Whig politician Henry Clay, revered across the country for his peacemaking role in the Compromise of 1850, had recently died. Clay's life had touched Bingham's in several ways. In 1844, when the artist first became politically active as a Whig, Clay had been the party's presidential candidate. Bingham had painted a canvas banner supporting Clay's candidacy and had chosen to depict Clay as the "mill boy," a childhood identity that he himself, during his youngest years in Virginia, shared with Clay. Thus, *Landscape with Waterwheel* was perhaps a fond autobiographical recollection, one of the many tributes paid across the nation to the old politician.

Over the rest of Bingham's career, he painted only a few more landscapes. In each instance, he was trying his hand at a type of subject that other artists had made popular. With his *View of a Lake in the Mountains* (1853), Bingham picked up a motif and organization popular in works by Cole and other Hudson River landscapists; and in *Moonlight Scene: Castle on the Rhine* (1856–59), painted in Düsseldorf, Bingham undertook a style and motif popular among his European contemporaries. Later, like Bierstadt and Moran, he was to paint a few far western landscapes such as *View of Pikes Peak* (1872), and *Colorado Mountain Landscape* (1872). Up to date as they were in their subjects and approaches, these landscapes had little of the technical accomplishment and artistic commitment of Bingham's agrarian scenes of the late 1840s. Those were where his heart was as a landscapist.

Although Bingham's agrarian landscapes virtually defined what many fellow Westerners thought of as their proper environment, Easterners had quite different associations with the West. From earliest Colonial times they had thought of the West as a wilderness. Whether it was mountainous or dominated by prairies, they referred to the land stretched toward the Pacific as

*Plate 24* The Storm. *c. 1852–53. Oil on canvas, 63.81 × 76.35 cm. (25¹⁄₈ × 30¹⁄₁₆ in.).*
*Wadsworth Atheneum, Hartford, Connecticut Gift of Henry E. Schnakenberg*

*Plate 25* Deer in Stormy Landscape. *c. 1852–53. Oil on canvas, 63.5 × 76.20 cm. (25 × 30 in.).*
*The Anschutz Collection, Denver, Colorado*

*Fig. 18 Thomas Cole,* The Old Mill at Sunset. *1844.*
*Oil on canvas, 66.36 × 91.44 cm. (26⅛ × 36 in.). Jo Ann and Julian Ganz, Jr.*

untraveled and "trackless." Citizens poised on the Eastern rim of the continent saw this territory as presenting a dilemma: it was a land of perils, not the least of which were Indians, but it was also a land of promise and unlimited opportunities—opportunities in land, mineral riches, and, best of all for many, personal regeneration. The West, Easterners fantasized, was a place where men could start fresh, and where they could build communities that would lack the social stratification of crowded cities. In what became the most famous statement of these hopes, William Gilpin proclaimed in 1846 that "The *untransacted destiny* of the American people is to subdue the continent—to rush over this fast field to the Pacific Ocean—to animate the many hundred millions of its people, and to cheer them upward—to establish a new order in human affairs—to set free the

enslaved—to change darkness into light." Two centuries of dreams about the West produced Gilpin's grand scheme for a national drama and a host of other notions that were not necessarily true or even implementable. These notions formed much of the intellectual background that audiences of the 1840s and 1850s brought to pictures of Western life.[60]

Although the Eastern imagination pictured Western space as a paradise, when they told tales of actual men who had explored and lived there, their stories took on an entirely different tone. From early in the century, anecdotes and travelers' reports focused on savage Indians and completely disreputable Western Anglo-Saxon characters. Whether the Anglo-Saxon characters were fur traders, hunters, or backwoodsmen, storytellers tarred them as dirty, antisocial, and irresponsible. Accounts of the boatman Mike Fink, for example, who had started his life as a trapper, presented him as violent and lawless. Tales of backwoodsmen of Alabama and Arkansas in the 1830s lampooned them as uneducated, lazy, and raucous.[61]

Granted that life on the frontier could hardly have had the amenities of life in Boston, much of Easterners' exaggerated denigration of Westerners was in fact a worried interpretation by city people of what would happen to the average citizen who emigrated to the West. Would he take civilization with him? Or would he succumb to the temptations offered by complete freedom and become a virtual wild man? Another tension fueling this antipathy to early Western types was the competition that Easterners felt from the growing political power of citizens in the West. As early as 1830, one-third of the population of the United States lived West of the Alleghenies. In Congress, Western citizens demanded funding for internal improvements such as canals and railroads that would benefit them economically; they exercised political leverage on votes of key importance to Easterners. A "Westerner" was to many New Yorkers almost as suspicious in his political power as a Southerner.

Discrepancies between dreams about the West and caricatures of those who lived there presented the potential genre artist of the West with a challenge. An artist who painted the West had to deal with the implications of these types, known by word of mouth and in literature to a wide audience; moreover, the artist needed to be sensitive to the social psychology and regional enmities that fueled these conflicting attitudes.

What came to make the painter's task considerably easier, however, was Easterners'—especially New Yorkers'—changing point of view toward at least part of the West in the early 1840s. During those years, increasing numbers of Eastern families began to travel the Oregon trail to

*Plate 26* Landscape with Waterwheel and Boy Fishing. *1853. Oil on canvas, 63.81 × 76.20 cm. (25⅛ × 30 in.).*
*The Museum of Fine Arts, Boston, Massachusetts Robert J. Edwards Fund*

establish new homes in the highly touted agrarian paradise of Oregon. Hardly a periodical could be picked up that did not feature a story about settlers' life and inform Eastern readers about its harshness, simplicity, or even rural refinement. Audiences began to think of the West less as a trackless waste and more as a potential home. Although occasionally stories would poke fun at the naive Easterner who began his trip west with no skills whatsoever, most of the reports made heroes of the pioneer adventurers. Perhaps because Easterners themselves, or their children, were traveling westward, tales focused on the hardships families endured, and such hardships, including death on the trek and dangerous prairie fires, inspired images by artists Charles Deas, William Ranney, and others of emigrant families on the trek. These images presented the Westward experience as one in which the entire community, including women, acted with courage and nobility.[62]

In the constantly changing environment of artistic production in New York, where American artists were battling the rising popularity of European art, nationalistic art critics like Henry Tuckerman urged American artists to paint scenes that could not possibly be mistaken for European: to paint, in short, the colorful activities and noble events of the "borderlands."[63]

Bingham, on the borderlands if anyone was, faced an unprecedented opportunity. He could not compete with the Hudson River landscapists on their turf, but he could claim authority on his own, as a Westerner.

He began with *Family Life on the Frontier* (Plate 27), which he painted before 1845 as perhaps his earliest foray into genre painting. This work, painted before *Fur Traders Descending the Missouri* and *The Concealed Enemy,* shows that at least early in his career he wanted to present the frontier as a settlement of families. Such a definition of the frontier was certainly what Missourians typically brought to the topic. In this painting, Bingham created an interior that is humble but warm. The time is night, and the several members of a family pursue various activities before the fire and around the lamp. The father, formally dressed and closest to the viewer, reads from a small book, while behind him, at a large table, two young girls under the supervision of an older one prepare to set the table. Near the other end of the table the mother nurses a baby, and in front of the fireplace sit two boys who stare dreamily into the fire. The furnishings are simple, the accoutrements in the cabin at a minimum: there seem to be only a clock about the fireplace and, next to it, a picture that is a landscape. The scene is quiet, serving as an example of appropriate family behavior and responsibilities. Bingham perhaps conceived the painting as part of a series to show the Western experience as one of community-building by families, an attractive idea in the middle of a decade

when so much attention was being paid to group emigration. But he did not exhibit the work, and he returned to the subject of the frontier family only once. He was to focus overwhelmingly thereafter on the experience of the male in the West.

In *The Squatters* (see Plate 12), his second image of family life, the shift of Bingham's interest in depicting Western "community" is startlingly apparent. The earlier painting depicts family life centered around the home interior, where the woman has a moral influence; this one presents the outdoor community, in which the male plays the major role. The painting depicts an extended family that has made itself at home in a small part of a beautiful natural scene under an overarching sky. Their home of logs is at the extreme left, so that we see beyond it to distant prospects of land, river, and hills. Two members of the family dominate the grouping: a young man of perhaps thirty sits comfortably on a log, resting his arm on his knee, and a grandfatherly figure stands leaning on a long pole. Accompanied in their vigil by an alert terrier, the two men look beyond the viewer, with expressions of openness and waiting. Visible between them is a dismally bent-over woman who washes clothes in a tub by the front door of the cabin; those that she has already washed hang on the line on the left. Two male figures, perhaps young adolescents (and perhaps her children), sit talking in the background by the fire and kettle. The painting is suffused with a purifying golden light that pulls the viewer's attention to the great areas that lie in the right distance.

Bingham depicted here an early phase of Western settlement, in which the first families to follow the scouts cleared the land, built a cabin on it, lived by hunting rather than farming, and then moved on to repeat the process elsewhere. This wave of settlement was quite distinct from the situation Thomas Cole depicted in his *Home in the Woods* (Fig. 19). In Cole's painting, a hunter returns to his family with the bounty of the day's adventure. The family cabin is elaborate, with evidences of domesticity that include flowers and a home garden; a wife and children run to greet the man. Cole's painting shows a permanent settlement, with a home in the midst of a large woods and distant mountains that protectively enclose the family.

In Bingham's painting, on the other hand, no obvious children convey the message of happy, settled domesticity. The antlers are testimony of the hunt that keeps the family in food, and there is no accompanying house garden. The woman is associated merely with the day-to-day labor of upkeep. The vast amount of the painting given to the sky and to the distant vista on the right convey the wide spaces that beckon this family to move on. Their vision outward to lands farther West

*Plate 27* Family Life on the Frontier. *Before 1845. Oil on canvas, 61.59 × 76.20 cm. (24¼ × 30 in.).*
*Private collection Photo courtesy of the New Orleans Museum of Art, New Orleans, Louisiana*

*Fig. 19 Thomas Cole,* Home in the Woods. *1847. Oil on canvas, 111.76 × 167.64 cm. (44 × 66 in.). Reynolda House, Winston-Salem, North Carolina*

rather than inward to a family circle, typical of the dreams of thousands of their countrymen, produced the continuous moving on that was so important in the historical process.

The term "squatters" in Bingham's title has suggested to twentieth-century audiences that he was unremittingly critical of this class of settlers. This is inaccurate. "Squatters" did not become an unequivocal term of opprobrium until the land struggles of the twentieth century. In the nineteenth century, especially in the years of the 1840s and 1850s, the successful settlement of the frontier depended on the occupation of the land by emigrants who claimed it for "civilization" by "squatting" on, or occupying it. To encourage this kind of settlement, land prices in the West had long been inexpensive. Missouri's own Senator Thomas Hart Benton, in fact, was a long-term advocate of free availability of land for all who would settle it. Commentators as early as J. Hector St. John de Crèvecoeur noted the restlessness of the pioneer family, who would "settle" a claim, farm it

perhaps once, and then move on.[64] But most recognized that was a part of the civilizing of the West, for the next group who occupied the land would husband it and encourage the growth of towns nearby. Indeed, many commentators enshrined the moving on as quintessentially national. The *New York Tribune* wrote on April 1, 1843, for instance, that the pioneers were "Strange, restless beings. . . . Fearlessness, hospitality and independent frankness, united with restless enterprise and unquenchable thirst for novelty and change are the peculiar characteristics of the Western pioneer. With him there is always a land of promise farther West, where the climate is milder, the soil more fertile, better timber and finer prairie. And on—and on—and on he goes, always seeking and never attaining the Pisgah of his hopes."

There was an underside to "squatting," however, and it lay precisely in the relationship of squatters to the politics of citizens in the nearby towns. Squatters could register to vote, and it was certainly in the interest of politicians running for office to enlist them on their side. Often, however, because squatters were short-term residents, the issues or candidates they helped at the polls prevailed long after the squatters had moved on, sometimes to the community's disadvantage. Then there was widespread disgruntlement with squatters' political power.

These contradictions in the actual roles of the squatters were very apparent to Bingham. In the painting, he presents them without negative judgment; in fact, the two main characters project an openness to the future, even a dreaminess, that captures the very appeal of the open West. By comparing the drawings for these figures with the details from the paintings (Plate 28, Fig. 20), one can see that Bingham softened the intensity of the characters' expressions in his drawings into a gentle yearning in the painting in order to convey this mood. Bingham educated his New York audience about the settlers in a letter he wrote to the Art-Union: "The Squatters as a class, are not fond of the toil of agriculture, but erect their rude [i.e., simple] cabins upon those remote portions of the national domain, when the abundant game supplies their political wants. When this source of subsistence becomes diminished in consequence of increasing settlements around, they usually sell out their slight improvement, with the *'preemption title'* to the land, and again follow the receding footsteps of the savage."[65]

However, Bingham alluded to the squatter class in another piece of correspondence, and in that instance he clearly regretted their political clout. Bingham had just won an election in 1846 to the Democrat-dominated state legislature. The vote had been so close that his Democratic opponent demanded and received a recount. During the process, temporary settlers who had earlier voted for

115

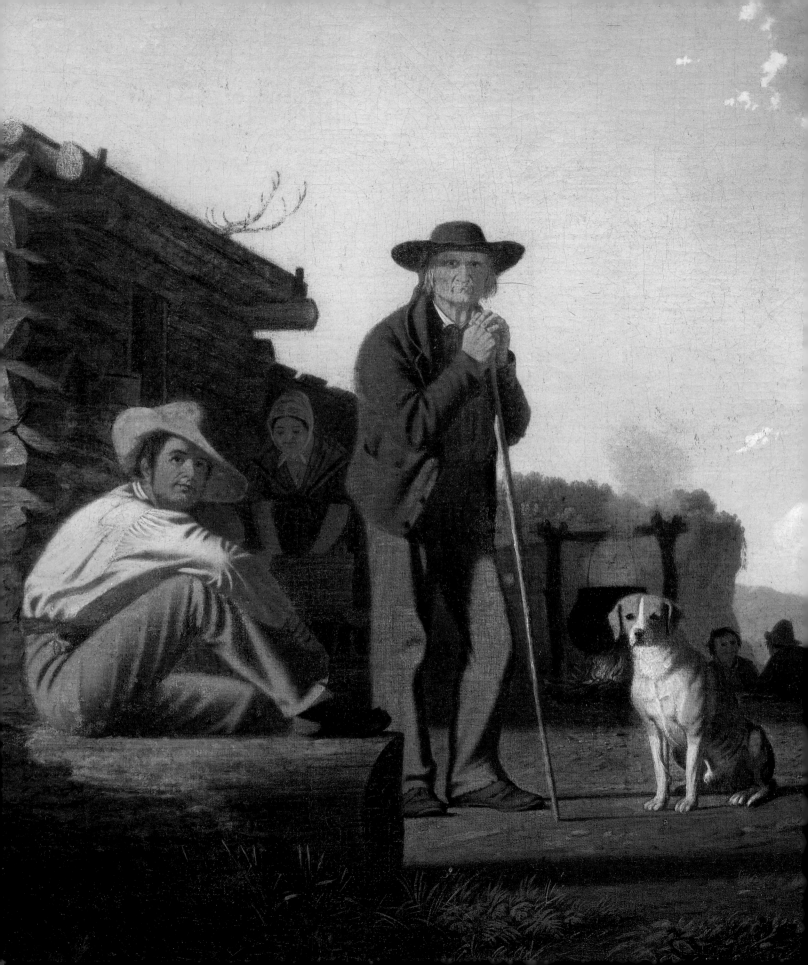

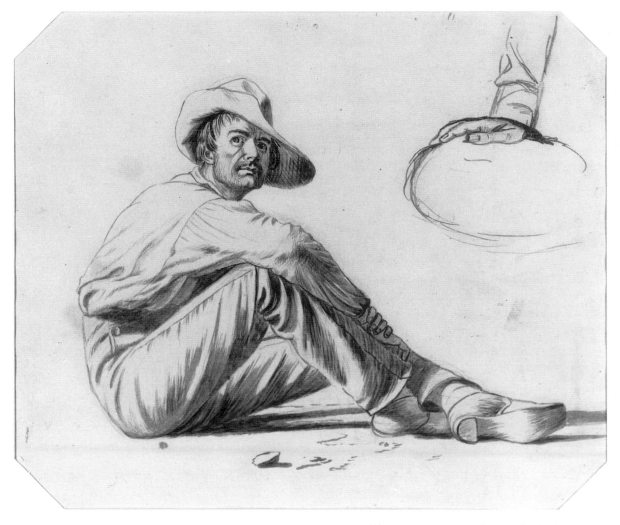

*Fig. 20* Family Man. *1850. Brush and black ink and wash over pencil 9⅝ × 11⅝ in. The People of Missouri*

Plate 28 detail of The Squatters, *1850. (See Plate 12.)*

this opponent were no longer around to support him. In the midst of the challenge to his election, Bingham wrote to his friend James Rollins: "These illegitimate Loco focos [radical Democrats], whose votes we wish to brush out of our way, have so scattered since the election, over our big prairies, that it takes a long time, with a good deal of pulling and hauling to get them up to the mark. Some of them have gone clear off to parts unknown. We have caught enough however, I think, to make out a clear case in our favor [Bingham thought he could prove that the votes for his opponent had been out of order], and when the evidence shall be read in the legislature I do not think a loco foco even can vote for my expulsion without a blush."[66] Much to his outrage, however, the Democratic legislature did oust him from his seat, giving the election to their fellow party member.[67]

In 1848, after his success in New York with *The Jolly Flatboatmen* and *Raftsmen Playing Cards* — scenes that featured Western male character types that were popular in stories and travelers' reports — Bingham painted an image and pendant that like his two scenes of families stand out as unusual over his career. He did not send either of the paintings East to be exhibited, and apparently did not exhibit them in Missouri for more than a decade.

In *Captured by the Indians* (see Plate 10), Bingham evoked the motif of the white frontier mother abducted by the savage Indian.[68] The painting shows a woman and child guarded at gunpoint by three Indians. The night is dark and menacing, with a fire off to the right that casts an eerie light throughout the painting. The Indians carry rifles, wear "savage" blankets and moccasins, and have their heads shaved to scalplocks. Yet Bingham planted ambiguous details in the work. The two captors near the fire are anything but vicious at the moment, having succumbed in sleep to the soothing warmth of the fire. The Indian who is awake sits apart from the fire, maintaining an alert guard, but the expression on his face is firm rather than savage, and his blanket, like those of the others, is colorfully decorated with yellows, blues, and reds. The woman and her child, in almost the exact middle of the picture, are a study in contrast. Long-faced and dark-eyed, solemn and poised, the woman lifts her head and eyes as though she is imploring heaven for help. She wears a brilliant red Indian blanket over her long dress, a detail of uncertain implication. Her little boy, with bare feet, sleeps peacefully.

Unlike *The Jolly Flatboatmen,* the incident and characters in the painting were not associated with the Missouri of the late 1840s. Although settlers much farther West continued to be threatened by Indians in sporadic incidents over the century, Missourians had long since driven out all Indian

tribes, and Indian raids on remote Missouri frontiers were things of the past. Why, then, did Bingham paint such a subject?

As a general Western motif, during a time in which settlers continued to push Westward, the captivity narrative had persistent currency. The theme had its deepest meanings in narratives of the settling of the wilderness that settlers even in the East had been spinning—and publishing—for almost two hundred years.[69] During Bingham's career, the most important of these meanings involved the nature of the Indian and the nature of the American woman.

As government policy pushed Indian tribes farther and farther West, off lands that had previously been guaranteed them through treaties, audiences justified the national treatment of the Indian as caused by the very nature of the Indian himself. What better way to assure themselves that Indians and whites could not live near each other than to perceive the Indian as savage and as a threat to the white settler's most vulnerable "possessions," his wife and children? The captivity narratives also embodied a deep cultural ambiguity toward women. In political rhetoric, sermons, and exhortations to domestic leadership, men in public positions exalted the woman as pure but intellectually and even morally weak. Denying women the vote, the right to own property, and the right to higher education, male leaders justified their circumscription of women's roles in society as necessitated by women's own nature. In addition, in many of the captivity narratives, women became foils to set off the strength and quick thinking of their white male rescuers. Such was the case in the story of Indians' abduction of the daughter of Daniel Boone, for instance, a captivity that she reportedly escaped without harm because of her father's courage, quick action, and overwhelming strength.

By mid-century, the quantity and the melodramatic tone of the captivity narratives had been reflected in imagery by a number of artists, ranging from history painter John Vanderlyn's presentation of a related subject in *Death of Jane McCrea* (Fig. 21), to numerous engraved illustrations (Fig. 22) that accompanied collections of published tales.

In the context of these many previous images, Bingham's painting is a melodrama that gives off mixed messages. Just how severely threatened is the woman? Her prayerful look to heaven, emphasized by the dramatic line between light and dark that Bingham placed down the middle of her face, suggests that she is in imminent danger of being ravished or killed. However, her motherhood—and the fact that the child is not part Indian—mitigates the situation's potential sexual innuendoes. Other details, too, blur the potential horror of the scene. The Indians are full

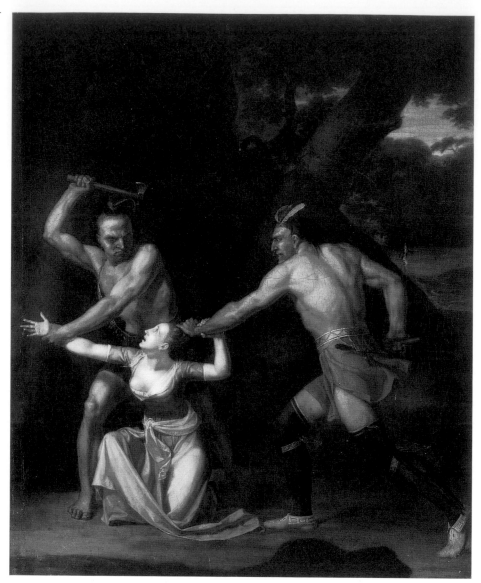

bodied—like those in Vanderlyn's scene of murder—but do not appear to be vicious. The woman wears an Indian blanket, and her child is barefooted. Have the Indians just carried off the pair and offered the woman the blanket to ward off the night chill, or have the mother and child been captive for some time, gradually adopting Indian ways? We sense no interiority in any of the figures that would give us a clue. In fact, the painting's very inconclusiveness reveals the incompatibility of such a potentially emotion-laden scene with Bingham's own artistic temperament.

In the context of his many paintings refuting the Eastern stereotype of the Western white male

as wild or at least disreputable, Bingham's attempt to take on the motif of the captivity narrative is curious. While he could turn stereotypes about white males upside down, in *Captured by the Indians* he could neither fully perpetuate nor wholeheartedly deny the stereotypes of the savage Indian and helpless white woman. Earlier, of course, he had been able to depict the Indian as a savage in *The Concealed Enemy*; and, his other characterizations of women, few though they may be, were role-bound. Unsuccessful as the painting was, however, the motif and format stayed with him for an amusing sequel. When he painted *Belated Wayfarers*, dated by Bloch as 1852, and originally called *In Camp* (see Plate 11), he chose canvas the same size and sold the two paintings to the same individual, who exhibited them together in 1859.[70] Bingham placed his scene in *Belated Wayfarers* in almost exactly the same setting as *Captured by the Indians.* In this later painting, two white men sleep by the fireside in an encampment in a woods, with a fire off to the right and a central tree

*Fig. 22 Cornelius T. Hinkley*, Abduction of Daniel Boone's Daughter. *Illustration for* Wild Western Scenes, *by John Beauchamp Jones, 1841. The Newbury Library, Chicago, Illinois The Everett D. Graff Collection*

serving as a vertical anchor for the pictorial structure. Even in their details of bark and branches, the trees in the two paintings are very much alike. But the emotional content of the scenes is drastically different. Bingham treated the two men in *Belated Wayfarers* with subtle humor. First, they are obviously emigrants. They are not dressed like Westerners—they wear no buckskins or hunter's jackets. Their tidy suits, jackets, and cravats and scarfs are sure clues that they are Easterners. And second, the men are in the amusing situation of being caught napping. The man nearest the fire, seated against the tree (either on a rock or at the base of the tree), attempts to stay upright, but his head nods against his chest; he is almost bald, a white fringe of hair visible around the edges. The younger man is stretched out on a blanket, leaning his head against the roots of the tree. He has pointed his stocking feet toward the fire, and his high-topped shoes lie in the right foreground where he has pulled them off. What a contrast in the situation to that of *Captured by the Indians.* These men wear the careful grooming of the city, as opposed to the native dress of the Indians and the Indian blanket thrown over the woman. They abandon themselves to sleep—in this case like two of the Indians in *Captured,* but very unlike the woman, who is seemingly awake for the duration of her captivity. The men are so at ease, in contrast to both the woman and the Indian on guard in *Captured,* there is not even a weapon in the picture to suggest they need to defend themselves.

Although Bingham apparently did not exhibit these two paintings in New York, the ideas underlying them had separate logical constituencies. An Eastern audience, steeped in lore of the savage Indian and removed from the immediate danger of Indian attacks, could more easily have viewed *Captured by the Indians* with the equanimity that comes from safety. *Belated Wayfarers,* on the other hand, was a humorous assessment of the emigrant that was much more risible for a Western audience who had seen examples of urban naiveté again and again. This painting is the closest that Bingham would come to the humor of William Sidney Mount, who made a career out of poking fun at Yankee country folks in such pictures as *The Sportman's Last Visit* (Fig. 23). What Bingham usually portrayed in the Westerner did not call for laughter.

The Westerners Bingham wanted his audiences to think about were, overwhelmingly, male. Like Mount, his counterpart in New York, Bingham gave his attention to depicting the naiveté, openness, and matter-of-fact self-confidence of the white American male. The white male was, after all, the citizen who was both the perpetrator and the subject of political debates, exhortations to good work habits, and countless amused anecdotes. There was little in the American popular repertory of stories and enumerated values that gave women multi-dimensional qualities. And

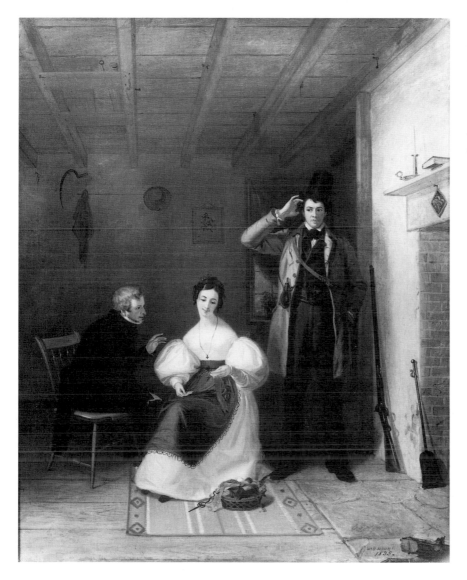

*Fig. 23 William Sidney Mount,* The Sportman's Last Visit. *1835. Oil on canvas, 53.97 × 43.81 cm. (21¼ × 17¼ in.). The Museums at Stony Brook, Stony Brook, New York Gift of Mr. and Mrs. Ward Melville*

certainly in the winning of the West, women played roles that were relatively unexamined in public discourse—or else, as in the captivity narratives, were patronizingly set aside from "regular" experience. When Bingham did include women in his works, he pictured them in the roles with which they demonstrated proper functions of their gender—such as the wife supervising dinner preparations in *Family Life on the Frontier,* the woman washing clothing in *The Squatters,* the mother hanging on to her child in *Captured by the Indians,* and the women on the balconies of the hotel in *The Verdict of the People.* Even in *The Emigration of Daniel Boone,* where women are prominent, Bingham gave them symbolic rather than individualized roles.

123

In 1850, after painting several scenes of river men, Bingham launched into subjects that involved men on the shore in rural communities. Rather than connecting these country characters with the West of the river, Bingham more generally implicated the American population that was pushing westward over the land.

As he had begun to do in his river pictures and paintings about the political process, Bingham drew for his characters on a repertory of Western types that he had sketched from life. These types were not so much occupational as those of age and attitude. For example, he depicted prominently in all his figures—both as sketched and as painted—a readiness to be observed. He showed characters who radiate good-naturedness but not mental brilliance; he depicted their gatherings as calm and low-keyed. As Bingham saw it, the Western male had laid claim to a new country, and he had absorbed some of its openness. Bingham's images suggest that Western nature—a benevolent wilderness—is not vulnerable to humanity but instead shapes it. Perhaps most important, Bingham saw Western men not as rugged individuals—as scouts or trappers—but as participants in settled, even if simple, communities.

In short, he painted men at leisure, who are gathered here and there to enjoy the pleasures of community as well as the perquisites of male free time (privileges that women did not have in such pictures as *Family Life on the Frontier* and *The Squatters*) and male sovereignty (as in *Country Politician, Stump Speaking, The County Election,* and *The Verdict of the People*).

One of Bingham's early such inland scenes was *Shooting for the Beef* (Plate 29), in which he depicted a relaxed group of men outdoors enjoying the pleasures of a shooting contest that had a very tangible reward, a generous portion of a steer standing at hand ready to be butchered. In American rural festivities, shooting contests were by no means exclusively Western. Indeed, the Eastern turkey shoot was a major event in James Fenimore Cooper's novel *The Pioneers* of 1823. The very fact that several artists had exhibited turkey shoot scenes in New York may have given Bingham the idea to create a distinctively Western version of the festivity. Edmund Flagg reported on such a scene in 1838 in *The Far West.* "As I rode along through the country I was somewhat surprised at meeting people from various quarters, who seemed to be gathering to some rendezvous, all armed with rifles, and with the paraphernalia of hunting suspended from their shoulders. At length, near noon, I passed a log-cabin, around which were assembled about a hundred men; and, upon inquiry, I learned that they had come together for the purpose of 'shooting a beeve' (or beef), as the marksmen have it. The regulations I found to be chiefly these: A bull's eye, with a centre nail, stands at a

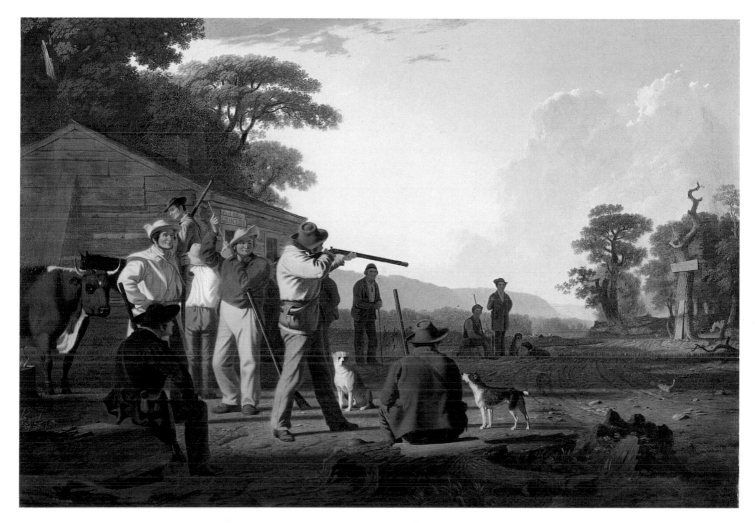

*Plate 29* Shooting for the Beef. *1850. Oil on canvas, 85.40 × 125.41 cm. (33⅝ × 49⅜ in.).*
*The Brooklyn Museum, Brooklyn, New York Dick S. Ramsay Fund*

distance variously of from forty to seventy yards; and those five who, at the close of the contest, have most frequently driven the nail, are entitled to a fat ox divided into five portions. Many of the marksmen in the vicinity, I was informed, could drive the nail twice out of every three trials."[71]

Flagg's description forms a veritable guide to Bingham's picture. The artist chose to paint the scene on a horizontal that would permit the greatest breadth. The event takes place at a bend in the road, the center of community life, at which stands a cabin (simply constructed, although not from logs) that serves as post office and grocery. On the middle left of the picture stand the participants in this activity, with one man taking aim at the target nailed to a tree in the right distance. Most eyes are on him—soon, no doubt, they will be on the target. Near the marksman, the man who will perhaps take his turn next pushes his ramrod down the barrel of his gun (Plate 30, Fig. 24). The pleasant expression on his face, along with that of another witness nearby, creates an atmosphere of good-natured sociability. These men seem to appreciate each other; the very setting, flooded with a clear light, is favorable to their good time. Bingham saw this gathering as completely characteristic, filling out the assemblage, as he often did in his pictures, with a character and pose from an earlier painting. The old settler in *The Squatters* appears in the middle distance in *Shooting for the Beef*; he wears a different hat, and leans on a shorter stick, but he has the same waiting expression. Similarly, the dog in *The Squatters* makes another appearance in *Shooting*, his ears pulled back as he studies the intention of the other dog in the scene.

Much to his advantage with his Missouri audiences, Bingham was often visited in his studio when he was working on his paintings. In addition, he perhaps judiciously invited newspaper editors to his studio when he had nearly finished a particularly promising subject. When he had reached a propitious point in *Shooting for the Beef*, for instance, a writer from the *Missouri Statesman* reported enthusiastically on the image to the St. Louis readers: it is "one of those paintings which no one can sketch so well as Bingham. It is said to be of rare conception [no doubt Bingham personally made sure that the reporter knew that he was the first artist to paint the subject] and most graphically delineated. The painting represents a western scene—*Shooting for the Beef*—and presents a group of characters with lifelike fidelity. There are seen the eager marksmen in the attire of the backwoodsman; the log cabin at the crossroads, with sign above the door lintel, "POST OFFICE GROCERY;" the prize in contest, a fat ox, chained to a stump hard by; a beautiful landscape in prospective, and—but a description is impossible. . . . Every feature on the canvas is instinct with life. Indeed, it seems an incarnation rather than painting, and gives us reason to exult

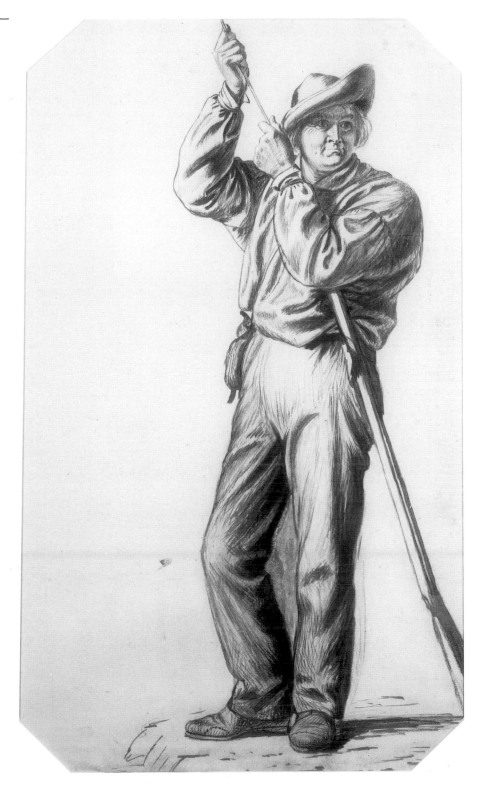

*Fig. 24* Marksman. *1850.*
*Brush and black ink and*
*wash over pencil 15¹⁄₈ ×*
*9⁷⁄₁₆ in. The People of*
*Missouri*

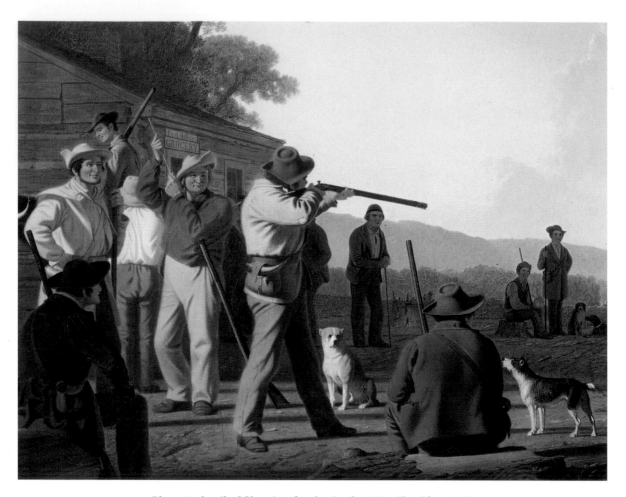

*Plate 30 detail of* Shooting for the Beef, *1850. (See Plate 29.)*

in the genius of Bingham, a nature Artist of our own State."[72] So strong was Bingham's reputation with the directors of the American Art-Union that George Austen, treasurer of the organization, had commissioned the work for distribution; the catalogue of 1851 introduced the image to its national audience by reprinting the praise of the St. Louis papers.[73]

The same year, Bingham painted *The Checker Players* (Plate 31), another new motif. The painting is smaller than the outdoor shooting scene, but it presents an equally affable cast of characters. Bingham set the colorful scene in a darkened tavern. Seated at a table right next to the bar, two checker players are carrying out their deliberations under the watchful eye and perhaps interfering comments of the barkeeper, who virtually hangs over his serving board to watch the

action. There are few details in the painting; the interior is so dark that beyond the brightly lit foreground group one can make out only a few of the items on the shelves in the bar. The game seems to be about five moves underway, and each player has captured one of his opponent's checkers. The man on the right makes a cautious move; his opponent evaluates the situation knowingly. According to the principles of phrenology, which were then at the height of their popularity, the man on the right, with a broad face substantially developed in its lower parts, should do much less well in the game than his opponent, whose forehead is high and face narrow. The barkeeper has a round face, somewhere in the middle in the conventional estimates of the relationship of shape of head and face to intelligence.[74] Yet all three—players and onlooker—wear expressions that combine amusement, confidence, friendliness, and total devotion to the game. With touches of red and warm greens, blues, and browns, Bingham painted an amusing commentary on the ordinary folk of the West and their pleasures.

In contrast to scenes of card playing, long popular in the history of the genre tradition and a topic that Bingham had already painted himself, this scene of checker playing presents no overt cheating, collusion, or potential uproar. In fact, checkers was seen by many at the time as a moral pastime, as a game of calculation and thus very much unlike cards, which, reprehensibly, were games of chance. Checker advocates took pains to write of the complex strategy one needed in order to play well. So respectable was the game—or at least so respectable did some people want to make it—that proper conduct was a matter of etiquette. In 1852, for instance, Henry F. Anners of Philadelphia urged potential checker players in a handbook on the subject that there were several "laws" that had to be followed in the playing of the game. Bingham may have counted on his audiences' getting the connection between these rules for deportment and the motions of the figures in his painting: "Follow the rules of the game most rigorously, and compel your antagonist to do the same; without which, Draughts [checkers] are mere child's play. Never touch the squares of the board with your finger, as some do, from the supposition that it assists their powers of calculation, and accustom yourself to play your move off-hand when you have once made up your mind; without hovering with your fingers over the board for a couple of minutes, to the great annoyance of the lookers-on. Finally, bear in mind what may well be termed the three golden rules to be observed in playing games of calculation:—Firstly, to avoid all boasting and loud talking about your skill— Secondly, to lose with good temper—and, Thirdly, to win with silence and modesty."[75]

Ironically, this view of Western leisure—a modest, pleasant checker game—was perhaps too

mannerly for the directors of the Art-Union. They declined to buy the painting when Bingham sent it for sale in 1851, and it went back to Missouri. In contrast, Richard Caton Woodville's *The Card Players* (Fig. 25), which the Art-Union had engraved in 1850 to distribute to its membership, depicted a scene much closer to the disreputable behavior that half-thrilled, half-disgusted Eastern audiences who generalized about "Western men." Woodville's picture is rich in details and complex in its implied narrative. In the Woodville work, the older player on the left seems to be the victim of a scam being perpetrated on him by the sharply dressed player on the right and the deceptively impartial figure looking over the table. A black man sits in the far corner, adding an enigmatic psychological note, and throughout the scene are such eye-catching details as a cuspidor, stage schedules, pictures on the wall, a stove with a pan on it, luggage, a clock, and umbrellas. Each detail further nuances the image. Bingham, on the other hand, painted a picture of Western congeniality, exalting the amiable community of Western men as he had done in *Shooting for the Beef. The Checker Players* did not have the punch of a card-playing scene that pictured the participants as rascals. Bingham's own *Raftsmen Playing Cards* (1847), had some of that complexity, and that painting sold.

All told, the Art-Union had an enormous impact on Bingham's career and in turn, primarily because of Bingham's paintings, on Eastern audiences' perceptions of Westerners. After the organization failed in 1852, audiences and artists turned all too quickly to European paintings for standards. Bingham's work was never to be the same. Before that major shift, however, he created one more quintessentially Western work.

Even though landscape was a much-admired pictorial form from early in the century until after the Civil War, the very highest kind of subject to which an artist could aspire was history painting. A legacy of the academic tradition in Europe that traced its heritage back to Renaissance giants Michelangelo and Raphael, history painting took as its topic the behavior of human beings in situations that revealed them at their intellectual or moral height. Traditionally, European painters had tapped the Bible, classical history, and mythology for such subjects. In the late eighteenth century, when a new understanding of history refocused people's attention on the capacities of ordinary mortals to achieve heroism, English and European painters began to interpret national history through the heroic deeds of political and military action. In the United States, however, history painters had only limited success. One reason was that few members of the early nineteenth-century audience for art, when painters were attempting to introduce historical subjects, had

130

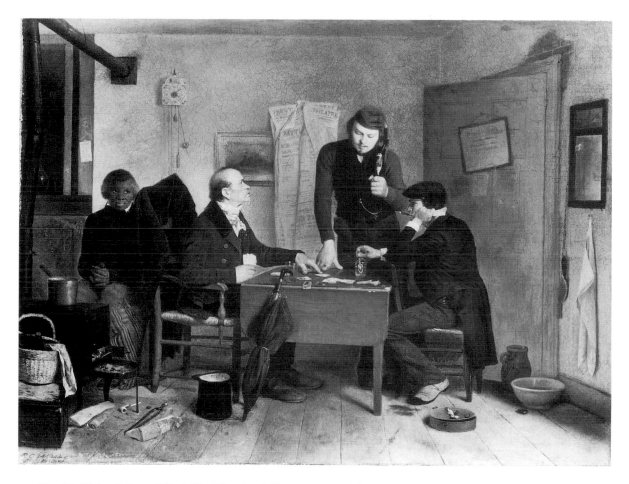

*Fig. 25 Richard Caton Woodville,* The Card Players. *1846. Oil on canvas, 46.99 × 63.5 cm. (18½ × 25 in.). The Detroit Institute of Arts, Detroit, Michigan Gift of Dexter M. Ferry, Jr.*

experience in looking at pictures, and thus they did not know the conventions of history painting. Even more important was that the nation had a short history, and little of it that people all across the country could agree was of current significance. By 1840, though, a consensus had begun to develop about particular heroes and deeds that had been crucial to the nation's past. History painters such as John Vanderlyn, John G. Chapman, and others were painting scenes for the walls of the Capitol Rotunda that monumentalized the nation's beginnings, events such as Columbus arriving in the New World, LaSalle Christianizing the Indians of the Mississippi Valley, and Pocahontas being baptized by the settlers of Virginia. Soon Emanuel Leutze would paint his great heroicizing picture of George Washington, *Washington Crossing the Delaware.* Audiences were begin-

*Plate 31* The Checker Players. *1850. Oil on canvas, 63.5 × 76.2 cm. (25 × 30 in.).*
*Detroit Institute of Arts, Detroit, Michigan Gift of Dexter M. Ferry, Jr.*

ning to believe the most significant events of American history had unfolded very close to the present.[76]

There was no doubt that among the most important of these occurrences was Westward expansion. This process, during the years 1845 to 1850 when Bingham was painting flatboatmen and other rivermen for the appreciation of his New York audiences, defined the West as *the* arena for the development of the nation. The outcome of the Mexican War, in 1848, had added to the nation more than one million square miles of land. That same year, wealth-crazed citizens began the rush to California gold fields in hopes of becoming rich overnight. The Compromise of 1850, which provided for the admission of California to statehood, settled certain issues in slavery temporarily and pushed the national boundary to the Pacific Coast. Thereafter, a vast Western empire stretched before Americans. This was the time audiences could conceive of—and needed to conceive of—a Western pioneer as a hero. It was time to interpret in retrospect what moving Westward had meant in the past and what it would mean in the future.

The figure of Daniel Boone was a rallying point for this interpretive need. The historical Boone had begun life in North Carolina in 1734. By 1760 he was conducting exploratory journeys over the Appalachian ridge, following animal and Indian trails, and battling hostile Indians, in order to find passages through which settlers could journey into what was then the "West"— Kentucky. In 1773 Boone attempted to take his first party of settlers over those trails, a group that included his family, but he had to turn back after a devastating encounter with attacking Indians. Two years later, he and his family finally made the arduous journey successfully. A hardy traveler, smart enough to outwit Indians and strong enough to meet them in bodily combat, Boone went on to escort many other families into Kentucky. He himself kept moving farther West, and eventually he settled in Missouri.

Boone's exploits were discussed in print almost as soon as he finished them. From 1784, genteel writers extolled his courage and foresight as a standard-bearer of civilization; one very early author celebrated him as the founding father of Kentucky. Others, who tended to see the comic side of any-one who was not a "genteel" city dweller, preferred to see Boone as a child of nature who fled again and again from the niceties of civilization, refusing to be "closed in" by other settlers. Thus a major interpretative question about Boone as a symbol of American pioneers was whether he—and by extension, the nation—was civilization's "advance guard" or whether in fact he was a natural man of the wilderness who could not stand to be "hemmed in." By 1820, when he died, Boone was virtually

apotheosized. Throughout the rest of the century he was the "Columbus" who had taken the crucial next step westward, a symbol of the westward migrant as heroic, brave, and completely admirable.[77]

Missourians took Daniel Boone as their own. The areas where Boone settled came to be known as "Boonville," and "Boonslick," and Boone County was named after him. There, in 1816, the portraitist Chester Harding painted his portrait, and the image was engraved and distributed to admiring audiences (Fig. 26). In the late 1840s, as talk of Westward emigration inevitably reminded

*Fig. 26 James Otto Lewis,* Col. Daniel Boone. *Stipple engraving*

*Fig. 27 William Ranney,* Daniel Boone's First View of Kentucky. *1849. Oil on canvas, 95.25 × 137.16 cm. (37½ × 54 in.). National Cowboy Hall of Fame and Western Heritage Center, Oklahoma City, Oklahoma*

speakers of Boone's work as a pathfinder, William Ranney painted several tributes to Boone and other scouts who had first gone over the difficult mountains into Kentucky (Fig. 27).

When Bingham decided to paint *The Emigration of Daniel Boone* in 1851 (Plate 32), the subject of Boone was a natural one for him. One of his earliest memories as an aspiring painter was meeting Harding and talking with him about his portrait of the old pioneer. Later, some ten years after Boone died, the young Bingham painted a signboard for a hotel in Boonville (1828–30) that showed "old Danl Boone in buck skin dress with his gun at his side."[78] And later still, in 1844, Bingham proposed the figure of Boone for a Whig political banner for Boone County, Missouri. "I would suggest for the design as peculiarly applicable to your county, old Daniel Boone himself engaged in one of his death struggles with an Indian; painted large as life, it would make a picture that would

take the multitude, and also be in accordance with historical truth. It might be emblematic of the early state of the west, while on the other side I might paint a landscape with 'peaceful field and lowing herds' indicative of his present advancement in civilization."[79]

Almost a decade later, Bingham conceived and painted *The Emigration of Daniel Boone*. At the time, he was not in Missouri, but in New York City, where he was overseeing the engraving of his *The County Election.* He wrote his friend Rollins, "I am now painting the *Emigration of Boone* and his family to Ky. I do not know whether I will sell it to one of the Art Unions, or have it engraved with the expectation of remunerating myself from the sale of the engraving. The subject is a popular one in the West, and one which has never been painted."[80]

Bingham felt overwhelmingly confident in this venture. After all, he had already claimed the attention of his Eastern audience with scenes of "characteristic" Westerners: the fur trader, married to an Indian; the flatboatman, a carefree adolescent; the rough frontier family always on the move; and small-town Western men entertaining themselves with tavern activities and outdoor shooting contests. These were types and activities that flourished in the newspapers, journal stories, and anecdotes that Easterners read daily about the West. Now, Bingham perhaps projected, it was time for a more inclusive vision, one that would uplift the entire Westward enterprise into the symbolic realm in which it would have its most enduring meaning. The noble Daniel Boone could supplant symbolically all the adventurers, cardsharpers, and rapscallions who had gone West for selfish purposes in a representation of the meanings of the *nation's* venture Westward.

Bingham's *The Emigration of Daniel Boone* is large and brilliantly lit in the foreground, where we observe a group of noble figures. Daniel Boone, in frontier costume with a gun on his shoulder, leads a group of settlers and their families into the wilderness. Accompanied by a pioneer who scans the distance as intently as he does, Boone holds by the reins a sturdy white horse that carries a dignified woman rider. On the other side of the horse, a scout stoops to tie his shoelace, his alert dog before him. Behind this front foursome, which Boone dominates, the party proceeds single file; the gap through the wilderness is narrow. A second, younger woman rides behind the woman beside Boone; a man walks near her carrying a mallet, and others, carrying guns, ride behind her. In the deeper distance we can see drovers with sticks, encouraging cattle to keep up the pace. A bright warmth lights up the blue sky in the distance, suggesting the security of the settled East from which this group has come. In the front of the image, the sharp crags of the trees in the wilderness, their edges lit for drama, convey the dangers into which this party is making its way. The scene re-creates

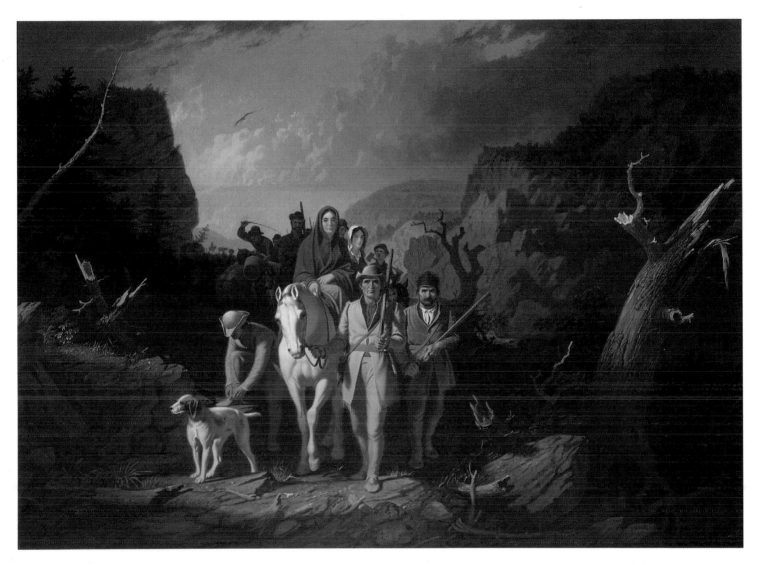

*Plate 32* The Emigration of Daniel Boone. *1851–52. Oil on canvas, 91.72 × 127.63 cm. (36½ × 50¼ in.).*
*Washington University Gallery of Art, St. Louis, Missouri Gift of Nathanial Phillips, 1890*

*Fig.* 28 Pioneer. *1851.*
*Drawing, 37.30 × 17.30 cm.*
*(14¹¹/₁₆ × 9⅝ in.).*
*The People of Missouri*
*Acquired through the*
*generosity of Emerson*
*Electric Company*

the very crest of the actual journey, when the party—composed of Boone, his wife and daughter, and other settlers—crossed from North Carolina into Kentucky. Boone himself wrote of the spot, "The aspect of these cliffs is so wild and horrid, that it is impossible to behold them without terror."[81]

Bingham carried a clear conception of type and body language from drawing to painting (Plate 32). He conveyed Boone with the same dignity that Harding had, as a look at the James Otto Lewis stipple engraving after Harding's portrait reveals. Bingham made Boone much younger, of course, but the long gun, hunting costume, and moccasins in Harding's portrait were prominent aspects of his characterization as well. As he had done in earlier paintings, Bingham considerably softened the physiognomy of his characters in rendering them in paint. Whereas in the drawings both the pioneer and the guide (Fig. 28) wear dour expressions, with severely turned-down mouths, in the painting they are considerably idealized. Their scowls have become admirable concentration.

Bingham's is a group with a mission, an agrarian mission. The men are not male trappers, going into the wilderness to extract skins for a profit and then leave; they are not men heading to the rivers for several years of entertaining employment as rivermen. They are not even the group of courageous scouts that Ranney painted in such works as *Daniel Boone's First View of Kentucky*. Rather, they are the families of earnest, respectable Easterners who are heading West to make it an agrarian community. The painting depicts the Westward movement as no accident, no adventure for personal gain. In no uncertain terms, it asserts the complete integrity of Westward expansion.[82]

It was one of the last vigorously felt works Bingham would create. Thereafter, partially because of the loss of patronage but even more because the West he had celebrated had changed so quickly into something else, Bingham repeated his earlier motifs. Eventually he gave up almost every subject but portraits and turned to politics.

No single painting of Bingham's career better brings together than *The Emigration of Daniel Boone* the separate threads of his ambitions and achievements, as an artist and as a "Missouri artist." Bingham was an agrarian who valued sturdy independence and came from a state which also did. Moreover, he was persuaded that the future of the nation lay in the West, and specifically in the kind of settling of the West that Missourians had already achieved. Bingham's painting summarized and shaped anew the claims of mid-century white Americans who pressed forward to work out their "destiny."

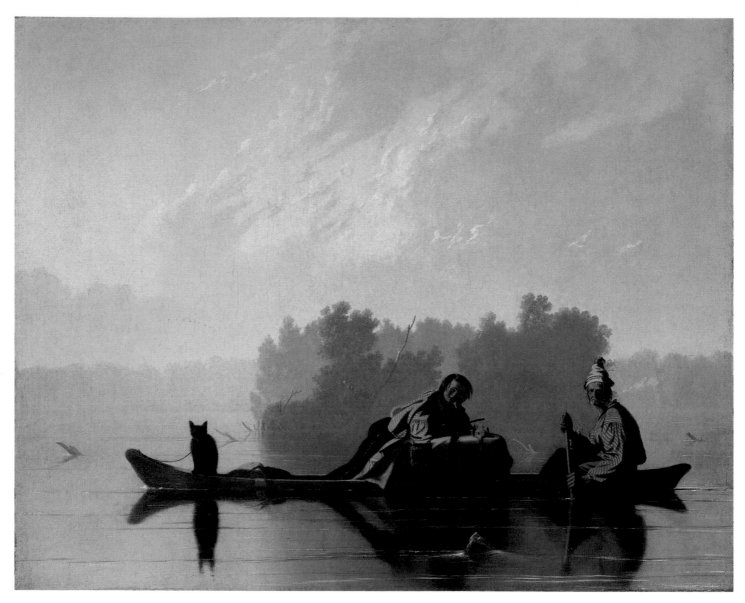

*Plate 33* Fur Traders Descending the Missouri. *1845. Oil on canvas, 73.66×92.71 cm. (29×36½ in.).*
*The Metropolitan Museum of Art, New York, New York Morris K. Jesup Fund, 1933*

# THE RIVER PAINTINGS

## *By Michael Edward Shapiro*

In 1837, having ventured as far east as St. Louis in search of clients and of broadening his artistic education, George Caleb Bingham returned to central Missouri and painted a double portrait of a mother and son. The painting, *Mrs. David Steele Lamme and Son William Wirt* (Plate 34), indicates a modest technical advance in the twenty-six-year-old painter's ability to depict people and objects in space, but, more importantly, in its depiction of a boat and water, it prefigures one of the primary future directions of his artistic career.

Until this time Bingham had painted individual, half-length portraits of citizens of central Missouri. The faces of his sitters, seen in three-quarter view and enclosed by starched collars or lace bonnets, float like illuminated white shapes against a generally dark background. In *Mrs. David Steele Lamme and Son William Wirt,* Bingham extended his concept of picture making by suggesting the furnishings of the room and providing a view of a landscape. Through the starkly cut window, the viewer sees a world of eerie and limpid beauty: tree-covered hills, a body of water, and a small sailboat blown along by the wind. The boat holds several tiny passengers, and its billowing sails are reflected in the calm waters beneath it. The idyllic view out the window is the first tangible sign of the seminal role that water, boat, and shore would play in Bingham's then unformulated career.

Bingham was first drawn to the waters of Missouri, their forested banks, the river boats and river people as a subject worthy of contemplation in the 1830s, but the formulation and refinement of his views of frontier river life was lengthy and complex. Water, a fluid and reflective substance contained by the natural envelope of the riverbanks and illuminated by the sky above it, was a

fundamental structural and metaphorical element of the river paintings. Though there had been many topographic views of river life before Bingham, he alone translated the suggestiveness of the river as an indicator of the passage of time, of commerce and pleasure, of physical and mental nourishment into images. Within this sphere of the elegiac river, Bingham placed his benign and heroic workers—the humble river men who, like Tom Sawyer, were in tune with the natural rhythms of the "natural" life of man in the West. The chariots of these men were plain wooden boats, powered by the current of the water, embraced by the shores and gently illuminated by the skies above. Combining these elements of transparent elusive water, rich landscape foliage, and humid early morning light, powerful and kindly figures and their simple craft, Bingham created his sequence of paintings known as "The River Paintings." Characterizing far more than just Bingham's feelings about his region, they evoked with striking clarity the values and aspirations of our country.

Within the year after painting his portrait of Mrs. Lamme and her son, Bingham travelled to Philadelphia to broaden his exposure to art and to expand his skills as a painter. He stayed in Philadelphia from March until June of 1838. It was there, in his experience of other works of art, that he realized the role water played as a powerful visual component in American landscape. In the fall of 1838, a few months after returning to Missouri, he submitted a painting which paired a man ashore with a view of a river. The title of the painting, *Western Boatman Ashore*, suggests that in his pairing of figure and water Bingham had rapidly absorbed the prevailing landscape and genre styles and translated them into a symbol of his own experience of the West. Only the prior year water, shore, and boat had appeared in his work as a hazy, visual anecdote.

A second surviving example of Bingham's early combination of figure and water is in his full-length portrait of *Leonidas Wetmore* (Plate 35). In his dazzling buckskin costume, Wetmore's pose may bear some relation to the missing *Western Boatman Ashore* of 1838. To the left of Wetmore are the placid waters of a river or a lake, as in the double portrait of the previous year. In the Wetmore portrait Bingham came a step closer to using the shape of the river as a key structural element. The water is foreshortened in space to entice the viewer into the painting rather than flowing parallel to the picture plane as it did in the earlier work.

The figures and water in the Lamme and Wetmore portraits and several other works of the period provided new pictorial opportunities upon which Bingham ruminated and to which Bingham returned when his painting skills and artistic vision matured. The ancillary elements in the early River Paintings became the core strength and subject of his finest later ones. Just as several

early paintings anticipated the course which he later took, several late works serve as distant echoes of the achievements of his River Paintings of the mid-1840s and 1850s. From the mid-1840s until 1857, his paintings of river life marked the apogee of his artistic career.

Portraiture and landscape presented Bingham with two different paths. He selected, refined, and combined aspects of each to yield a third direction: genre painting. First conceived in the portraits of the late 1830s, the River Paintings synthesized genre incident, landscape, and figure, by the artist's ability to fuse these elements into new visual arrangements. This synthesis did not develop until the 1840s, after nearly five more years of additional study and development.

When George Caleb Bingham returned to Missouri from Washington, D.C., in December of 1841, he was on the brink of the most important creative period of his artistic career. While he was in Washington he wrote to Rollins: "I am a painter and desire to be nothing else . . ."[83] During his travels East, first to Philadelphia in 1838 and then to Washington from 1841 to 1844, he absorbed much more than principles of picture making. He become increasingly drawn to a range of subjects that he knew well, whose visual formulation he had already begun to explore, and which seemed to be a specifically "American" subject: life along the Missouri and Mississippi Rivers.

The lure of "American" subjects was forcefully felt in Bingham's age as it coincided with the increasing self-confidence and growing nationalism of a country with expanding economic and political horizons. The greatest calling for American artists of this period was to define a national, indisputably American subject matter for works of art. For Bingham, the river—upon whose banks he had grown up, with the boats and boatmen he had observed as a child—was a subject which both characterized a particular region and held within itself the larger values and aspirations of the nation: work, harmony among men and with nature, and individual freedom.

At mid-century, American artists seeking indigenous subjects described our country through depictions of social customs. Although suggestions of European models in the compositional formats can be found in the work of practically any American artist, the actual subjects and activities depicted were indigenous: in the area of portraiture—American political heroes; in landscape painting—the configurations of the Hudson River Valley; and in genre painting—the relaxed, rural subjects of William Sidney Mount. All of these approaches described the values of a larger democratic whole.

During Bingham's time "abroad" in the East, he came in contact with The Apollo Association in New York—and its successor, the American Art-Union. This organization became the catalyst

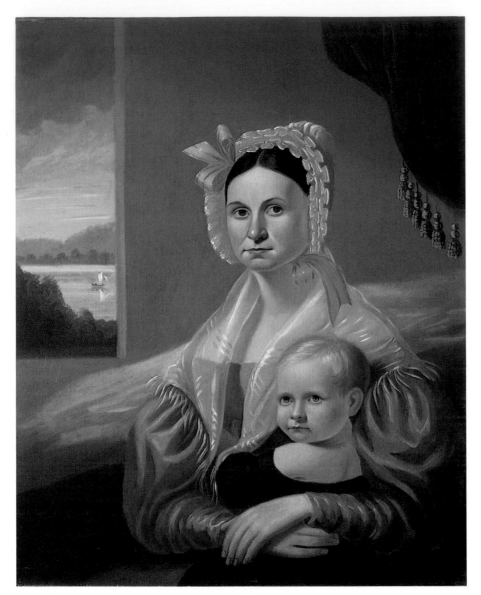

*Plate 34* Mrs. David Steele Lamme and Son William Wirt. *1837. 89.54 × 71.12 cm. (35¼ × 28 in). Private collection*

which assisted and encouraged Bingham to combine his sources. It suggested the pictorial and commercial opportunities for images of the land and people where Bingham was raised.

In the 1840s there were few commercial galleries in America and even fewer collectors. In the context of this thin, difficult soil for the patronage of American artists, The Apollo Association and the American Art-Union played a seminal role in financially and spiritually nurturing artists, in disseminating their works of art to a broad constituency, and in guiding their attitude toward certain types of subjects. Both organizations were highly visible promoters and formulators of an emergent

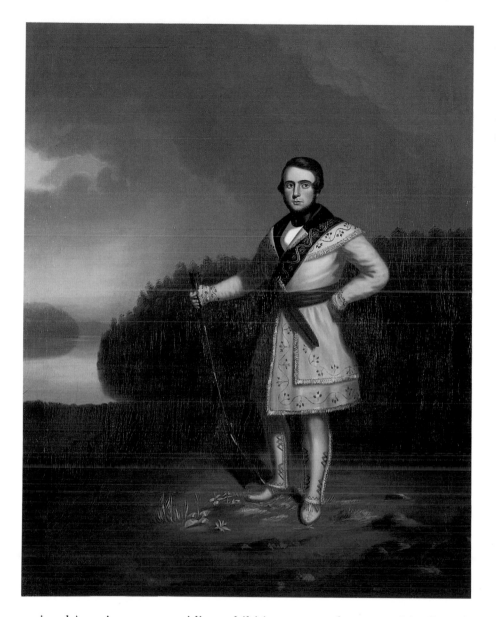

*Plate 35* Leonidas
Wetmore. *1839–40.
Oil on canvas, 152.4 ×
101.6 cm. (60⅛ ×
40⅛ in.). Private
Collection*

national American art, providing exhibition space and opportunities for artists to sell their paintings and sculpture.

The Art-Union purchased original paintings from artists and distributed them by means of raffles to its subscribers. They also made engravings after some of the paintings which were subsequently distributed by the organization to its nearly 10,000 members. Through these prints, the Art-Union assisted greatly in distributing images of Bingham's work.

The Art-Union's penchant for views of life in the West fed an Eastern fascination with the

farther reaches of the country. This preference for Western subjects encouraged Bingham to paint pictures which characterized aspects of the world in which he had grown up with some assurance that the paintings would find a market in the East. From 1845 to 1852, (with the exception of 1850 and 1851), at least nineteen of Bingham's paintings were purchased and distributed by the Art-Union—making the organization his most consistent and important patron. He submitted additional paintings to the Western Art-Union in Cincinnati, which purchased and distributed them as well. This era of patronage coincided with and perhaps stimulated the production of what we now see as Bingham's finest paintings.

In 1845, Bingham sent four paintings to the Art-Union. *Cottage Scenery* (see Plate 21) was painted within six months of Bingham's return to Missouri from Washington, D.C. It is likely that the picture was painted not for a Missouri clientele but for those who lived on the East Coast. The painting shows three people conversing—a straw-hatted youth, an old man seated on a bench, and a young woman who leans over a Dutch door. Contented cows graze on the banks of a river that flows in the distance. As is true with many of Bingham's paintings, it is the conversation, set within the larger harmonic structure of nature, that is the focus of the work. In later years, *Canvassing for a Vote* (Plates 43, 44), used the device of depicting an informal dialogue taking place in front of a rustic building and elevated it to a broader political plane.

The language of forms which Bingham chose for *Cottage Scenery* reflects the influence of both French and English eighteenth-century paintings of rustic life. While the composition of trees and cottage have been compared to scenes by Joshua Shaw, an English-born painter who emigrated to America, or before him to an earlier prototype, George Morland, another English artist, the motifs in the painting democratize those initially developed in Europe and transfer them to a generic landscape setting.

The tone of domestic and natural harmony continued in a second work Bingham sent to the Art-Union that year, *Landscape: Rural Scenery* (see Plate 22), in which a young woman bends over her wash bucket by the side of a stream. The family cottage can be glimpsed in the middle ground of the picture, cozily enclosed within the woods. One of her two young children plays in the water while the other, seated on the flat rocks, observes his mother. The placidity of the water, the abundance and stillness of nature, and the soft reflections in the water link this picture with the fully realized masterpiece sent to the Art-Union that same year, *Fur Traders Descending the Missouri* (see Plate 33).

To be sure, there are formal and iconographic similarities between the two paintings; however, a great distance of artistic achievement and innovation lies between them. In *Fur Traders Descending the Missouri*, Bingham's mature style is suddenly and firmly stated. He now speaks with his full voice and charts in visual terms the new direction his finest paintings would take.

*Fur Traders Descending the Missouri* creates an extraordinarily seductive image, restrained in subject and spare in design. Bingham could well have witnessed this scene as a child sitting on the banks of the Missouri in Franklin or Arrow Rock. We watch the silent passage of two figures who guide a canoe swiftly and expertly around the snags in the river. The picture has a hallucinatory quality, with the soft light of dawn illuminating the tranquil scene. The boat holds a grizzled older figure with his pink-and-white striped shirt and yellow and red cap. His son, dressed in a blue-and-white striped shirt and maroon buckskin pants, leans forward over a rifle, fringed bag, red sash, and the bird he has just shot. A trophy of their time in the wilderness, their pet bear cub, is leashed to the prow. First named *French Trapper and His Half Breed Son*, the painting was retitled in a more romantic vein, probably to appeal more directly to Eastern curiosity about the West.

*Fur Traders* represents the first of Bingham's genre pictures in which the figures engage the viewer with honest directness. The black-haired, full-faced boy looks out at the viewer amiably, while his pipe-smoking father stares with greater seriousness. The painting relates to the popular and sentimental use in the nineteenth century of the image of water as a metaphor for life. In many ways, it seems a Western equivalent of the canoe-shaped boat in Thomas Cole's allegorical painting, *The Voyage of Life: Youth* (Fig. 29), conflating the four-part arrangement into a single image of youth and later life.

Like Cole, Bingham used the medium of water as the agent for both practical and philosophical movement. The river is more than a mode of transport. It connects the remote with the urban, and in its gentle form of presentation by Bingham, it becomes a lustrous form of poetry. Water served as a mirror of the sky, of the landscape, and of man. A tranquil agent of change, water invites meditation, and its buoyant nature supports the figures who seek and return the viewer's gaze.

Bingham's penchant for having his genre figures directly engage the viewer is an effective pictorial device perhaps inspired by the continual gaze of his portrait subjects. In *Fur Traders*, the viewer sits almost at eye level with the boat and its inhabitants. Since the banks of the river are not visible in the foreground, the viewer might be positioned low on the bank or perhaps seated in his own boat. In either case, the viewpoint is just above water level.

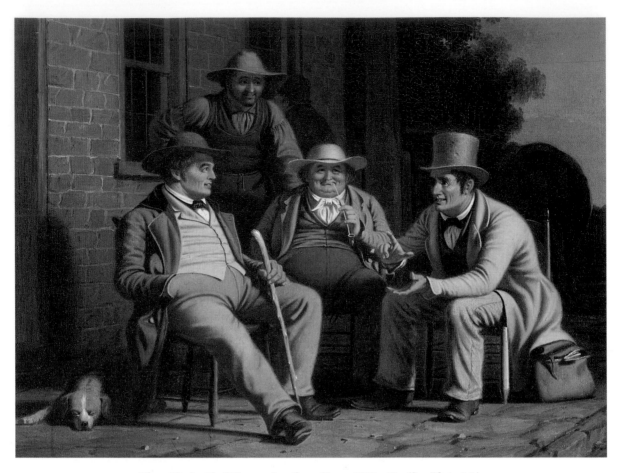

*Plate 36 detail of* Canvassing for a Vote, *1851–52. (See Plate 14.)*

The two figures and the canoe are the only crisply defined elements in the painting. The distant landscape disappears in early morning fog. The soft and blurred reflections in the water beneath them and the palpably moist air behind them evoke a feeling of dreaminess.

*Fur Traders* has been compared to William Sidney Mount's *Eel Spearing at Setauket* (Fig. 30), which also was painted in 1845. The two works share uncanny formal and spiritual affinities. Both seem to be drawn from recollections by the artists of their childhood. The distinctions in subject matter and form suggest the differences between the more domesticated outdoor life of the Long Island Sound and the rugged, yet no less romantic life on the Missouri River. The similarities between the sharp delineation of the main forms and soft reflection of the water in the two views make them, ultimately, kindred spirits.

The fourth genre painting that Bingham sent to the Art-Union that year, *The Concealed Enemy* (see Plate 9), depicts a lone Indian peering over the edge of the cliff, ready to cock the hammer of his rifle. The dominant formal effect in the painting is the reiteration of the basic foreground shape of the Indian and the hill ever more deeply into space. While the narrative situation in the painting is unresolved, the picture operates successfully at a formal level in which the central motif becomes a continuing echo of itself in the landscape.

What these two paintings, *Fur Traders Descending the Missouri* and *The Concealed Enemy*, accomplished was a translation of European landscape styles into an American lexicon, containing stylistic references to the seventeenth-century European landscape painters Salvator Rosa and Claude Lorrain. Henry Adams has suggested that *The Concealed Enemy* reflects the "savage" mode of Rosa while *Fur Traders* represents the more classical model of Lorrain.[84]

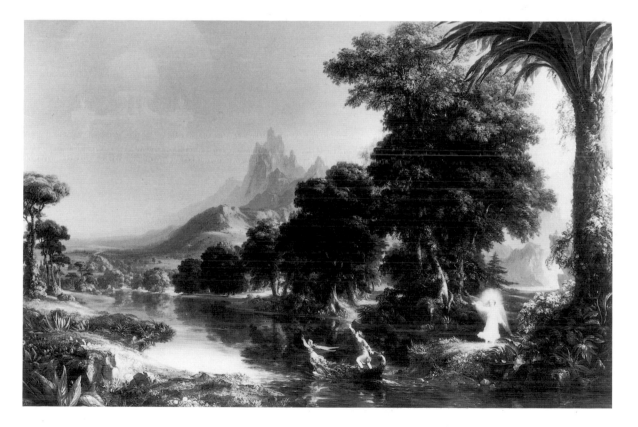

*Fig. 29 Thomas Cole,* The Voyage of Life: Youth. *1840. Oil on canvas, 133 × 199 cm. (52½ × 78½ in.). Munson-Williams-Proctor Institute, Utica, New York*

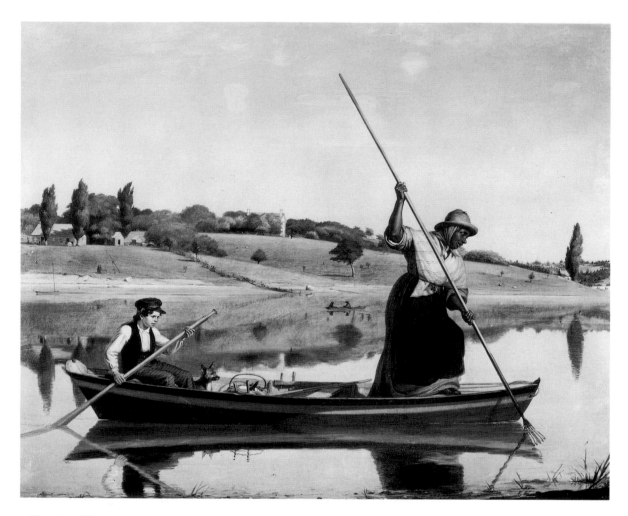

*Fig. 30 William Sidney Mount,* Eel Spearing at Setauket. *1845. Oil on canvas, 73.66 × 91.44 cm. (29 × 36 in.).*
*The New York State Historical Association, Cooperstown, New York*

The transformation of these sources into tools for depicting the mythology of the American West has been so complete that they remained undetected for more than a century. It is only recently that the two paintings have been regarded as pendants. In this context, *The Concealed Enemy* can be seen as representing the end of the Indian civilization, while *Fur Traders Descending the Missouri* presages the dawning of a new age.

So-called "pendants," like these two paintings, do not appear to have been intended as such, but rather are a reflection of the dualistic operations of the artist's mind. Bingham may have developed a somewhat binary viewpoint, expressed in pairs of loosely related genre paintings,

through his long experiences as a portrait painter who made many paired images of husbands and wives.

In *Boatmen on the Missouri* (see Plate 38), painted the following year, Bingham definitively found his heroes of Western American life: the river and its workers. Three figures, firmly and crisply silhouetted against the hazy bank of trees on the far shore, will soon be transferring wood to the steamboat which is fast approaching in the distance. By most accounts, nineteenth-century Missouri boatmen were a boisterous and a vulgar lot; here, Bingham seems to consider them as ancient river gods, relaxed and confident guardians of commerce. Imbued with classical restraint, they beckon the viewer into their world, a world not of bookish wisdom, but rather one of physical well-being, psychological balance, and practical good sense. As Bingham called up his recollections of life along the Missouri to present an Arcadian view of the river world, so would Mark Twain present his Mississippi later in the century through the eyes of Tom Sawyer.

The visual prototypes which exist for Bingham's paintings of river life have a prevailing topographic orientation. For example, George Catlin's *St. Louis from the river below in 1832, a town on the Mississippi, with 25,000 inhabitants* has a bird's-eye viewpoint which allows the artist to describe the extent of the city and its geography but eliminates any hope for narrative coherence. Even in the slightly later painting by a lesser artist, Antonio Mendelli, *View of Cairo, Illinois,* the painting is cluttered with incidental details and devoid of the central focus and constructive geometry of Bingham's paintings. Bingham reformulated these and other approaches into a more humane and intimate narrative moment. By tightening the focus of his works, he greatly enhanced their significance.

Of the three figures in *Boatmen on the Missouri,* two return the viewer's gaze with sympathetic equanimity while the third, closing the composition, holds his head down as he works. The unblinking stare of the boatmen locks into the viewer's eyes, while the horizontally extended oars intersect with the vertical edges of the canvas to hold the composition firmly in place. In this painting, Bingham reused one of the key formal innovations of *Fur Traders*—the placement of the dugout parallel to the picture plane—by placing it in another context. Now, the formal relationship of boat, oars, and the edges of the picture plane call attention to the edges of the canvas, almost in a tongue-in-cheek manner. The sharply defined image is suspended in place, for the benefit of both the viewer and the artist. The structural geometry of the river paintings elevates Bingham's work above all precedents to a new level of accomplishment and visual resolution.

———

151

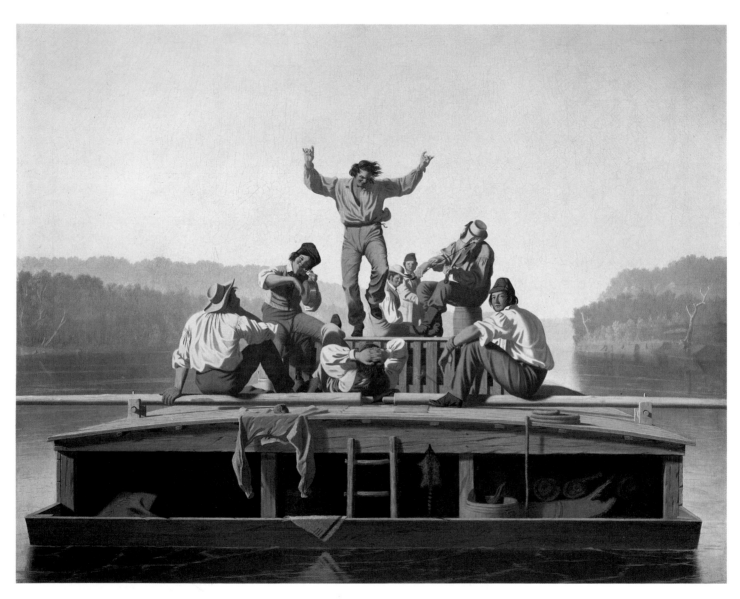

*Plate 37* The Jolly Flatboatmen *(1). 1846.*
*Oil on canvas, 96.63 × 123.19 cm. (38⅛ × 48½ in.). Manoogian Collection*

If *The Concealed Enemy* and *Fur Traders,* respectively, suggest the decline of Indian civilization and the dawn of a new age, *Boatmen on the Missouri* suggests the end of the era of the flatboat and its replacement by the steamboats which began to travel the Missouri and Mississippi Rivers with increasing frequency after the 1820s. In his landscape and genre paintings, Bingham seems more comfortable depicting the flatboats, even though by the 1840s they had almost disappeared in favor of steamboats. Bingham's next river picture, *The Jolly Flatboatmen* (see Plate 37), broke the mood of river stillness. Instead of a wood boat awaiting a steamer, he takes us further back in the past to observe the steamboat's predecessor, the flatboat. The painting, constructed as sparsely and as tightly as possible, features eight figures set against the cloudless, but gently modulated, sky of early morning. A central silhouetted figure dances as the sun rises, while he and the other men float gently down the calm waters.

William Sidney Mount had effectively used dancing figures and musicians in such works as *Dance of the Haymakers* (Fig. 31), but none of his celebrants have the dramatic compositional impact of Bingham's single, dancing, silhouetted figure clothed in red and blue. We can almost hear the humble sound of the boy tapping on the tin plate, the scratchy sound of the country fiddle, and the snap of the dancer's fingers breaking the silence of early morning. Like the poetry of Walt Whitman, it is a song of the open road.

As in *Boatmen on the Missouri,* the placement of the oars locks the painting into the picture plane, and the edge of the boat is absolutely parallel to the lower edge of the painting. Part of the flatboat is shown in cross-section: on the top edge of the boat hangs a raccoon skin and a drying blue shirt held in place by a rock. Bedrolls and a curled rope are stowed below. A turkey pokes his scrawny head out of the slatted structure on which the dancer jumps and the two musicians sit, and a cloth that hangs over the lower edge of the flatboat is reflected in the water beneath it with the same softness as the canoe in *Fur Traders.*

The picture is easily entered from our low and nearby vantage point. Of the eight figures, four acknowledge our gaze while their companions remain absorbed in dancing, playing, or listening. The viewer is both acknowledged and ignored, suggesting that this moment is unfolding before our eyes.

The painting was purchased and raffled off by the Art-Union, which used its image twice, first as the etched frontispiece to their bulletin for 1846, and then in a distribution to the Art-Union's

membership, as a line and mezzotint engraving made after the painting in New York by Thomas Doney in 1847.

When *The Jolly Flatboatmen* and another river painting, *Lighter Relieving the Steamboat Aground* (Plate 39), were exhibited together at the Art-Union in 1847, the pair indicated elements of harmony and disharmony on the river. *Lighter Relieving the Steamboat Aground* suggests the dangers to commerce, which snags and other dangers of the river posed, while *The Jolly Flatboatmen* is an ode to the positivist spirit. As Nancy Rash has indicated in an important recent article, *Lighter* alludes to Bingham's and the Whig party's endorsement of federal funding to pay for internal

*Fig. 31 William Sidney Mount,* Dance of the Haymakers. *1845. Oil on canvas, 62.23 × 75.08 cm. (24½ × 29⅞ in.). The Museums at Stony Brook, Stony Brook, New York Gift of Mr. and Mrs. Ward Melville*

improvements of inland waterways. Bingham used the beached steamboat as a subtle indication of the commercial perils of poor river maintenance.[85]

Bingham was an ardent Whig, and the connection between commerce and politics merges in his paintings of life along the river. River crafts served as political emblems in his early political banners for Whig conventions in 1840 and 1844. As Rash has pointed out, contemporary descriptions of these now unlocated banners indicate the use of canoe and boat as emblems of civilization in various stages of commercial development. Bingham's river paintings chart the three-tiered development of Western commerce: from the canoes of the French traders, to the flatboats and subsequently the technologically more advanced steamboats. For all their power and efficiency, however, the steamboats could never match the romantic appeal of the flatboat. Bingham, then, looks back to the simple days of Edenic harmony in the West, takes note of the contemporary political and commercial context of the river, and offers a warning for the future.

When *Lighter Relieving the Steamboat Aground* was first exhibited in St. Louis at Wool's picture store, it was described in the press as depicting "a steamboat, in the distance, aground on a sand bar. A portion of her cargo has been put upon a lighter, a flatboat used to load or unload boats, to be conveyed to a point lower down the river. The moment seized upon by the artist is when the lighter floats with the current, requiring neither the use of oar nor rudder, and the hands collect together around the freight to rest from their severe toil."[86] The writer astutely observes that Bingham does not depict a particularly dramatic incident but rather "has taken the simplest, more frequent and common occurrences on our rivers . . . such as would seem, even to the casual and careless observer, of the very ordinary moment, but which are precisely those in which the full and undisguised character of the boatmen is displayed."[87] The painting can thus be seen as entirely characteristic and typical of river life in general, as well as highly specific and particular in its political meanings.

Canoe, flatboat, and steamboat work as emblems of commerce, technology, and progress, values which allow them to function to this day as "national" images. And, as Rash points out, they indicated Bingham's views on important Whig political issues of the day. *Lighter* and its pendant, *The Jolly Flatboatmen,* indicate the nuances of meaning, the internal dialogue, and references which take place within this series of paintings and which take place within the political process as well.

In *Raftsmen Playing Cards* (Plate 40) the six figures are either entirely preoccupied with the game of cards or lost in their own thoughts, the kind of meditative self-absorption that is a recurring

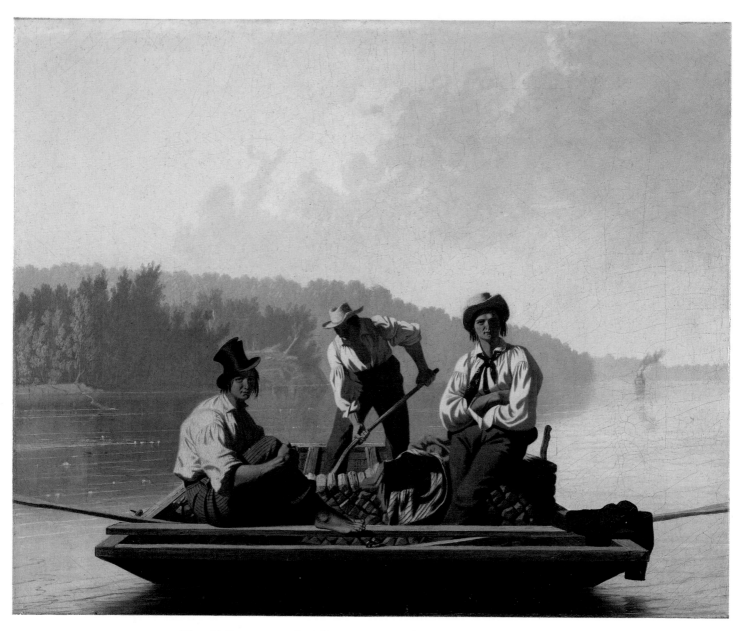

*Plate 38* Boatmen on the Missouri. *1846. Oil on canvas, 63.5 × 76.2 cm.*
*(25 × 30 in.). The Fine Arts Museums of San Francisco, San Francisco, California*
*Gift of Mr. and Mrs. John D. Rockefeller III*

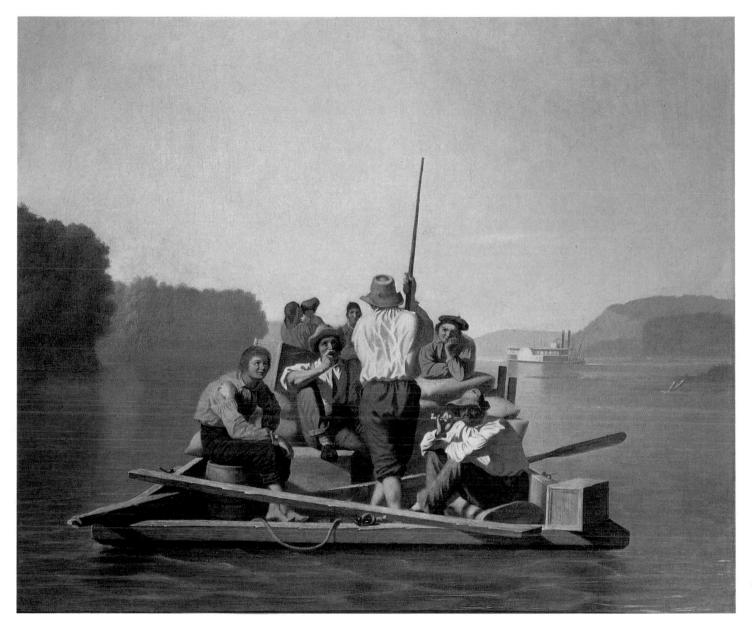

*Plate 39* Lighter Relieving the Steamboat Aground. *1846–47. Oil on canvas, 76.8 × 91.4 cm. (30¼ × 36 in.). The White House Collection, Washington, D.C.*

theme in Bingham's work. With *Raftsmen Playing Cards* he approached his subject still more closely. For the first time the viewer is on the raft itself, as it is poled through the shallow water between the snag on the right and the sandbar on the left. Like the previous paintings, the time of day is dawn with sunlight casting long shadows across the boat. In the foreground are the charred remains of the previous night's fire. And a figure who sits groggily at the left has not fully awakened.

Bingham evolved his river pictures with an almost cinematic self-awareness—moving the viewer from the riverbank onto the raft itself, moving from the simpler format of two *Fur Traders* to the multiplicity of six figures. In this picture, instead of the geometry of the extended oars in the wood boat and the flatboat, Bingham uses the foreshortened trapezoidal form of the raft to project us more deeply into the picture space and to contain our concentration on the six men. The two prongs of shoreline and the hazy banks in the distance gently enfold the foreshortened form of the raft.

*Raftsmen Playing Cards* was also submitted by Bingham to the Art-Union, where it was purchased and distributed by lottery. *The Jolly Flatboatmen* and *Raftsmen Playing Cards* suggest active and passive aspects of life among the raftsmen, and in that sense, they too, might be considered loose pendants. While the state or condition of Bingham's characters may vary, the river, sky, and land remain tranquil and consistent.

After painting *Raftsmen Playing Cards,* the artist executed a group of four works of river people on the shore. Thematically, the paintings marked Bingham's return to his first known river painting, *Western Boatman Ashore* (1838). Of these works, only one has been located, *Watching the Cargo* (Plate 41), which depicts a group of three asymmetrically-placed figures lounging on a river sandbank. In the previous picture, the viewer was upon the raft; now we are firmly ashore, observing the group of three figures lounging on the riverbank. They are the protectors of the stored cargo removed from the listing steamboat in the distance which, as in *Lighter Relieving the Steamboat Aground,* rests unceremoniously and powerlessly on the right side of the composition. An improvised lean-to protects the cargo from the chance of rain, and the freely painted clouds announce the arrival of evening. In the distance we see a tiny skiff onto which two other figures continue to unload the cargo from the injured steamboat.

The viewer seems close enough to speak to the men on shore who, with their work completed, now rest. The man in the foreground is casually, yet heroically posed. Both he and the frontally placed older man in a blue cap return the viewer's gaze, while the most youthful member of the trio is absorbed in an amusing attempt to start a fire. Rash has indicated the irony of the attempt to start

a wood fire in the foreground, even as the wood-fired steamboat is a helpless captive in the background.

*The Wood-Boat* (Plates 2, 42), like *Watching the Cargo,* features an off-center composition. The central figures await the arrival of a steamboat, which will need to be loaded with fresh wood. The painting shows dawn breaking once again, far from any urban location. The poleman, with his endearingly cocked head and strongly silhouetted form, is the heroic figure in this work. His assertion is as two-sided as any of the pictures discussed thus far—strength and gentleness, industry and passivity and, perhaps above all, abundant good health. In the timeless world of these paintings, there is little sense of danger or death.

A raking pink light washes across the picture, casting its rosy glow on the stony bluffs, on the edges of the stacked wood, and on the rocks by the river. Each of the figures—the wizened old man puffing on his thin pipe; the simple, round-faced boy who sits with his hand on his chin; the ruddy-cheeked central figure; and the half-hidden fisherman slouching forward—are all lost in their own thoughts. Their job is to wait.

The same year as *The Wood-Boat,* Bingham painted *Fishing on the Mississippi* (Plate 43), which also groups figures on the banks of the river. The rope that moors the unseen fisherman's boat is tied to a tree stump in the foreground. Another man has a fishing line extended tautly in the water. As in *The Wood-Boat,* the figures wait patiently, in this case for a fish to bite. As a counterpoint to the inaction of the fishermen, three men are seen in the middle ground, vigorously maneuvering their flatboat. *Fishing on the Mississippi* has one of Bingham's most dramatic skies. The clouds range in color from green in the foreground to pink in the background, the light casting pink highlights in the stones on the rocky bank. The following year, 1851, Bingham painted *Mississippi Fisherman* (Plate 53), with a single figure who quietly and calmly sits in the subdued shade of the riverbank.

It seems contradictory that an artist as devoted to hard work and diligent effort in his personal and professional life as Bingham was should create so many paintings in which the central action appears to be inaction. Yet, there are many virtues and facets to rest—contemplation, moderation, and deliberation being just a few. And when we consider that the subjects who meditate before us, impassively smoking long-stem pipes or gazing toward bobbing fishing lines in the river, are anonymous members of a working class, then we can clearly realize that Bingham was celebrating the heroism of the common man while defining an American type of democratic hero. In the rivers, rafts, and people Bingham depicted in the 1840s, the artist found a Western American ideal.

Cleansing these stevedores of their flaws, he displayed them as poised, hearty men in tune with themselves and their place.

While Bingham painted an explicit group of river paintings, he also made a small group of landscapes, such as *Landscape with Cattle* (see Plate 23), which incorporate the river into their benign view of man and nature. When this painting was put up for raffle in St. Louis at five dollars a chance in 1846, it was described as ". . . representing the majestic old woods rising on the rich bottom; the herd declining beneath their shade; the river winding its way in the distance, and in the background, a bold bluff rearing its high summit, in wild grandeur, beside the father of water."[88] In this painting, where the river is deeply embedded in the landscape, one is reminded of Thomas Cole's belief that without water "every landscape is defective."[89] Two trees flank the deep central space: on one side, an intimate woodland glen closes the view, while on the other side, a purple mountain blocks further recession into depth. Cows, as symbols of human settlement, point the viewer into the scene. They sit with the same stolid and comfortable placidity as Bingham's river boatmen or Mississippi fishermen and, though people are not depicted in the painting, it is as deeply homocentric as the more overtly domestic paintings.

*Landscape with Waterwheel and Boy Fishing* (see Plate 26), approaches the river more conventionally and is more closely tied to Bingham's own youthful memories than with commerce on the river. Here Bingham took the structure he previously had depicted as a rustic cottage and adapted it into a rustic mill. The role of children in these paintings not only reflects the artist's reminiscence of his own youth, but also his involvement with his own young family. Like a number of Bingham's landscapes, this work does not seem specifically rooted in the American West, but has a rather generic quality which ties it more closely to European sources such as the paintings of George Morland.

The common formal connection in these various landscape paintings is the use of water. Water is a soothing, almost continual presence in Bingham's landscapes and in many of his genre paintings. Its movement and reflections are visual metaphors for his thoughts about the passage of time and experience, the conduit which allowed Bingham to create images out of his own past. Water was a primary component of his own upbringing in Franklin and in Arrow Rock, and its shifting, yet constant, nature prompted Bingham to filter out extraneous details, to use a foreshortened view of the river as a formal pictorial device, and to depict water in the hazy, dream-like light of early morning.

Pure landscapes form something of an anomalous category in Bingham's work. They may have served as source materials for some of his more successful genre paintings, in which river, trees, and background support a narrative situation. Yet the landscape paintings are never as pictorially self-sufficient as the genre paintings. Nowhere are landscape and meaning more tightly bound than in the River Paintings.

By the mid-1850s Bingham had accomplished a great deal. He was a well-trained artist who had achieved some national recognition, but major commissions still eluded him. And he had not personally seen the European paintings that he had studied in prints. European travel held out the possibility of completing his artistic education and propelling him in the direction of great history painting. Thus, the "Missouri Artist," revered in his home state and possessing a modest national reputation, was spurred into a European sojourn by the Missouri Legislature's commission of portraits of Washington and Jefferson. He went abroad with the full blessing of his home state and pointed himself in a new direction: historical portraiture. His ambitions pulled him away from the paintings we so highly admire today. Certainly, the closing of the Art-Union in 1852, and the loss of its support made it easier for him to turn away from the rich soil, water, and people who had inspired him for more than a decade. He was moving into a different sphere of artistic ambition; yet, he was not closing the door unequivocally. At least one great river picture remained to be painted.

The commission to paint a portrait of George Washington for the Missouri State Capitol stimulated Bingham to execute a genre painting that might serve as a prototype for a large historical painting and which indicated, rather humorously, the powerful grasp which his images of river life had upon his imagination, (see Fig. 13). Emanuel Leutze's huge painting, *Washington Crossing the Delaware,* is the best-known example of a carefully constructed history painting done in Düsseldorf. Bingham may have seen the painting when he visited the *Industry of All Nations* exhibition in New York in 1853, where the painting was enormously popular. In his work, Leutze deftly enlarged and romanticized a historical incident. In response to Leutze's vision of Washington at the prow of a long boat, Bingham devised a painting of the same subject he appears to have begun in America and completed in Europe. Instead of a long boat, Bingham placed the "Father of Our Country" rather unceremoniously amid soldiers crowded on what appears to be a Mississippi flatboat. Of the soldiers with the poles in the foreground of *Washington Crossing the Delaware,* only the one in the far right-hand corner has any energy. The front left poleman and the central soldier are lost within their thoughts as they look out toward the blue-green ice. The painting is far from the spacious and gentle

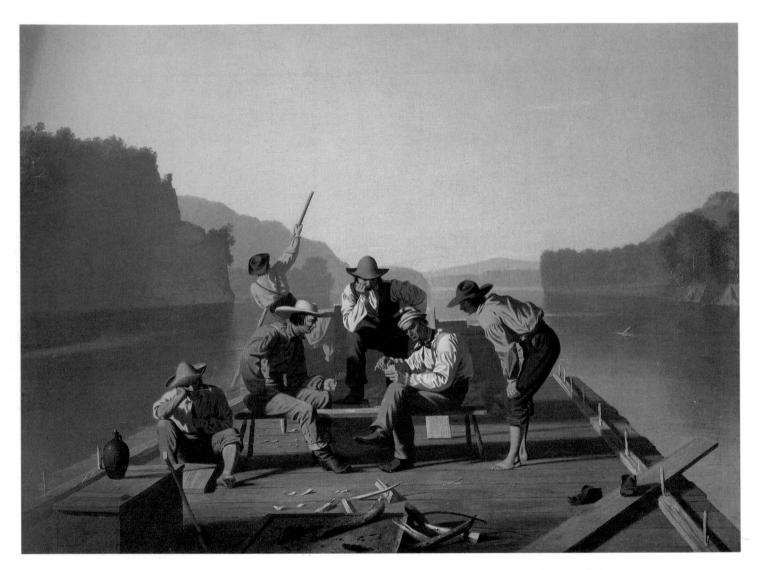

*Plate 40* Raftsmen Playing Cards. *1847. Oil on canvas, 71.12 × 96.52 cm. (28 × 38 in.).*
*The Saint Louis Art Museum, St. Louis, Missouri Purchase: The Ezra H. Linley Fund*

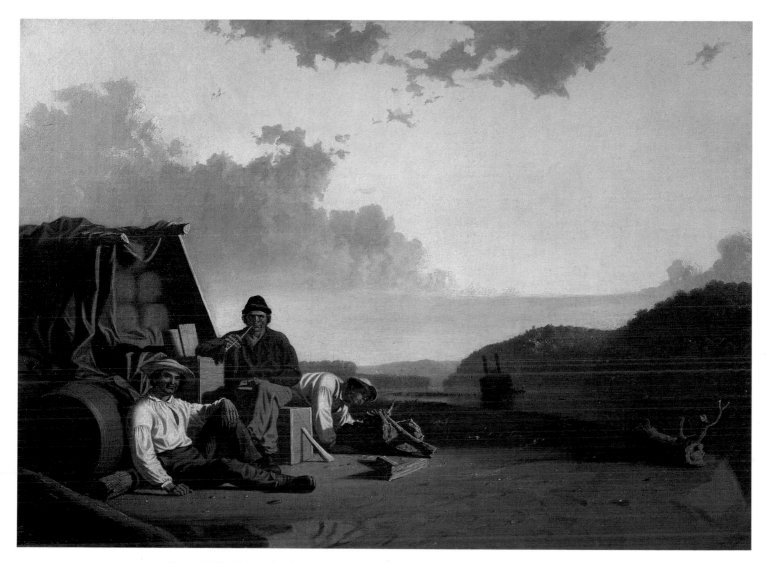

*Plate 41* Watching the Cargo. *1849. Oil on canvas, 66.04 × 91.44 cm. (26 × 36 in.).*
*The State Historical Society of Missouri, Columbia, Missouri*

mood of the river paintings, the figures farther still from the relaxed, almost languorous freedom of his boatmen and woodmen. William Ranney's *Marion Crossing the Pedee* (Fig. 32), which may be a source for the later work, is a far more integrated use of a flatboat in historical context than Bingham's.

The Bingham family traveled first to Paris and then to Düsseldorf, another substantial artistic center, late in October 1856, obtaining a studio through the assistance of the American expatriate painter, Emanuel Leutze. A number of American painters gathered around Leutze, including Worthington Whittredge and Eastman Johnson. A fellow Missouri artist, Charles Wimar, left Düsseldorf to return to St. Louis just before Bingham arrived. Thus, the city was an active location for Americans, one can say especially Missourians, abroad. Bingham looked to Leutze and the Düsseldorf Academy to complete his artistic education, and in that regard he followed in the footsteps of Johnson and Whittredge.

The life of Düsseldorf's German artistic community centered around the Düsseldorf Academy, whose teachers favored a style of precisely painted historical narrative. The fact that there was a single, preferred manner of painting was suited to Bingham's style and temperament, and the more relaxed, rural pace of the city appealed to him as well. Soon after his arrival in Düsseldorf, he was welcomed into Leutze's studio.

Bingham's last major river painting, *Jolly Flatboatmen in Port* (Plate 45), was conceived and executed during Bingham's residence in Düsseldorf. The painting's structure and its dry execution reflect the artist's exposure to and absorption of Baroque principles of pictorial construction. These principles endorsed a painting which opened asymmetrically, with a complex grouping of figures that lead to a dramatically posed central element. The first part of the title and the pose of the dancing central figure refer back to the earlier *The Jolly Flatboatmen* of 1846, but in composition, setting, and size the latter picture is distinct from its predecessor.

In a letter written from Düsseldorf, Bingham referred to the painting as "a large picture of 'life on the Mississippi'."[90] This characterization may be helpful in viewing the work less as a specific river painting and more as an effort by Bingham to extend and broaden his vision. As the sun rises on the east side of the river, the flatboat, docked at the wharf in St. Louis, is crowded with dancing, music making, and boatmen relaxing. The sharp morning light etches the shape of the straw-hatted man in the foreground and of the still-life arrangement of the jug, basket, and wooden bucket beside him. The activity at the center of the picture is so lively that the men aboard another flatboat have

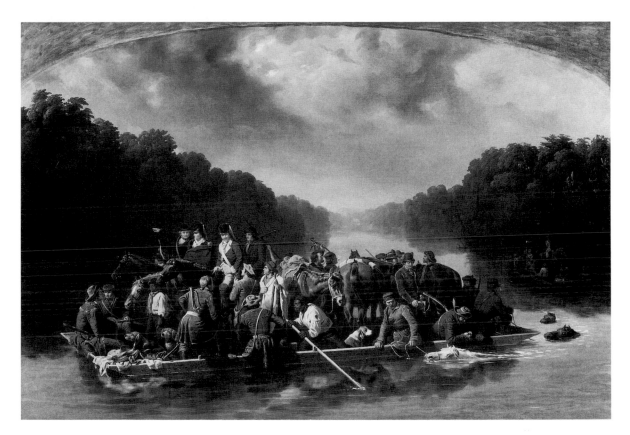

poled over, and are about to tie up to listen to the music. Yet, the scene appears to be commonplace. Neither the two men conferring nor the children playing "mumble the peg" to the right of the central group notice the raucous action beside them.

In place of the frontal approach and classical equipoise which so forcefully silhouetted the primary figures in the earliest of his river pictures, *Jolly Flatboatmen in Port* is structured obliquely. Massing the figures on the left of the canvas, Bingham used the edge of the boat and the line of the dock to open the scene onto a vista of river warehouse buildings and docks. The subject matter of the urban docks might relate to an unlocated painting from 1849, *St. Louis Wharf.*

Although Bingham dramatically weighted some river paintings to one side, like *Watching the Cargo,* they had only three or four figures. However, his complex, multi-figured political paintings from the 1850s also emphasized a particular side. *Jolly Flatboatmen in Port* is the only

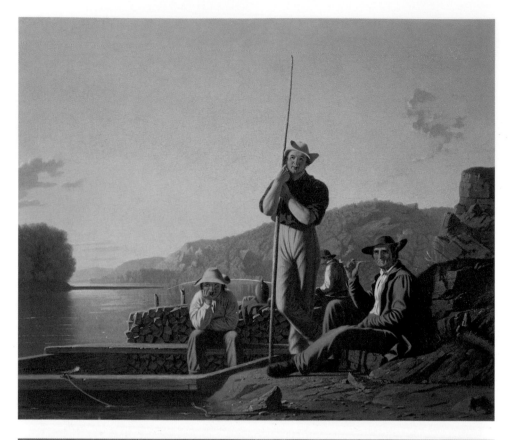

*Plate 42* The Wood-Boat. *1850. Oil on canvas, 62.86 × 75.24 cm. (24¾ × 29⅝ in.). The Saint Louis Art Museum, St. Louis, Missouri Museum Purchase*

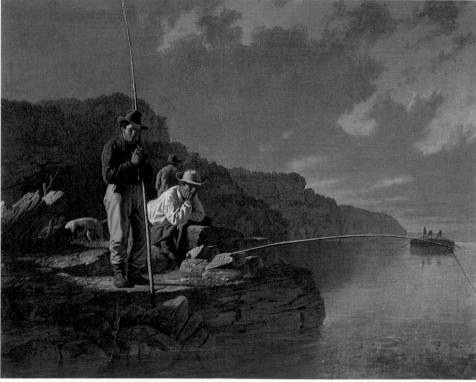

*Plate 43* Fishing on the Mississippi. *1850. Oil on canvas, 72.54 × 91.12 cm. (28⁹⁄₁₆ × 35⅞ in.). The Nelson-Atkins Museum of Art, Kansas City, Missouri Nelson Fund*

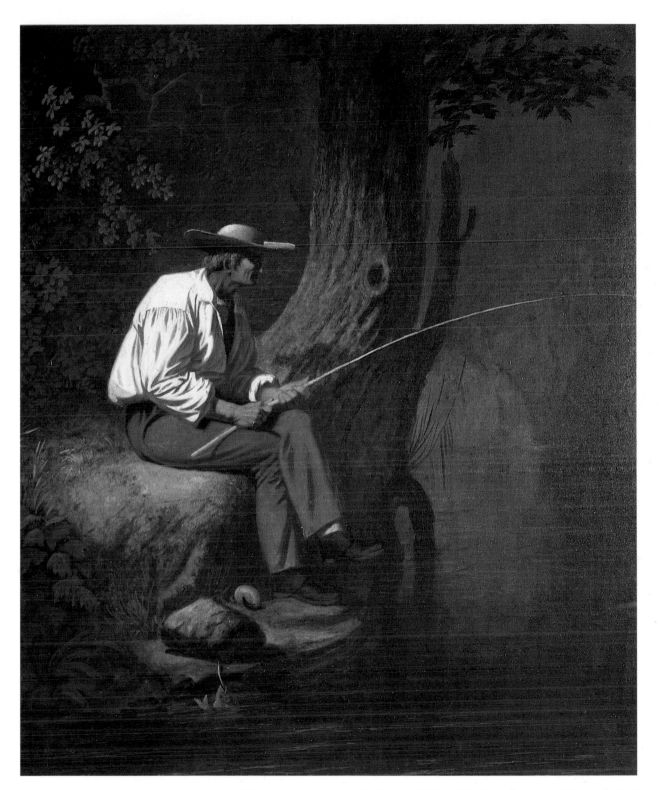

*Plate 44* Mississippi Fisherman. *c. 1851. Oil on canvas, 74.93 × 62.23 cm. (29½ × 24½ in.). Jamee and Marshall Field*

river painting that aspires to the structural complexity of the political paintings. The baroque asymmetry of the composition in *Jolly Flatboatmen in Port,* its complex amalgam of nearly two dozen figures, its reach to the soaring crescendo of the dancing figure, and its width of more than five and one-half feet, suggest complicated spatial elements and new ambitions in the artist's formal vocabulary.

Rather than marking a new period of increasingly sophisticated painting, *Jolly Flatboatmen in Port,* in fact, marked the concluding note of one of the most important periods of Bingham's career. It was the last fully creative work in his great sequence of River Paintings—both a summation and an end point which re-employs figures, some from more than a decade before, and reuses groups and settings in a dramatically different manner.

The painting was intended as a grand statement, an American picture which in size and complexity was in the tradition of important European paintings. It achieves that aim, but not without certain costs. As the eighteenth-century American painter John Singleton Copley's work became more rhetorical when he emigrated from Boston to England, so does this painting seem a more Europeanized version of an American subject. Bingham's direct experience of European painting collections had changed him. This picture, his last transcendent river picture, integrated both the European and American influences in perfect, complex stasis. It was a point of creative convergence, of artistic achievement, and of finality.

When Bingham first began as a portrait painter, he developed a compositional format into which he inserted individual sitters. As his style matured, his formal range broadened. One of the remarkable aspects of the River Paintings, however, is the personal and artistic variation and growth within the finest works of the sequence. The theme grew, beginning with the four figures in *Boatmen on the Missouri,* adding the dynamism of the central figure and the greater breadth of the flatboat in *The Jolly Flatboatmen.*

In *Raftsmen Playing Cards,* the painting included the presence of the viewer on the craft itself. And, it encompassed the men on the banks of the river: those who watch the cargo, anticipate the steamboats, or wait for fish to strike their lines. The series is drawn together by the types of figures, their attitudes and activities and, most of all, the river itself. The sequence completes itself with the achievement of the *Jolly Flatboatmen in Port.*

Beginning in 1851, just six years after his first river painting, Bingham began to repeat himself in an uninspired manner. *Trappers' Return* (Fig. 33), the last painting by Bingham to be purchased

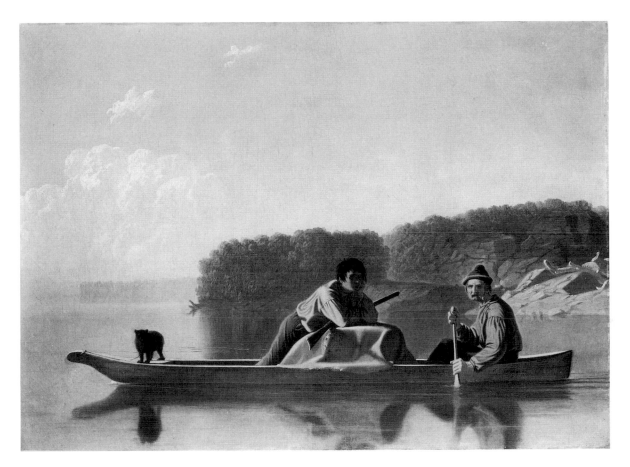

*Fig. 33* Trappers' Return. *1851. Oil on canvas, 66.68 × 92.08 cm. (26¼ × 36¼ in.).*
*The Detroit Institute of Arts, Detroit, Michigan Gift of Dexter M. Ferry, Jr.*

by the Art-Union, was auctioned in 1852 along with the remaining property of the organization. The painting explicitly refers to *Fur Traders Descending the Missouri,* but with a marked diminution of effect. In each instance that Bingham repeated himself, the second version is invariably inferior. With *Trappers' Return,* the lack of detailing of costume and objects and the plainness of the sky diminish the glorious and delicate effects of the original painting.

Also in 1851, Bingham painted *In a Quandary* (Fig. 34), on commission from Goupil & Co., to serve as the basis for a print. The painting adapts the central grouping from *Raftsmen Playing Cards* and integrates them into an evening setting. Bingham's attempts to extend his work into the moody realm of nocturnes did not meet with success. Two paintings, each titled *Woodboatmen on a River* (1854), combine elements in earlier paintings like *The Wood-Boat* and *Watching the Cargo*

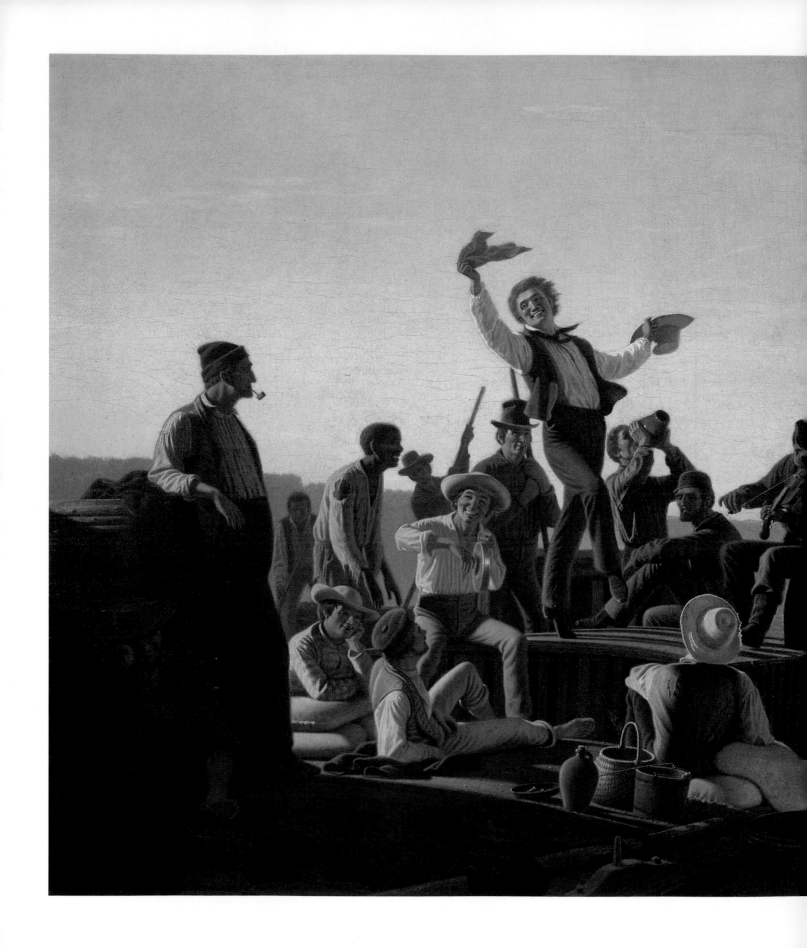

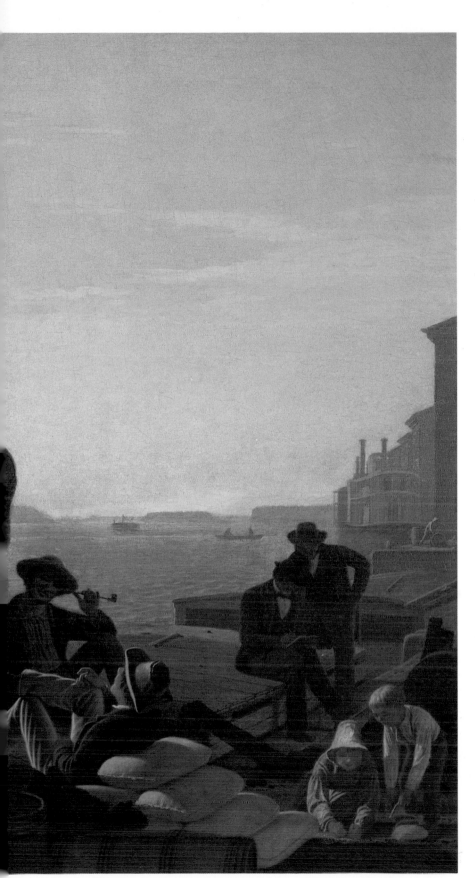

*Plate 45* Jolly Flatboatmen in Port. *1857. Oil on canvas, 119.53 × 176.84 cm. (47¹/₁₆ × 69¹⁰/₁₆ in.). The Saint Louis Art Museum, St. Louis, Missouri. Museum Purchase*

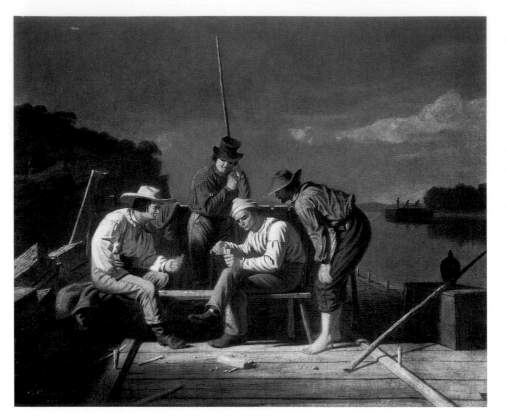

*Fig. 34* In a Quandary. *1851. Oil on canvas, 43.81 × 53.34 cm. (17¼ × 21 in.). The Henry E. Huntington Library and Art Collections, San Marino, California The Virginia Steele Scott Collection*

with the humid, nocturnal atmosphere of a campfire group. But the complete introversion of these paintings lessens their ability to serve as more than mood pieces.

The painting that explicitly sums up the problems of replicas and adaptations in Bingham's work also strikes the final chord in the sequence of the River Paintings: *The Jolly Flatboatmen,* 1877–78 (Fig. 35). In the original painting of similar name from 1846, the central figure energized the painting with his bursting good health and well-being; in the late painting he has become the awkward boy who holds his hat in one hand. The flatboat itself, in the later version, is plainer in construction, darker in color, with a less pronounced grain than before. Perhaps the most telling index of the differences between the late adaptation and the original painting is that the water itself—the buoyant liquid that is the vital force behind these paintings—is duller and less reflective than in the earlier paintings. The late version of *The Jolly Flatboatmen* is a dispirited denouement to Bingham's earlier achievements.

Because of the combination of the loss of the Art-Union, the Civil War, his involvement with politics, his family travails, and other factors, we can say with assurance that his artistic commit-

ment slackened. The replicas, revisions, and adaptations by Bingham of his earlier work indicate a severe relaxation of his initial vision and his artistic concentration. His Arcadian views of water as the source for commerce, food, and domestic activity had a distinct prelude in some of his earlier works in the 1830s, but the finest achievements which unified water, landscape, boats, and people in utter synthesis were circumscribed by a twelve-year period, from 1845 to 1857. The clarity of light, of composition, and of execution—the movement of the sequence, from the singular unit of *Boatmen on the Missouri* to the complicated scaffolding of *Jolly Flatboatmen in Port*, represents a series of utopian views. The complex dialogue of meditation on labor, on nature, on progress, and commerce that these images contain, bear within themselves the most exemplary values of American experience.

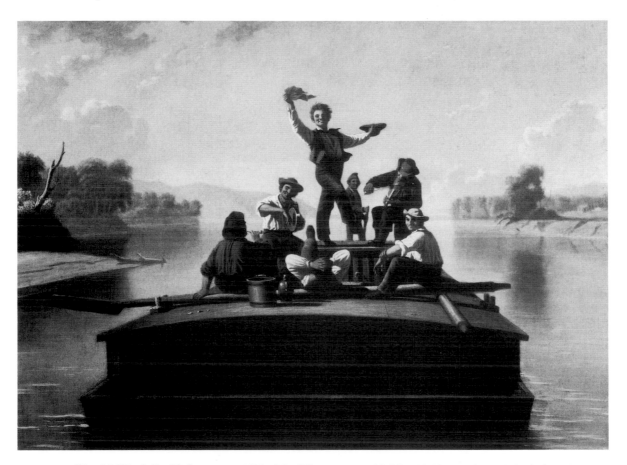

*Fig. 35* The Jolly Flatboatmen. *1877–78. Oil on canvas, 66.04 × 92.07 cm. (26 × 36¼ in.).*
*Terra Museum of American Art, Chicago, Illinois Daniel J. Terra Collection*

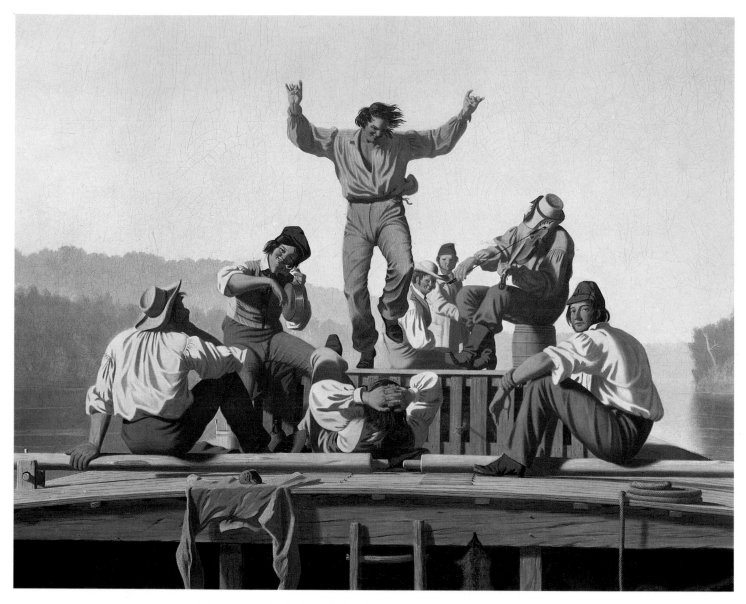

*Plate 46 detail of* The Jolly Flatboatmen (1), *1846. (See Plate 37.)*

# BINGHAM'S GEOMETRIES AND THE SHAPE OF AMERICA

## By John Wilmerding

Looking at the configurations of Bingham's career, we are struck by the fact that out of a relatively long life (1811–1879) and an extensive working output from about 1830 up to 1879, his truly significant art is confined just to the ten years between 1845 and 1855. But in that decade exactly straddling the mid-century mark he was a major figure who made some of America's greatest art. To be sure, during the years leading up to this period he made numerous workman-like portraits and several charming landscape and genre pieces. In their design and touch these showed his artistic awareness of precedents by Thomas Sully and Joshua Shaw, and even when he turned to his classic frontier genre pictures in the later 1840s, we know he was indebted to the inherited traditions of seventeenth-century Dutch and eighteenth-century English compositions. Partly as a result of his trip to Düsseldorf in the late 1850s, Bingham modified his style to the more polished finish and dramatic manner of the German school, and his subjects thereafter tended increasingly toward theatricality, contrivance, and obvious sentiment. While there is a clear technical finesse in many of his later portraits, his later history and genre pictures labor under exaggerated gestures, detailing, and narrative message. All the more commanding, then, is his triumphant combination of subtlety and energy in the slightly more than two dozen democratic images painted in the high noon of those central ten years.

Stylistically, Bingham's work of this critical period has a consistent clarity, structure, and solidity about it which, on one level, we recognized as his signature manner and, on another, as an expression of America's supreme moment of self-confident optimism and expansionism. No matter the variety of posture or complexity of detail, Bingham was able to distill both a visual order and

palpability of space and form which spoke directly to the period's aspirations for harmony between the real and the ideal and between man and nature. To achieve this purity of design and volume in his compositions Bingham relied primarily on a few fundamental geometries for his arrangements of figures in space. These were in linear and planar terms the horizontal and the triangle, but more importantly the solid geometries of pyramid and sphere, purely classical in their serenity, individuality, and dignity.

Indeed, the stable pyramid is the organizing form in his most famous painting, *The Jolly Flatboatmen,* but it also served as the basis for groups of boatmen ashore, as in *Watching the Cargo* and *The Wood-Boat.* Transferred to a tavern setting, the formula worked in variants for *The Checker Players, Country Politician,* and *Canvassing for a Vote.* Bingham made further use of this massing, both for a single figure in *The Concealed Enemy,* as well as for one of his first large group compositions, *The Emigration of Daniel Boone.* He constructed at least three of his other finest boatmen pictures around what might be called an implied or truncated pyramid, namely *Fur Traders Descending the Missouri, Boatmen on the Missouri,* and *Raftsmen Playing Cards.* Yet a third formal type could be termed the partial pyramid, where we see the massive sloping volume cropped and pushed to the left-hand side of the painting, most notably in *Cottage Scenery* and *Shooting for the Beef.* Closely related are yet two others which combine different pyramidal geometries for the landscape and figures respectively: *The Squatters* and *Fishing on the Mississippi.* However modulated, this is clearly the language of classicism or, more properly in mid-century America, neo-classicism, for which we can find numerous echoing parallels and similarities in the other major art forms of these years.

The circle and the sphere, of course, in their symmetry and unity are also essentially classical forms. Bingham especially delighted in using this volume both for the heads and torsos of his figures, as may be seen in *The Concealed Enemy, Country Politician, The Checker Players,* and *Canvassing for a Vote.* Finally, art historians have well noted Bingham's literal quotations of classical references, particularly Renaissance and ancient sculpture.[91] This dominant classicism of both form and content in Bingham's work just between 1845 and 1851 makes us all the more alert to his changes in scale, massing of forms, and spatial organization that appear to occur around 1852 with the large *Election* pictures and most obviously with the Düsseldorf *Jolly Flatboatmen in Port* of 1857. Given the traditional evolution of stylistic movements, we might see the *Election* canvasses as a baroque phase of Bingham's work, notable for their density, complexity, asymmetrical organization,

and animated contrasts of light and shadow. By extension, the later *Jolly Flatboatmen in Port* represents an emerging rococo style, lively, even fussy, sentimental and theatrical.

Bingham's classical core of work may readily be placed in the larger context of an exuberant, proud, and self-assured America in the years around 1850. His artistic vision of stability, centrality, and equipoise perfectly matched its time and place. His best art was created at the almost exact midpoint of the nineteenth century and in the near geographical center of the country. America's growing population and territorial expansion were rapidly moving west, accentuated by the California Gold Rush of 1849. Said Thoreau at the time: "Westward I go free."[92] Like the center of a compass, Bingham's world at the confluence of the Missouri and Mississippi rivers was in the cross-axis of America's great geographical tensions. Born in the East himself, he moved west along with many of his countrymen. That movement of settlers, adventurers, and the railroad from east to west across the continent was still in motion by the 1850s. But while the prairie schooners sailed on one course, steamers and barges moved on the north-south axis of the Mississippi River. Symbolically, this direction was also the locus of the country's growing conflict over slavery, addressed in our literature's two greatest novels on the subject, *Uncle Tom's Cabin* and *Huckleberry Finn*. The former, published by Harriet Beecher Stowe in 1852, significantly coincides with the apogee of Bingham's oeuvre. We know of the sometimes frustrating firsthand involvement the artist had in politics from the 1840s to the 1870s. He set down his wide-ranging observations on the vitality and foibles of democracy in the *Election* series of the early 1850s.

But American politics, especially in this critical antebellum decade, focused increasingly on the slavery issue, itself intimately bound up with the frontier territories. The decade of the 1850s was on one level a high moment of national achievement, but on another the currents of tension and instability were inexorably rising to the flashpoint of civil crisis by the 1860s. Bingham's physical and emotional terrain was bounded by the key events of that time and place—the Compromise of 1850, "Bleeding Kansas," and "Free Soil" Missouri—which debated the inseparable concerns of territory and freedom, slavery and union. With the passions of sectionalism at a feverish high in 1856, Bingham, as politician and artist combined, began to contemplate a pictorial response to the passage of the Kansas-Nebraska Bill of two years before. This purported to decide slavery in certain territories on the basis of so-called "Squatter Sovereignty," and led only to border warfare and spreading violence.[93] Subsequent hostilities in 1863 finally led him to paint *Martial Law* or *Order No. 11*, not finished until 1870 in, by then for Bingham, an unfortunately melodramatic style. The

point is that Bingham's landscape was literally at the center of American history, and his dominant artistic attention to pictorial order and balance is all the more interesting in this light.

The metaphors of zenith and apogee are applicable not only to Bingham's art but to many other aspects of America at this moment. The decade of the 1850s was a period of national triumph, in part because of the temporary stasis which followed the ending of the Mexican War in 1848. The consequent political strains were held in check until the end of the 1850s and the inevitable outbreak of the Civil War. Meanwhile, the concept of Manifest Destiny, which had seized the national imagination during the second quarter of the nineteenth century, seemed near its fullest realization in claiming the breadth of the continent for the union. Territorial expansion was more than matched by staggering increases in the country's population and the gross national product. This period might also be seen as the moment of brief balance and harmony between nature and the so-called "axe of civilization." For the agents of the new prosperity and growth were those of coming industry and its intrusions into the silent wilderness. New technologies in mass production, communication, and transportation were now having a dramatic impact in all corners of the country. For example, the manufacturing of interchangeable parts affected everything from Samuel Colt's firearms in Hartford, to standardized balloon-frame construction of wood buildings everywhere. Morse's telegraph radically changed the pace of conveying information, and the steam engine perhaps above all was poised to revolutionize travel both on land and on water.[94]

Thoreau's celebrated references to the telegraph and the train engine call to mind the proliferation of railroad images in American landscape painting beginning at this time. Among the most famous were George Inness's *Lackawanna Valley* (1855), and *Delaware Water Gap* (1857), Asher B. Durand's *Progress* (1853), and Thomas P. Rossiter's *Opening of the Wilderness* (c. 1858). All of these were significant American visual hymns to the still-harmonious relationship between wilderness and technology. First fully articulated in that decade, the relationship would have poignant echoes in America's self-awareness up to the present. Commonplace by the 1850s, the railroad finally linked the entire continent together by the end of the next decade, and steampower in manufacturing as well as in the ironclads was to be decisive for the North in the Civil War. Symbolic of this age's sense of accomplishment was the United States' triumph in the first America's Cup sailing race against Britain in 1851. Among the several artists who depicted the event was an important contemporary of Bingham, Fitz Hugh Lane, who was also to paint some of the period's most beautiful scenes in his Boston Harbor views of the mid-fifties. Comparable to their colleagues'

renderings of the railroad, these are tender and celebratory responses to a time of poise between sail and steam.

Although the tensions of change underlay much of the country's affairs in the few years surrounding 1850, this period, which coincides with Bingham's highest achievement, was remarkably in many quarters a golden noontime of national self-expression. American literary and cultural historians refer to this moment as the "American Renaissance,"[95] noting the unusual if not unprecedented appearance within a five-year span of more than a half-dozen of America's masterpieces of literature. This canon includes *Representative Men* by Emerson and *The Scarlet Letter* by Hawthorne in 1850; the latter's *The House of the Seven Gables* and Melville's *Moby Dick* in 1851; *Pierre* by Melville in 1852, and *Walden* by Thoreau in 1854; and Whitman's *Leaves of Grass* in 1855. In addition, a number of other nearly as important works were published in close proximity: Whittier's *Songs of Labor,* 1850; Hawthorne's *The Blithedale Romance,* as well as Stowe's *Uncle Tom's Cabin* already noted in 1852; part of Thoreau's *Maine Woods* appeared in *The Atlantic* in 1858; and Hawthorne's *Marble Faun* and Emerson's *Conduct of Life* in 1860.[96] More recently, critics have gone further to call this as well the "American Women's Renaissance," for besides Harriet Beecher Stowe, there was also work appearing by Louisa May Alcott and Lydia Sigourney, among others, and the earliest poetic production of Emily Dickinson in a "rich literary movement . . . when American women's culture came of age."[97]

As historians have shown, this literature embodied many of the tensions and paradoxes of the age, on the one hand "governed by a faith in progress, Manifest Destiny, and human perfectibility," and on the other by an underlying doubt, cynicism, even demonism.[98] But the dominant vision asserted reform and renewal, independence and creativity, typified in Emerson's belief that "unlike all the world before us, our own age and land shall be classic to ourselves."[99] Such dreams of perfection informed not just the art of Emerson and Bingham and their immediate colleagues but, as already suggested, a much broader expression in the American arts at mid-century.

In painting alone we might argue that genre painting reached its apogee in this period, foremost in Bingham's hands but almost equally with William Sidney Mount, whose masterpiece *Eel Spearing at Setauket* coincides with Bingham's first great works in 1845. Likewise, the flourishing of still-life painting at this moment attained an amplitude and ripeness as much in style as in subject, especially in the examples of Severin Roesen and John F. Francis from the mid- and later 1850s. Some painters produce their single most important pictures in this decade, for example,

*Kindred Spirits* (1849), by Asher B. Durand, and *Blue Hole, Flood Waters, Little Miami River* (1851), by Robert Duncanson—both tributes to nature's spiritual strength. Sharing the clarity and suffusion of light found in Bingham's paintings, some of the most powerful paintings by the luminists date from the decade of the fifties. Between 1858 and 1859 alone come Sanford Gifford's *Mount Mansfield,* Martin Johnson Heade's *Coming Storm,* and John F. Kensett's first versions of *Lake George, Shrewsbury River,* and *Beacon Rock, Newport Harbor.*

Arguably, America's two purest landscape painters at this date, Fitz Hugh Lane and Frederic Edwin Church, produced in a comparably brief span of years their best body of work, as accomplished and commanding as the volumes by their literary counterparts in the American Renaissance. The planar structures of Lane's compositions and his glowing ambiences of light parallel Bingham's solid geometries and sun-flooded spaces. In Lane's paintings of Gloucester, Salem, and Boston Harbor, Blue Hill, Penobscot Bay, and Mount Desert, executed between 1850 and 1860, is an imagery of serenity and well-being, personal and national self-fulfillment, which are at the heart of the antebellum calm before the storm.[100] At the same time Church created scenes of blazing light and particularly sunset which were wholly new and supreme in their elocution of the country's heroic course of destiny. Technically and intellectually, they are at the apogee of American landscape painting in the nineteenth century.[101]

These were equally the years of neo-classicism's ascendancy in American sculpture, whose perfected forms and message could be no better seen than in Hiram Powers' *Greek Slave* (1843), and Thomas Crawford's pediment for the U.S. Capitol, *The Progress of Civilization* (1854–56). This was also when the daguerreotype as a medium was at its finest in the hands of Southworth and Hawes, and when Donald McKay gained the pinnacle of clipper ship design with his *Flying Cloud* of 1851.[102] In both enterprises Americans balanced utility and creativity. It was another American sculptor, Horatio Greenough, who articulated these ideas most eloquently in his essays published in 1852, at the end of his life, *The Travels, Observations, and Experiences of a Yankee Stonecutter.* There he argues that "those who have reduced locomotion to its simplest elements, in the trotting-wagon and the yacht America, are nearer to Athens at this moment then they who would bend the Greek temple to every use. I contend for Greek principles, not Greek things."[103] In fact, America in the 1850s relished both Greek principles and Greek things. Classical geometries governed not only painting and sculpture, but the principal forms of architecture at this time as well. Neo-classicism in America had evolved out of imported English Georgian styles at the end of the eighteenth century

into a delicate Adam-influenced Federal style, which in turn gave way during the first quarter of the nineteenth century to the increasingly bold and muscular forms of the pure Greek revival. The more linear and planar character of earlier architecture, expressed mostly in wood, gradually yielded to brick, masonry, and granite composed in powerful solid volumes of space and mass. By mid-century the Greek revival had reached its fullest expression and most widespread influence. One of its major exponents was Robert Mills, who had designed a number of public buildings in Washington and elsewhere. He completed one of his finest works, the United States Treasury building, in 1842 and left office in Washington in 1851, by which time the classical style not only had dominated official buildings but was pervasive throughout much of the country in all manner of domestic and anonymous structures.[104]

In terms of organization the Greek revival style stressed clarity of the various elements, gathered in rhythmic relationships into a unified whole, not unlike the compositional process we have seen in Bingham's art. In terms of character and meaning the style was readily adaptable and pragmatic, therefore well suited to democratic needs. Moreover, its solidity and sense of balance expressed the developing nation's wish for order and strength. At once simple and bold, Greek revival classicism embodied the republic's common aspirations.[105] As with landscape and genre painting, the upheaval of the Civil War period challenged and transformed these modes of expression, whether by a new romanticism, industrial dynamism, or naturalism. The asymmetries of the gothic soon introduced complexities and irregularities appropriate to changed needs.

Bingham, like America in 1850, held moving forces in balance. His triangles and pyramids suggest both apex and pivot. On the one hand, expressions in American literature, painting, and architecture were at a zenith in the nation's life. On the other, this was a decade in transition—between agriculture and industry, sailpower and steampower, sectionalism and union. Artists such as Lane saw the poignant paradox of twilight as both stillness and change. Bingham's dancing flatboatman evokes simultaneously the immediate moment and the transcendent ideal. Exuberantly he occupies center stage, stable vertical set upon solid horizontal, while lifting his feet and snapping his fingers to the pulse of motion and music in the soft still air.

# NOTES

THE MAN AND HIS TIMES

Anyone who seeks to write about George Caleb Bingham must consult the artist's and his family's letters. These are in the University of Missouri Western Manuscripts Collection, Columbia, and in the State Historical Society of Missouri Manuscripts. I am thankful for permission to use this material, and for the encouragement of the Society's director, James W. Goodrich. Many of the letters Bingham sent to James S. Rollins are printed by *The Missouri Historical Review* in a series beginning October 1937, Volume XXXII. The editor was C. B. Rollins. A descendant of James Rollins, Mrs. John C. Cooper III shared information about her forebear with me. I am very grateful for her interest.

I'm much obliged to Henry Adams, curator of American art in The Nelson-Atkins Museum of Art in Kansas City. He responded generously to my needs, which included bringing to my attention a manuscript memoir of Bingham. I appreciate the Nelson-Atkins Museum's permission to use this valuable document, written by the artist's niece. I thank Professor Leah Lipton of Framingham State College. It was she who discovered Bingham's significant recollection of Chester Harding. Thanks go to the New-York Historical Society for allowing me to study the papers of the American Art-Union.

I have depended heavily upon Kathy Heins, the able research assistant in The Saint Louis Art Museum, who never failed me as she gathered material for my use. Kelly Ebeling, research assistant in The Nelson-Atkins Museum of Art, kindly helped me to discover more about Mattie Bingham. In visiting the neighborhood of Arrow Rock, I was cheerfully guided by Coradean and Cecil Naylor, Catherine Kennedy, and Bingham Turley. Mrs. Kennedy exhumed some important land and slave records for me in the Saline County courthouse. The distinguished historian, Charles van Ravenswaay, himself a product of Bingham's countryside, cordially shared his understanding of the artist and took me to see a number of Bingham paintings privately owned in Delaware.

In New York City, Russell Burke of the Kennedy Galleries arranged for me to view Bingham's *The Puzzled Witness*. Doreen Bolger, curator of American art in New York's Metropolitan Museum, generously answered my questions while she showed me *Fur Traders Descending the Missouri*. My approach to Bingham's early genre painting was strengthened by conversations with Paul Perrot, director of the Virginia Museum of Art, and with William Rasmussen, curator of nineteenth century American art in that museum.

Increasingly over the years, many students of American art have written helpfully about Bingham. I am particularly appreciative of publications by E. Maurice Bloch, Albert Christ-Janer, John Francis McDermott, and Fern Helen Rusk. Volumes of *The Missouri Historical Review* and *The Art Bulletin* contain a number of worthwhile articles. I especially recommend the essay by Henry Adams, "A New Interpretation of Bingham's *Fur Traders Descending the Missouri*," which appeared in *The Art Bulletin* (LXV, December 1983), pp. 675–680.

Persons who wish to know more about the Missouri of Bingham's day should read volumes by Perry McCandless and William E. Parrish, which are part of *A History of Missouri*, a series published by the University of Missouri Press. These volumes appeared in 1972 and 1973. There is also *Missouri, A History*, by Paul C. Nagel, which W. W. Norton and Company published in 1977 and which the University Press of Kansas brought out in a paperback edition in 1988.

I have benefited from the reassuring presence of colleagues who have written other parts of this book. For many kindnesses, I thank the project's director, Michael Shapiro, chief curator in The Saint Louis Art Museum, and Mary Ann Steiner, director of publications for the Museum. I've taken comfort from my friend David McCullough, that most

talented of biographers and himself a student of Missouri's character.

My largest obligation as a writer is invariably to my wife, Joan Peterson Nagel. This time the most important reward came from Joan's skill as a genealogist, for it was she who led me through the early U.S. census records to where the Bingham family is hidden.

## THE "MISSOURI ARTIST" AS HISTORIAN

1. George Caleb Bingham to James S. Rollins, November 2, 1845, "Letters of George Caleb Bingham to James S. Rollins," ed. C.B. Rollins, *Missouri Historical Review,* 32 (Oct. 1938), p. 15. Hereafter cited as "Letters," *M.H.R.*

2. "Letters," *M.H.R.*, 32, p. 170.

3. The literature on the paintings is extensive, diverse, and fascinating. See, for example, Roger F. Westervelt, "Whig Painter of Missouri," *The American Art Journal,* vol. 2, no. 1 (Spring, 1970), pp. 46–53; Keith Bryant, "George Caleb Bingham; The Artist as a Whig Politician," *M.H.R.*, 59 (July, 1965), p. 456; John Demos, "George Caleb Bingham: The Artist as Social Historian," *American Quarterly,* 17 (1965), pp. 218–228; Gail E. Husch, "George Caleb Bingham's *The County Election*: Whig Tribute to the Will of the People," *American Art Journal,* vol. 9, no. 4 (1987), pp. 4–22.

4. John Vollmer Mering, *The Whig Party in Missouri,* University of Missouri Studies (Columbia, Missouri, 1967), gives a county-by-county date of organization of the Whig Party in Missouri and the Presidential election years in which each county turned in a Whig majority, pp. 264–265.

5. See Mering, *The Whig Party in Missouri,* pp. 89–93, and the chapter entitled "Whig Characteristics," pp. 52–70. See also Daniel Walker Howe, *The Political Culture of the American Whigs* (University of Chicago Press, 1979), who believes Whigs were non-partisan as a matter of principle initially but eventually joined the fray wholeheartedly. By 1840, both Democrats' and Whigs' "energetic campaigning produced not only high voter participation but also a high degree of party regularity. Neither the participation nor the regularity has been equaled in America since," p. 14.

6. David D. Van Tassel, *Recording America's Past, An Interpretation of the Development of Historical Studies in America 1607–1884* (University of Chicago Press, 1960), p. 100. Also see George H. Callcott, *History in the United States, 1800–1860* (Baltimore: Johns Hopkins Press, 1970).

7. Van Tassel, ibid. p. 100. The author goes on to note that most Western states "had a history of exploration, Indian trade, wars and settlement that long predated statehood, but could claim little or no share in the great national moments of the Federal Union . . . [These] local historical and pioneer societies concentrated . . . on the 'golden age' of the pioneer period and territorial days."

8. Ibid., "Rise of the Romantic Nationalists, 1830–60," pp. 111–120, offers a succinct survey of writers who answered the "patriotic clamour for . . . national history . . .," p. 111. Two colleagues to whom I am indebted should be acknowledged here. William Truettner, "The Art of History: American Exploration and Discovery Scenes, 1840–1860," *The American Art Journal* (Winter, 1982), pp. 4–31, gives a most thorough and penetrating discussion of the ties between Manifest Destiny and the writing of American history. Vivian Green Fryd, "Two Sculptures for the Capitol: Horatio Greenough's *Rescue* and Luigi Persico's *Discovery*," *American Art Journal,* 19 (1987), pp. 17–39, helped me to think about the "Indian issue" in fuller terms.

9. See, for example, Roy Harvey Pearce, *The Savages of America: A Study of the Indian and the Idea of Civilization* (Baltimore, John Hopkins Press rev. 1965), who traces the evolution of the concepts pertaining to Indian "savagery" and English/American "civilization" in the sixteenth, seventeenth, and eighteenth centuries. Compare to this a later interpretation of civilization: when, at the end of the nineteenth century, Matthew Arnold confronted Americans full of pride in their prosperity and now defining civilization in strongly material terms, by saying, "Do not tell me only of the magnitude of your industry and commerce, of the beneficence of your institutions, your freedom, your equality; of the great and growing number of your churches and schools, libraries and newspapers; tell me also if your civilization—which is the great name you give to all this development—tell me if your civilization is *interesting*" (Matthew Arnold, *Civilization in the United States,* [Boston, Discourses in America, London, MacMillan and Co., 1885], 3rd. discourse given in Boston, p. 170). "Progress," "savage," and "civilization," because they are such loaded, and ethnocentric, words, should be thought of as having quotation marks around them; to print them always with these additions, however, will make for cumbersome and distracting reading.

10. Henry Adams, "A New Interpretation of Bingham's *Fur Traders Descending the Missouri*," *The Art Bulletin,* 65, no. 4 (December, 1983), pp. 675–680.

11. Adams' analysis is much more detailed, of course, and culminates in an examination of the contrast between the Salvator Rosa mode of *Concealed Enemy* and the Claudian mode of *Fur Traders.*

12. E. Maurice Bloch, *George Caleb Bingham, The Evolution of an Artist,* vol. 1 (Berkeley and Los Angeles, University of California Press, 1967), p. 112.

13. Roy Harvey Pearce, "The Significances of the Captivity Narrative," *American Literature,* 19 (1947–48), pp. 1–20. This essay later formed part of *Savages of America.* I am reminded in a book written by Robert F. Berkhofer, Jr., of the profound ethnocentricism of my every mention of "Indian," since I, like Pearce and most other non-Indians, treat all Native Americans as a single stereotype in order to make a point about somebody else's stereotyping. As a writer who speaks against such cultural abstractions, Berkhofer deals not only with "The *Indian* in White Imagination and Ideology" but also with "The Genealogy of the Scientific Image of the Indian" in *The White Man's Indian: The History of an Idea from Columbus to the Present* (New York, Knopf, 1978).

14. Fryd, "Two Sculptures for the Capitol," p. 30.

15. A. Theodore Brown, *Frontier Community, Kansas City to 1870* (Columbia, Missouri, University of Missouri Press, 1963), p. 49. In *Political Culture of the American Whigs,* Howe mentions several times that the Whigs in general were opposed to the Indian policies of the Democratic administrations and particularly to the Indian Removal Act, though eventually "prudential considerations dictated Whig acquiescence in the removal of the tribes," p. 42.

16. Bingham to American Art-Union, November 19, 1850, quoted in Bloch, *George Caleb Bingham, The Evolution of an Artist,* vol. 1, p. 105.

17. In August 1856, Bingham told Rollins, "I have it in contemplation to paint a series of pictures illustrative of 'Squatter Soverignty' [*sic*] as practically exhibited under the workings of the Kansas-Nebraska bill" ("Letters," *M.H.R.,* 32, [January, 1938], p. 201). Here he does show marked distaste but he refers specifically to the lawlessness of the voting connected with the border wars: "I shall commence with the *March of the Border Ruffians* . . ." See below, p. 22.

18. *Annals of the Missouri Historical and Philosophical Society,* no. 1, 1848, 1–6. See also Sec. 2 of the Act of Incorporation (1845) of the Society: "The objects of the Society shall be to collect, embody, arrange and preserve in an authentic form, the materials for the history of this State, to accumulate a library of books, pamphlets, maps, charts, manuscripts and papers, a cabinet of ores, minerals, fossils, and other natural productions; and a museum of relics, curiosities and other articles that may illustrate the history of the country. It shall be an object of the Society to rescue from oblivion the memory of the early pioneers of this State, and to obtain and preserve in an authentic form the history of their exploits and perils; and it shall

exhibit in their true light the resources of the State. It also may take proper steps to promote the study of history, and to diffuse and publish information relating to the description and history of Missouri."

19. *Annals of the Missouri Historical and Philosophical Society,* p. 23.

20. As quoted by E. Maurice Bloch, "A Bingham Discovery," *American Art Review,* 1 (September-October, 1973), p. 22, in which Bloch's discovery of the work (in a private collection) is published. The newspaper reporter's assumption was first repeated at the turn of the century by May Simonds, "A Pioneer Painter," *The American Illustrated Methodist Magazine,* vol. 8, no. 2 (October, 1902), p. 74.

21. "Letters," *M.H.R.,* 32 (October 1937), pp. 19–20.

22. "Letters," *M.H.R.,* 32 (January 1938), p. 167. Benton and Bingham, incidentally, were slave-owners.

23. Bingham did paint a portrait of Benton, sometime after 1850 (according to Bloch, vol. 2, p. 84). It is, however, distinctly formal; the hair is smoothed, the features bland and dignified, and the clothing impeccably crisp. Bloch does not state his reasons for giving the small canvas (30 × 25 inches) this date.

24. "Letters," *M.H.R.,* 32, (January, 1938), p. 167.

25. William N. Chambers, *Old Bullion Benton* (Boston, Little, Brown, 1956 [1970]), p. 349.

26. *Missouri Statesman,* January 22, 1847, quoted in James F. McDermott, *George Caleb Bingham: River Portraitist* (Norman, Oklahoma, University of Oklahoma Press, 1959), p. 64.

27. Fern Rusk, *George Caleb Bingham: The Missouri Artist* (Jefferson City, Missouri, H. Stephens, 1917), p. 60: "The statesman-artist, as Bingham has often been called, must have had in mind such occasions as the notable Whig convention at Rocheport when he placed his speaker (said to be E. D. Sappington) on this platform out under a great tree . . . On the platform behind the speaker sits a big fat personage whom we are told is Ex-governor M. M. Marmaduke, so accurately portrayed that he felt insulted." See also "Letters," *M.H.R.,* 32 (January 1938), p. 172, no. 13, by editor C. B. Rollins: "There are several so-called keys to 'Stump Speaking.'" One of these, in the collection of the Missouri Historical Society, was drawn up by a Mr. Spencer of St. Louis, using information from Dr. Oscar Potter of Arrow Rock. Besides claiming to know even the names of the two dogs ("Scamp" and "Hector," the latter his own mastiff), Dr. Potter identified the speaker as Darwin Sappington, the scowling man taking notes behind him as Bingham himself, and the extremely well-dressed individual in the crowd opposite as Claiborne Fox Jackson.

28. A lithograph by T. Bowen after a painting by William Hall.

29. "Letters," *M.H.R.*, 32 (January 1938), p. 171.

30. The sequence was this: In November of 1847, Bingham completed *The Stump Orator* (dimensions unknown), which has been reported lost, though a tintype and contemporary descriptions give some idea of the painting; in June of 1849 *Country Politician* was listed for sale at the Gallery of the Western Art-Union in Cincinnati; *Canvassing for a Vote* was completed by 1852 and commissioned by Goupil and Co., who published a lithograph after the painting; in 1851–52 Bingham painted *The County Election*, according to Bloch the version now owned by The Saint Louis Art Museum, the second being painted in 1852 and now owned by The Boatmen's Bank; *Stump Speaking* was finished in 1854; the first version of *The Verdict of the People* was completed in mid-1855 and a smaller version was listed among the effects of the artist's estate in 1879. One cannot guess what went through Bingham's mind, but looking at the course of events (and thinking about what Paul C. Nagel has to say about Bingham the man), I think it is likely that after the 1852 commission the artist fairly quickly realized the market possibilities of the election series. Later he thought of *Stump Speaking, The County Election*, and *The Verdict of the People* as forming a narrative in terms of content because he exhibited them together. Rather endearingly, the paintings seem to mirror Bingham's excitement about their potential, as they grow larger by the year, making *Stump Speaking* a bigger canvas than *The County Election* which it precedes when the paintings are hung sequentially.

31. What is considered the second version of *County Election*, painted in 1852 and the source of an engraving by John Sartain, does not include this incident: The motif, if we may call it that, was not unknown in political prints. Henry R. Robinson, a Whig, published a lithograph (n.d.) showing an Irish immigrant telling campaigners at the polls, "I'm a hindependent Helector. I means to give me Wote according to conscience and him as Tips most!" Often, historians seeking confirmation of Bingham's patriotic desires for *The County Election* quote the *Daily Louisville Times*, April 6, 1853: "Was ever anything so exquisitely life-like? Those groups of sturdy old farmers who have come to town with a grave sense of their responsibility as citizens . . . how serious and honest and sensible they look . . . !" As the reporter goes on (and on) about the "vast majority" of Americans being "sober, incorruptible and independent citizens," he gets in a sly dig at local Kentucky politicos and rationalizes the several instances of drunkenness (some "narrow minded critic" may wonder about men "allowed to vote whose suffrage can be influenced by a glass of whiskey") by the curious reasoning that "such votes as are in the market for money or liquor neutralize each other," i.e., both sides do it.

32. See Mering, *The Whig Party in Missouri*, p. 54: "A survey of persons active in politics during the Whig period . . . [shows] the Whig party represented more wealth and contained a higher proportion of professional and educated men than did the Democratic party. Furthermore, Missouri's Whig party seems to have been primarily a business party . . ." And ". . . the Aristocratic aura that clung to the Missouri Whigs may have harmed the party's fortunes quite as seriously as its economic program," p. 68.

33. Mering, *The Whig Party in Missouri*, p. 68.

34. Mering, *The Whig Party in Missouri*, p. 70.

35. "Letters," *M.H.R.*, 32 (January 1938), p. 182.

36. Elizabeth Johns has thoughtfully suggested that the darkish man with bowed head in the foreground represents an urbanized or half-breed Indian, stereotypically drunk and morose.

37. When I first saw *The Verdict of the People* in the early 1970s, the canvas was hung in a dim room, very high on the wall. At that time, straining to decipher the wording on the banner, I caught only "Freedom for" and what I thought was a word ending in "AS," which I then assumed meant "Kansas." Beautifully displayed in a light-filled room in the new building of The Boatmen's Bank of St. Louis, the painting can now be easily read, though its details are all the more puzzling. "Freedom for Virtue" is a rather cryptic slogan and thus far has not yielded its secret. I have put what I construe of the banner in the text, a reading I consider most plausible, but the phrase "Freedom for Virtue" could invoke other issues. It could refer to anti-prostitution activities (in which case "Remember the Ladies" would take on a far different connotation than the one usually derived from Abigail Adams's feisty words to her husband). Both Missouri and Philadelphia, where Bingham executed the canvas, were deeply concerned with attempts to solve the prostitution problem. The American Society for the Prevention of Licentiousness and Vice and the Promotion of Morality was one vehicle for reform and it was modeled after the American Temperance Society. Both reformist efforts identified themselves as being "for" virtue and attracted feminists, as did the abolition movement. Bingham's target or reference, then, may have been a number of issues with which women were involved. Why, one wonders, do the women he pictures vary in attire, and especially why is the woman who leans over the balcony bare-armed? Why does the flag across from them have 30 stars when there were 31 states (California) when Bingham painted the work? These details, like the tally slip, need not be decoded, to

use a word currently in fashion, in order for the painting to be appreciated; however, they niggle the viewer by their *apparent* significance.

38. These figures, reported differently by different sources, are from Perry McCandless, *A History of Missouri,* II (Columbia, 1982), p. 273.

39. "Letters," *M.H.R.*, 32 (January 1938). In *The Whig Party in Missouri,* p. 199, Mering reports that Rollins had switched from opposing to endorsing the Act by the time Bingham wrote to him.

40. Cf. Truettner, "The Art of History," p. 6: "Americans, obsessed with the idea of a half-empty continent, were . . . engrossed in . . . nationalistic pursuits, and more conscious than ever of a lack of tradition upon which to justify their expansionist motives. Historical myth makers had been hard at work in our country . . . searching what little past we had to give direction and meaning to the twenty years (1840–1860) that would, for all practical purposes, fill out our 'natural' geographical boundaries." And later Truettner quotes Emerson's remark, "There is properly no history, only biography" (p. 25), in the summary of his penetrating discussion of history, painting and historiography. Besides Daniel Boone, George Washington, and Christopher Columbus—predictable choices for American heroic forebearers—explorers from LaSalle to Cortez and Pizarro made appearances as well.

41. "Letters," *M.H.R.*, 32 (1938), pp. 13–14. Germane to the readings I have proposed is the entirety of Bingham's remark, for on the other side of the banner with Boone wrestling an Indian he planned, in his words, "a landscape with 'peaceful fields and lowing herds' indicative of his [the American's] *present advancement in civilization*" (italics mine).

42. Dawn Glanz, *How the West Was Drawn, American Art and the Settling of the Frontier* (Ann Arbor: University of Michigan Research Press, 1978, 1982), p. 23.

43. Bingham hoped to win a government (state) commission for a picture he described as " 'The Father of his Country,' connected with some historical incident, in a manner that would rival the far famed picture by Leutze" ("Letters," *M.H.R.*, 32 [January 1938], p. 187). He did receive portrait commissions that might be termed quasi-historical in subject matter. In 1856 he was asked to paint full-length portraits of George Washington and Thomas Jefferson for the Missouri Statehouse, both of which were executed during the artist's stay in Düsseldorf. He then received commissions for similar portraits of Andrew Jackson and Henry Clay. All were destroyed by a fire in the State Capitol in 1911.

44. Bingham is recorded as having been present at a Whig convention in Jefferson City in 1855 (Keith Bryant, "George Caleb Bingham; The Artist as a Whig Politi-

cian," *M.H.R.*, p. 456, and Bloch, *George Caleb Bingham,* vol. I, p. 303), although Mering, p. 199, says Bingham severed his ties with the Whigs in 1854 and cites an article in the *Missouri Republican,* March 23, 1854, as his source. In any event, the Whig party in Missouri in those years was fast disintegrating; nationally and at the state level, 1855 was the last year in which the Whig party, though not Whigs as individuals, could be said to exist.

45. Bloch, p. 224.

46. George Caleb Bingham, *An Address to the Public, Vindicating a Work of Art Illustrative of the Federal Military Policy in Missouri During the Late Civil War* (Kansas City, Mo., 1871), p. 11.

47. Barbara S. Groseclose, "Painting, Politics, and George Caleb Bingham," *The American Art Journal,* 10 (November, 1978), pp. 5–19.

THE "MISSOURI ARTIST" AS ARTIST

48. The major studies of Bingham, in which may be found extended quotations from contemporary reviews, are John Francis McDermott, *George Caleb Bingham: River Portraitist* (Norman: University of Oklahoma Press, 1959); E. Maurice Bloch, *George Caleb Bingham: The Evolution of an Artist,* 2 vols. (Berkeley and Los Angeles: University of California Press, 1967), and *The Paintings of George Caleb Bingham: A Catalogue Raisonné* (Columbia: University of Missouri Press, 1986). In addition, see Ron Tyler, "George Caleb Bingham, The Native Talent," in *American Frontier Life: Early Western Painting and Prints* (New York: Abbeville Press, Inc., 1987), pp. 25–49.

49. For recent studies of the landscape movement, see Edward J. Nygren, *Views and Visions: American Landscape Before 1830* (Washington, D. C.: The Corcoran Gallery of Art, 1986); John K. Howat, ed., *American Paradise: The World of the Hudson River School* (New York: The Metropolitan Museum of Art, 1987); and Kenneth Myers, *The Catskills: Painters, Writers, and Tourists in the Mountains 1820–1895* (Hanover and London: The University Press of New England, for the Hudson River Museum of Westchester, 1987).

50. For good examples of "prescriptions," see Anne Farmer Meservey, "The Role of Art in American Life: Critics' Views on Native Art and Literature, 1830–1865," *The American Art Journal,* vol. 10, no. 1 (May 1978), pp. 73–89.

51. William Dunlap, "On the Influence of the Arts of Design: and the True Modes of Encouraging and Perfecting Them," *American Monthly Magazine,* vol. 7 (February 1836): pp. 113–124. For general overviews of genre painting, see Patricia Hills, *The Painters' America* (New York:

Whitney Museum of American Art, 1973); and Hermann Warner Williams, Jr., *Mirror to the American Past: A Survey of American Genre Painting, 1750–1900* (Greenwich, Conn.: New York Graphic Society, 1973).

52. *Knickerbocker,* Nov. 1839, pp. 420–421.

53. For studies of Missouri, see Duane Meyer, *The Heritage of Missouri: A History* (St. Louis: State Publishing Co., 1973); Paul C. Nagel, *Missouri: A Bicentennial History* (New York and Nashville: W. W. Norton & Company, Inc., 1977,); and, with an emphasis on the antebellum period, Perry McCandless, *A History of Missouri: 1820 to 1860* (Columbia: University of Missouri Press, 1972).

54. He sent a landscape to the National Academy of Design in 1840 that is no longer extant; during the years 1838 to 1842, he also sent several genre scenes, but only one of Western types.

55. He followed the strategy that had worked so well the year before, sending along with the landscape two genre scenes, *Boatmen on the Missouri* and *The Jolly Flatboatmen.* The version sent to New York has not been located.

56. September 28, 1846.

57. These landscapes are listed in Bloch, *Paintings,* 1986, nos. 226, 227, 228, 229, 230, 231, and 233.

58. Quoted in Bloch, *Paintings,* 1986, no. 192.

59. Quoted in Bloch, *Paintings,* 1986, no. 229.

60. On the West, see the classic study by Henry Nash Smith, *Virgin Land: The American West as Symbol and Myth* (Cambridge: Harvard University Press, 1950 and reprints); quote from Gilpin is on p. 38. For a more recent survey, see William H. Goetzmann and William N. Goetzmann, *The West of the Imagination* (New York and London: W. W. Norton and Company, 1986).

61. See Richard Slotkin, *Regeneration Through Violence: The Mythology of the American Frontier, 1600–1860* (Middletown, Conn.: Wesleyan University Press, 1974); Jules Zanger, "The Frontiersman in Popular Fiction, 1820–1860," in *The Frontier Reexamined,* ed. John Francis McDermott (Urbana, Ill.: University of Illinois Press, 1967); Walter Blair, *Native American Humor* (New York: Harper & Row, 1930); and Walter Blair and Franklin J. Meine, *Half Horse, Half Alligator: The Growth of the Mike Fink Legend* (Chicago: University of Chicago Press, 1956).

62. Some of these images are reproduced in *American Frontier Life,* 1987. For a study of Western imagery in general, see Dawn Glanz, *How the West was Drawn: American Art and the Settling of the Frontier* (Ann Arbor: University of Michigan Research Press, 1982). For studies of women in the West, see Sandra L. Myres, *Westering Women and the Frontier Experience, 1800–1915* (Albuquerque: University of New Mexico Press, 1982); and Annette Kolodny,

*The Land before Her: Fantasy and Experience of the American Frontiers, 1630–1860* (Chapel Hill and London University of North Carolina Press, 1984).

63. Henry Tuckerman, "Our Artists.—No. V," *Godey's Lady's Book* (1846), pp. 250–253.

64. J. Hector St. John de Crèvecoeur, *Letters from an American Farmer,* 1782.

65. Quoted in Bloch, *Paintings,* p. 189.

66. Bingham to Rollins, Marshall, Missouri, November 2, 1846, in C.B. Rollins, ed., "Letters of George Caleb Bingham to James S. Rollins, Pt. 1: May 6, 1837–July 5, 1853," *Missouri Historical Review,* 32, no. 1 (October 1937), p. 16.

67. Realizing that *The Squatters* had both an Eastern and a Western audience, he exhibited it along with five others in St. Louis in October 1850, and then sent the paintings to the American Art-Union in New York in early 1851. The Art-Union was not able to raffle its paintings that year because of legal difficulties. When the Art-Union listed the painting for sale in its catalogue of 1852, it described it as follows: "A family has built its log cabin in the midst of a clearing, and commenced housekeeping." See McDermott, "Another Bingham Found: 'The Squatters,'" *The Art Quarterly,* 19 (Spring, 1956), pp. 68–71.

68. As the following text will suggest, I think the painting and its companion should be redated to the same year.

69. For studies of these narratives, see Slotkin, 1973; Glanz, 1982; Martha Levy Luft, "Charles Wimar's The Abduction of Daniel Boone's Daughter by the Indians, 1853 and 1855: Evolving Myths," *Prospects,* 7 (1982), pp. 301–314.

70. Both paintings were exhibited at the Fourth Annual Fair of the St. Louis Agricultural and Mechanical Association in 1859 by Charles Derby, owner, who reported their titles as *The Captive* and *In Camp.*

71. Edmund Flagg, *The Far West* or *A Tour beyond the mountains.* (New York: Harper & Bros., 1838), vol. 2, pp. 114–115.

72. From *Missouri Republican,* June 4, 1850, drawing on a story in the *Missouri Statesman.* Quoted in McDermott, p. 74; and in Bloch, *Paintings,* 1986, p. 190.

73. The painting was actually sold in 1852, when the holdings of the Art-Union were auctioned.

74. For a recent study of phrenology, see John D. Davies, *Phrenology, Fad, and Science: A 19th-Century American Crusade* (New Haven: Yale University Press, 1955).

75. Sturgess and Walker, *The Draught Player's Hand Book* (Philadelphia: Henry F. Anners, 1852), p. 33. I thank Penny Lazarus for bringing this text to my attention.

76. See the article by William H. Truettner, "The Art of History: American Exploration and Discovery Scenes, 1840–1860," *American Art Journal,* 14, no. 1 (Winter 1982), pp. 4–31.

77. For a summary of Boone's reputation, see Henry Nash Smith, *The Virgin Land: The American West as Symbol and Myth* (Cambridge: Harvard University Press, 1950), pp. 51–58.

78. Bloch, *Paintings,* 131. Bingham probably used as a guide the stipple engraving of Boone by James Otto Lewis.

79. Bingham to Rollins, September 23, 1844, in "Letters of George Caleb Bingham to James S. Rollins," pp. 13–14.

80. Bingham to Rollins, March 30, 1851, in "Letters," p. 21. Although William Ranney had painted Boone, he had not painted the emigrating Boone, the pioneer who marched through the wilderness escorting the future townsmen of the West.

81. *Life and Adventures of Colonel Daniel Boon, the First White Settler of the State of Kentucky . . . Written by Himself.* (Brooklyn, N.Y.: C. Wilder, 1823), p. 15; quoted in Bloch, *Evolution,* p. 127.

82. So much was the print firm of Goupil & Co. aware of the significance of this aspect of the work that when they lithographed the image, they dedicated it "To the Mothers and Daughters of the West." Bingham had offered the painting to the American Art-Union, but that organization became involved in litigation and could not buy it. The painting was raffled in late 1852 or 1853 in St. Louis. See Bloch, *Paintings,* p. 195.

THE RIVER PAINTINGS

83. Bingham to Rollins, in "Letters of George Caleb Bingham to James S. Rollins," *Missouri Historical Review, 32* (October 1937–July 1938), p. 13.

84. Henry Adams, "A New Interpretation of Bingham's *Fur Traders Descending the Missouri," Art Bulletin,* 65 (1983), pp. 675–80.

85. Nancy Rash, "George Caleb Bingham's *Lighter Relieving a Steamboat Aground," Smithsonian Studies in American Art,* vol. 12, no. 2 (Spring, 1988), pp. 17–31.

86. "Paintings," *St. Louis Republican* (April 21, 1847), p. 2.

87. Ibid.

88. *Weekly Reveille,* (St. Louis), September 28, 1846, 1012–2, in E. Maurice Bloch, *George Caleb Bingham, The Evolution of an Artist* (Berkeley and Los Angeles: University of California Press, 1967), p. 179.

89. Thomas Cole, "Essay on American Scenery," 1835, in John W. McCoubrey, ed., *American Art, 1700–1960, Sources and Documents* (Englewood Cliffs, N. J.: Prentice-Hall, Inc., 1965), p. 103.

90. Bingham to Rollins, June 3, 1857, in "Letters," p. 351.

BINGHAM'S GEOMETRIES AND
THE SHAPE OF AMERICA

91. For example, the *Dancing Satyr,* from Casa del Faune, Pompeii (Museo Nazionale, Naples), has been cited as a distant source for the dancing figure in the *Jolly Flatboatmen* series. See also the marble *Doryphorus* (Museo Nazionale, Naples) for *The Emigration of Daniel Boone; The Dying Gaul* (Louvre) for the foreground figure in each of the *Election* paintings; and the *Apollo Belevedere* (Vatican, Rome) for *Martial Law* or *Order No.11.* See E. Maurice Bloch, *George Caleb Bingham: The Evolution of an Artist* (Berkeley, 1967), figs. 56–57, 87–89, 94–99, 164–166.

92. Quoted in James M. McPherson, *Battle Cry of Freedom: The Civil War Era* (New York, 1988), p. 42.

93. See discussion of Bingham's artistic responses to these political events in Bloch, *Bingham: Evolution,* pp. 215–219.

94. See discussion of some of these themes in McPherson, *Battle Cry,* pp. 4–16.

95. The definitive pioneering study is F.O. Matthiessen, *American Renaissance: Art and Expression in the Age of Emerson and Whitman* (New York, 1941).

96. See Matthiessen, *American Renaissance,* vol. x, p. 659.

97. David S. Reynolds, *Beneath the American Renaissance: The Subversive Imagination in the Age of Emerson and Melville* (New York, 1988), pp. 339, 387.

98. Reynolds, *Beneath the Renaissance,* pp. 54, 91.

99. Quoted in Matthiessen, *American Renaissance,* p. 12; see also Reynolds, *Beneath the Renaissance,* pp. 94–96, 412–419.

100. The key works for Lane here would be *Lighthouse at Camden,* 1851, *Entrance of Somes Sound* and *Gloucester Harbor,* 1852, *Salem Harbor,* 1853, *Boston Harbor,* and *Blue Hill,* c. 1855, *Lumber Schooners at Evening on Penobscot Bay* and *Ships and Approaching Storm off Owl's Head,* 1860. For fuller discussion of the artist and these paintings see John Wilmerding et al., *The Paintings of Fitz Hugh Lane* (Washington, D.C., 1988).

101. For Church the list would include *Twilight, "Short Arbiter Twixt Day and Night,"* 1850, *Beacon off Mount Desert,* 1851, *Grand Manan Island, Bay of Fundy,* 1852, *Mt. Ktaadn,* 1853, *The Andes of Ecuador,* 1855, *Twilight* and *Sunset,* 1856, *Niagara,* 1857, *The Heart of the Andes,* 1859, and *Twilight in the Wilderness,* 1860. For further discussion see John Wilmerding et al., *American Light, The Luminist Movement 1850–1875* (Washington, D.C., 1980).

102. See Matthiessen, *American Renaissance,* vol. xxxci.

103. Quoted in Matthiessen, *American Renaissance,* p. 149.

104. See William H. Pierson, Jr., *American Buildings and Their Architects: The Colonial and Neo-Classical Styles* (New York, 1970), pp. 214, 417.

105. See Pierson, *American Buildings,* pp. 376, 386, 416, 436.

# INDEX